Arts TV

A HISTORY OF ARTS TELEVISION IN BRITAIN

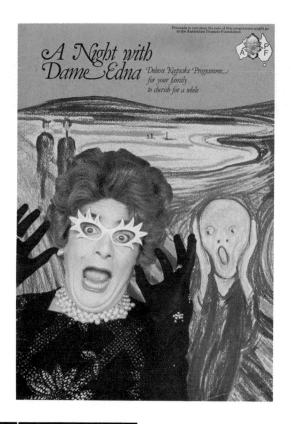

(Barry Humphries), the Australian comedian appeared in a Munch 'Scream' dress on British TV programmes in 1992 (including an arts pro-grammes - *The Late Show* BBC2, 3/12/92 - about 'The Scream' painting then on display at the National Gallery, London). As the above photo shows, Dame Edna's interest in the famous image of bourgeois angst and alienation dates back a number of years.

PROGRAMME COVER ILLUS. FOR 'A NIGHT WITH DAME EDNA', 1978. DESIGN BY DIANE MILLSTEAD.

Arts TV

A HISTORY OF ARTS TELEVISION IN BRITAIN

JOHN A. WALKER

John Libbey
JL
LONDON · PARIS · ROME

THE **ARTS COUNCIL** OF GREAT BRITAIN

British Library Cataloguing in Publication Data

Arts TV: A History of Arts Television in Britain
 I. Walker, John A.
 791. 45

ISBN 0-86196-435-7

Published by

John Libbey & Company Ltd,
13 Smiths Yard, Summerley Street, London SW18 4HR, UK.
Tel: +44 (0)81 947 2777
Tel: +44 (0)81 947 2664

John Libbey Eurotext Ltd,
6 rue Blanche, 92120 Montrouge, France.

John Libbey-CIC s.r.l,
via L. Spallanzani 11, 00161 Rome, Italy.

Book designed by Design & Art (London).
Printed in Great Britain by Whitstable Litho Ltd, Whitstable, Kent, UK.

Foreword

Just over 20 years ago *Ways of Seeing* was produced by the BBC, it represented a radical departure from the traditional arts programme as it took *seeing* to be the primary source of understanding the plastic arts. Further, it recognised the importance of understanding how the camera changes the meaning of paintings. John Berger in the book based on the series argued that 'the uniqueness of every painting was once part of the uniqueness of the place where it resided...As a result its meaning changes. Or, more exactly, its meaning multiplies and fragments into many meanings...This is vividly illustrated by what happens when a painting is shown on a television screen. The painting enters each viewer's house. There it is surrounded by his wallpaper, his furniture, his mementoes. It enters the atmosphere of his family. It becomes their talking point. It lends its meaning to their meaning. At the same time it enters a million other houses and, in each of them, is seen in a different context. Because of the camera, the painting now travels to the spectator rather than the spectator to the painting. In its travels, its meaning is diversified'. It is this status that *Arts TV: A history of Arts Television in Britain* attempts to illustrate and is the first book which constructs a comprehensive history of how the arts have been represented by British Television. The book looks at the complex set of relationships between the plastic arts, the institution of broadcasting and audiences. It aims to stimulate debate, extending it into a *history* of how the plastic arts have been represented by television.

Arts TV: A history of Arts Television in Britain considers the role of the plastic arts in a variety of television practices including, *popular* arts programmes, the *block-buster* series, and the experimental. This unique book will provide an invaluable reference work for students of art/art history and media studies. We trust that it will provide a fascinating book for the general reader interested in the arts and the mass media and hope it will stimulate possible ways of understanding the arts on television.

This is the fourth volume in a series of books on the way the media has transformed our understanding of the arts. The first volume, *Picture This: Media Representations of Visual Art & Artists,* dealt with a range of topics, including the representation of visual art in popular cinema, and how broadcast television has revolutionised our relationship to culture and cultural practices.

The second volume, *Culture, Technology & Creativity,* addresses various aspects of how technology and creativity inter-relate. Topics covered include:- digital technologies, computers and cyberspace. The third volume *Parallel Lines: Media Representations of Dance* collects together accounts of how dance and dancing have been represented on public television in Britain. The book considers the role of dance in a variety of television practices including pop-videos, *popular* dance programmes, and experimental and contemporary dance. *Arts TV: A History of Arts Television in Britain* continues the interrogation of the creative relationship between the traditional arts and the media; the most important means by which they are received and represented. Further planned volumes include *Opera and the Media* and a two volume anthology on the history of experimental film and video.

We would like to take this opportunity to thank John A. Walker for writing this book and the publisher John Libbey who joined us in its production. We are grateful to them for the untiring and thoughtful way in which they have approached the task.

Finally, the views expressed herein are those of the author and should not be taken as a statement of Arts Council policy.

Will Bell
Education Officer: Film, Video & Broadcasting Department
October '93

Preface

Arts programmes and series appearing on British television are the main concern of this book. To a lesser extent, it also considers the computer-generated imagery and graphics appearing on the screens of computer monitors and television sets. The book is a companion volume to *Art and Artists on Screen* (Manchester University Press, 1993), a text which explored the relationship between art and cinema. In both volumes the arts considered are the visual or plastic arts of painting, sculpture, architecture (plus artists' films and videos), rather than the performing arts of ballet, drama, music and opera. This is because my own interest and knowledge relates to the former rather than to the latter, and because some limit had to be placed on the object of study. In regard to the performing arts, several books have been published about television drama and in 1993 an anthology of articles about dance - *Parallel Lines: Media Representations of Dance* - was published in the same series as this book.

Most of this book is concerned with the forty year period 1950-90. It was during the 1950s that television overtook the cinema as the leading medium of mass communication in developed countries like Britain and the United States. A historical development is described but it has not been possible to provide a strictly chronological account because of the need to compare like with like, that is, to discuss arts programmes in terms of genres or types. The majority of programmes and series discussed are British in origin or have been transmitted in Britain. The huge number of TV programmes produced throughout the World means that no individual can provide a global history based on direct observation. A historian tracing the development of arts television over several decades within the boundaries of one country must, of necessity, remain in the same geographical vantage point. However, it is my contention that the contents of this book are not parochial because: first, some British series were distributed abroad, some were international co-productions and some were foreign productions; and second, the characteristics of the programmes and the issues they raise are not confined to Britain.

A justification for the focus on British television is the fact that this country has originated an unusually large number of arts programmes and series, many of which have been imaginative and innovative.

The story of arts television in Britain is a fascinating one - it deserves to be told.

Acknowledgements

Thanks are due to the following people for providing information, comment and assistance:
Roy Ascott, Simon Bradford, Melvyn Bragg, Nadine Covert, Geoff Dunlop, Rose Finn-Kelcey, David Hall, Richard Hamilton, Professor John Lansdown, John Latham, William Latham, Mervyn Levy, Ken Morse, Sandy Nairne, John Read, Jeremy Rees, Anna Ridley, Karl Sabbagh, Tony Steveacre, Katie Whitbread, Rodney Wilson, John Wyver and the library staff of Middlesex University.

Particular thanks are due to Will Bell of the Arts Council for his support and encouragement, and to David Hockin of Design & Art for his design skills. Thanks also to all the individuals and organisations who kindly supplied photographs and gave permission for their use as illustrations

Shortened versions of two parts of this book - 'Civilisation' and 'Ways of Seeing'- previously appeared as articles in the magazine *Art Monthly*. My article 'Art TV in the 1990s: the return of Pop Posh?' published in *AND: Journal of Art and Art Education*, (22), 1992, was also based on a chapter in this book.

Contents

Introduction

Television is the dominant mass medium of the present age because it encompasses all others as content, and because the daily flow of its images and sounds penetrates virtually every home in developed countries. Amongst television's myriad contents are the visual arts. For millions of viewers art is a phenomenon they encounter primarily via their TV sets. Even those who attend exhibitions to see works of art at first hand generally watch arts programmes previewing them, consequently their direct experience of art is mediated or supplemented by television's representations. In the case of certain types of time-based material - video, film and computer graphics - the 'secondary' relationship does not apply. The presentation of such material on television becomes, as John Wyver once put it, an 'alternative curatorial method'; in this instance, television functions as an electronic museum or gallery. It follows that, for good or ill, the relationship between television and the arts is a crucial one.

Television's ability to arouse the interest of the public in all kinds of specialist subjects has often been demonstrated, but in relation to the fine arts, the problems of audience, level and manner of presentation constantly recur: who are arts programmes for - knowledgeable or ignorant viewers? Should they be accessible or demanding? Is their purpose to entertain, educate or to encourage people to take up art? Should their aim be to persuade people to visit museums and art galleries or should they strive to make television itself a kind of art? What balance should there be between programmes dealing with the history of art and those dealing with contemporary work? Should programmes focus on works of art or the artists who made them? Should the comments of artists be preferred to those of critics and historians? Should television producers collaborate with artists or commission them to make programmes? Is the role of television to celebrate the arts or to criticise them? Should arts programmes concern themselves with popular culture as well as the traditional fine arts? What televisual style is appropriate and what relationship should obtain between sound and image? Should there be a single presenter, several presenters or no presenter at all? What channels should arts programmes appear on and at what time of day or night should they be scheduled?

Channel and time of transmission are important because they determine, to some extent, the size and kind of audience a programme attracts. While some arts programmes have been scheduled at peak times, there is currently a tendency to place them after eleven in the evening to appeal to those returning home from public houses. The more experimental arts programmes tend to appear on the minority taste channels (that is, BBC 2 and Channel 4) and to be assigned off-peak slots. Programmes featuring examples of video art in particular tend to be allocated the early hours of the morning when most of the populace is in bed. What precedes an art programme in the schedules can also be significant because some viewers are inherited from the previous programme.

The fine arts pose a particular problem to television producers because of the dichotomies between high and low culture, minority and mass audiences ('posh' and 'pop' in Peter York's terminology). The intervening category - middlebrow - should not be overlooked.

While researching this text it has been fascinating to observe how television, in representing the fine arts, has negotiated the contradictions between the different value systems of élite and popular culture. To reach their high levels of attainment, fine arts such as painting and sculpture required both intellectual and manual skills. These arts evolved over many centuries and were sustained by the surplus wealth produced by society as a whole but dispensed by various ruling groups: royalty, the church, the guilds, the aristocracy and the bourgeoisie. Understanding the meanings of these arts frequently depends upon a knowledge of history, the Bible and classical mythology. Literacy, education, a cultured family background, therefore, are generally prerequisites for such understanding. Television, in contrast, is a technological medium which belongs to the age of mechanical reproduction and mass communication systems; it is a medium which reaches all classes in society, hence it is more 'pop' than 'posh'.[1]

Fine art produced by living artists is contemporaneous with television but it too poses problems for the mass medium because its 'languages' and allusions are often different from those of television. 'Decoding' contemporary art normally requires specialist knowledge that in turn is dependent on access to higher education.

As we will discover, there has been a determined effort on the part of some British intellectuals to use television to popularise high culture. Kenneth Clark, for instance, employed the medium to propagate and preserve the values of European high culture, while John Berger used the medium to demystify that very same culture and, indeed, television itself.

Much of the content of television is popular culture or is about popular culture: movies are shown and they are also reviewed; adverts appear and they are also analysed. In recent years arts programmes have increased their coverage of popular culture and have treated rock music stars like Madonna and Prince as important artists worthy of being examined as seriously as Matisse and Picasso. In the early 1990s this development

provoked a heated debate in the press about cultural standards on British television. The issues at stake were revealed by Michael Ignatieff when he wrote:

> Because this is Britain, the cultural debate between élitists and populists is the class war in another form. In few other cultures are aesthetic standards so saturated with class content ... Any debate about cultural standards in Britain is necessarily about who gets to talk down to whom, about which accent does the judging.[2]

Existing literature

To my knowledge no history of television programmes about the plastic arts has been published in book form, though general histories of television channels and official reports on the future of broadcasting sometimes include a chapter on arts programming. (The archives of institutions like the BBC, of course, are sources of unpublished material.) The bulk of the published literature consists of brief articles in quality newspapers and in listings/media magazines. Newspaper articles encompass reviews of programmes by television critics, profiles of newly appointed commissioning editors and polemical pieces on the state of arts television. Articles in the press are written both by journalists and by television professionals like Joan Bakewell, Alan Yentob and Melvyn Bragg. Bragg, a long-standing commissioning editor and presenter, has written several articles about arts television over the years. John Wyver, of the independent production company Illuminations, has also penned a number of informative essays.

Numerous journalistic pieces about particular programmes have appeared in such magazines as *Radio Times* and *The Listener* (the latter has now ceased publication). More scholarly analyses are to be found in anthologies such as *Picture This* (1988) edited by Philip Hayward (see in particular Wyver's important essay 'Representing art or reproducing culture?') Biographies of, and autobiographies by, leading television personalities, art historians and film-makers, such as Sir Huw Wheldon, Lord Clark and Ken Russell, are a further source of information. The introductions of tie-in books are clearly of value in respect of the television series to which they relate.

Aside from the category of material known as 'video art' (most of which does not appear on broadcast television), the art press does not pay much heed to the medium of television but, occasionally, art magazines like *Art & Artists, Arts Review, Circa, Artists' Newsletter, Modern Painters* and *Art Monthly* publish articles on television's coverage of the arts. A useful series appeared in the last-named magazine during 1984. They were especially valuable because they were written by people actively involved in making arts programmes. Berger's 1972 *Ways of Seeing* series was exceptional in the amount of discussion it provoked: the literature on it includes a special issue of the artist's magazine *Art-Language* and two paperbacks by the art critic Peter Fuller (1947-90).

The fact that several conferences on the theme of arts television have been held in London (at the Institute of Contemporary Art, the Riverside Studios and the Victoria & Albert Museum) and in Brighton in recent years is evidence of a growing interest in the subject. The proceedings of the conference held at the Victoria & Albert have been published. At Brighton, in October 1992, the Arts Council and the BBC jointly organized a three day conference about broadcasting and the arts. The conference's title - 'The Odd Couple' - implied that the combination of broadcasting and the arts was awkward and strange.

Catalogues of exhibitions taking place in galleries and museums are yet another source of information. During the late 1980s museums in Europe and the United States evinced considerable interest in the relation between art and television. For instance, in 1986 the Queens Museum in New York staged a show called 'Television's impact on Contemporary Art'; in 1987 Dorine Mignot of the Stedelijk Museum, Amsterdam, curated - with the help of guest selectors - a show called 'Revision' which presented a survey of video recordings of art programmes from eight European countries. A substantial catalogue accompanied this exhibition.

In the same year Mignot collaborated with Kathy Rae Huffman of the Museum of Contemporary Art in Los Angeles to mount a show called 'The Arts for Television', an international, historical survey of arts programmes arranged in six thematic categories: image, theatre, literature, dance, music and television. Again a substantial catalogue was published. A version of both shows appeared at the Tate Gallery, London in 1989 following a world tour.

During the Autumn of 1990 the New Museum of Contemporary Art in New York examined an aspect of the history of American television in a show entitled 'From Receiver to Remote Control: the TV Set'. The show was conceived by the video artist Matthew Geller and considered the multiple impact of the TV set in the home, that is, in terms of the layout of rooms and family/gender relations. One display consisted of thirty-six TV sets tuned to the thirty-six channels available in New York! A book with seventeen essays by various authors was published by the New Museum in association with the show.

Computer art/graphics is a field that has expanded rapidly in the second half of the twentieth century and the literature on it is already extensive. An important survey of computer art in the United States during the 1960s was provided by Gene Youngblood in his wide ranging, innovative text *Expanded Cinema* (1970). The British art critic Jasia Reichardt organised the first London show of computer art in 1968 and she edited the book/catalogue entitled *Cybernetic Serendipity* that accompanied it. Subsequently, she wrote a second book about the subject. Jonathan Benthall provided another early survey in his 1972 paperback *Science and Technology in Art Today*. The magazine *Leonardo* (1968-) is concerned with the interface between art and science and it has published many articles over the years on computer art. In Dallas, in 1981, the SIGGRAPH '81 Art Show was inaugurated and became an annual event; catalogues and slide sets are issued.

During the 1980s a spate of books about computer graphics appeared. A representative example is Annabel Jankel's and Rocky Morton's (and others) *Creative Computer Graphics* (1984), a large format book with many colour illustrations. The text is based on direct experience because the two main authors, the founders of Cucumber Studios, are practising computer graphics designers.

One field of design that has greatly benefited from the progressive improvements in computer technology since the 1960s is television graphics. Several books have been published about this subject. Douglas Merritt, who headed the graphic design department of Thames Television, is the author of an informative and well-illustrated survey entitled *Television Graphics - from Pencil to Pixel* (1987).

Scholars and television

Despite the material cited above, little has been forthcoming from the academic community, that is, scholars, art historians and the publishers of art books. This is probably due to a residual disdain for popular cultural forms such as film and television. About the latter, Martin McLoone perceptively observes:

> The relationship between television and the visual arts is a clash between culture at its most popular and accessible and culture at its most exclusive and élitist. Indeed television occupies the ironic position of being at the centre of most people's everyday life whilst at the same time existing on the margins of cultural legitimacy. This is hardly surprising, given that cultural criticism today is still largely dominated by a number of traditional assumptions about art that tend to deny television its very status as culture and certainly would resist endowing it with artistic merit.[3]

Nevertheless, most academics would respond with alacrity if invited to appear on television or to undertake research for an arts programme. When this happens the high art system of values tends to be imported wholesale into the mass medium, as McLoone points out: 'The final irony is that television is most praised by this critical tradition when it reproduces the very assumptions which otherwise consign it to the rubbish heap.'

Television has been established in Britain for over fifty years. During this time it became the most popular form of mass entertainment and source of news, and yet it is still regarded with contempt by many politicians and intellectuals. For example, in 1991 a British minister advised children not to watch Australian soap operas because they were 'junk'. Television is routinely blamed for a decline in the ability of American and British children to concentrate and to read. (Words on paper still appear to take priority over images and sounds. Perhaps schools should begin to test the *visual* literacy of their pupils.) Researchers have even claimed that children who watch too much television fail to become properly socialised because they lack experience of human interaction.

This text is unusual, I believe, because it treats television as a form of culture worth taking as seriously as fine art itself, rather than as a 'plug-in drug'. It disagrees with the idea that television is intrinsically inferior to books or paintings. If watching television reduces direct social interaction, then so does the individualistic activity of reading. Most viewers may be channel hoppers or 'grazers', many families may treat television as 'moving wallpaper', as a backdrop to domestic activities, but this text assumes it is possible to watch television selectively, with discrimination and attention; to watch programmes all the way through in a concentrated manner and to study and analyse them in the same way that one would a work of art chosen from the collection of a major museum. Such behaviour may be untypical, but this does not make it illegitimate.

Many histories of television written by insiders are about internal power struggles or the development of technologies and institutions. I have not been employed by the BBC or ITV, so this book has been written from the perspective of an independent, outside observer, a consumer and user of arts television with a special interest in the visual arts and the mass media.

The audience researchers who compile viewing figures and who study how people behave in front of 'the Box' are only concerned with the home environment, but it should be remembered that television is also viewed in schools and colleges where programmes are used as visual aids. Furthermore, some home viewers are students of the Open University. In their case, television programmes have been specially designed as educational tools. Also, arts programmes are increasingly being screened in public museums. A different mode of viewing is encouraged when art programmes are detached from their normal physical and media contexts. Technological changes have also brought about new relations between viewers and the medium of television. For instance, the spread of video-cassette recorders (VCRs) during the 1970s and 1980s, and the proliferation of videotape recordings that could be rented or bought, meant that an evening's television no longer had to be a seamless flow. The timeshift capability meant that viewers no longer had to watch programmes at the time they were broadcast. (According to Sean Cubitt, 'timeshifting' is 'the most poetic word to enter the English language in the last twenty years'.[4]) Videotapes are discrete items. They can be watched at the viewer's convenience and viewed many times. The rewind, stop and pause buttons can be used to allow time for reflection or note taking.

Researching the early years of television is difficult because technical limitations meant that little of the live output of the 1930s and 1940s was recorded. (Telerecording via film and videotape had to take place while programmes were being transmitted.) Some 1950s arts documentaries were shot on 35mm film and so have been preserved but no trace remains of many other early, live programmes. In the case of the latter, the historian is forced to rely on memories and secondary sources of information. As already mentioned, VCRs became commonplace in homes, schools and colleges during the 1980s. The result was that programmes

which had previously been ephemeral could now be retained and studied as many times as desired. (Television had previously been dubbed 'the ephemeral art'.) The possibility that arts programmes could be recorded and watched several times may have encouraged arts series - such as *State of the Art* (Channel 4, 1987) - to become more complex, though there were other factors too, such as the increasing complexity of the discourse of art itself. As recordings accumulated, archives were formed which facilitated comparison both in terms of period and type. Without such video archives, the research for this book would have been far more onerous.

Mediation

As in the cinema, the illusionism of television's images generates a reality or transparency effect which makes it hard for viewers to grasp the ways in which the medium filters, frames and re-orders its subject matter. Most of the time, the technical processes of image and programme production are concealed from the viewer's gaze. As we shall discover later, episode one of John Berger's *Ways of Seeing* (BBC 2, 1972) was exceptional precisely because pains were taken to reveal how the pictorial and aural rhetoric of television works.

There are some naive viewers who believe television can and should present art and artists 'without any interference or distortion'. Yet, even those programmes with a minimum of 'interference' - live television relays of theatrical performances such as concerts, ballets or operas - involve transformations of the original events as far as the viewer at home is compared (clearly, the home viewer's experience of the event is different from that of theatre audiences). For instance, a live television transmission involves flattening and framing (reduction of a three-dimensional world to a two-dimensional image, reduction of the human eye's field of vision to the rectangular shape of the TV set), the elimination of any smells, alterations of sound and colour values, the introduction of spatial movement (caused either by actual camera movement or through the use of zoom lenses), and, if there is more than one camera, changes of viewpoint and a fragmentation of the performance as directors cut from one camera to another.

From the Renaissance onwards European painters strove to master the intricacies of form, perspective and lighting in order to make their images resemble those of mirrors and window views. A similar pursuit of illusionism was undertaken by the inventors and engineers associated with photography, cinematography and telecommunications. The result is that we now have television sets displaying colour images most people find realistic. This means that the medium of television can reproduce the appearance of an art object with some degree of conviction but, in the case of paintings, the desire for absolute fidelity is bound to be frustrated because, as Philip Hayward has reminded us, monitors vary in their screen sizes, colour/brightness settings (some sets are still black-and-white), and

in their sound/image reception qualities.[5] Hayward also noted that the very characteristics of paintings coveted by television - their precise physical attributes and their aura as original works of art - are those that are lost in the recording and transmission processes. It follows that television has to aim at something different, something more ambitious, than mere reproduction.

Improvement in the quality of television's reproduction of the colours and fine details of art objects is still possible. Those interested in the visual arts will no doubt welcome the appearance, during the 1990s, of sets with bigger screens and more sharply defined images. The new sets have larger, wider screens with a letter-box shape resembling that of CinemaScope screens (the aspect ratio changes from the present 4 x 3 to 16 x 9). Two HDTV (High Definition Television) systems - one Japanese and one European - are currently being designed and manufactured. HDTV sets are already on sale in Japan - at a cost of £20,000! The European system is due to be available by the mid-1990s. Europe's HDTV sets will have pictures with 1250 lines instead of the present 625; the quality of the image resolution, therefore, will be much better.

It is probable that virtual reality machines will soon be able to provide even more illusionistic simulations of artworks. Such simulations could be especially appropriate to the appreciation of architecture because the technology will enable viewers to take 'walks' through cities and buildings both actual and imaginary. Already such simulations are being used in the United States in the re-design of poor, urban districts of Los Angeles.[6] One paradox about the search for ever greater illusionism is the fact that modern artists, for the most part, have rejected it. This is another instance of a difference between the values of fine art and those of television.

Regarding the gap or discrepancy between art and its televisual representation, the British art critic John Roberts has asked why the loss of visual accuracy that accompanies reproduction should be considered a matter of *compensation*. The gap, he suggests, could be a productive *release* for analysis.

He concludes:

> The assumption that television has to be a convincing, vivid
> mediator of the direct encounter between spectator and artwork is
> simply the product of an unproblematised account of the recovery
> and production of meaning from art; the intractabilities of
> reproduction have become red herrings in a much deeper debate
> over art's relationship to knowledge.[7]

The fact that art plays an illustrative role on television does not bother Roberts because he believes this serves 'what television does best: the taking up and talking through of ideas'. Other experts - Kenneth Clark and Robert Hughes - it should be acknowledged, disagree: they think television is good at showing things but poor when it comes to expounding ideas and theory. There seems to be an implication here that there is a simple

division of labour between the image sequence and the soundtrack, that is, images show art objects, words interpret them. It could be argued, however, that when a television or film camera explores the details of a painting, it too is engaged in interpretation.

Television is routinely described as 'a visual medium' but, of course, it is simultaneously a sound medium. Indeed, some writers claim that in television the image is subordinate to sound. Good sound reproduction is obviously desirable when concerts and operas are being relayed, yet the loudspeakers of TV sets have often been found wanting in this respect. Noises, natural sounds, speech and music also play vitally important roles in arts documentaries. With modern film and video technology images and sounds can be recorded at the same time - synchronously - but they can also be recorded separately (via silent film camera and tape recording) and then brought together during the editing phase. (Some British documentary film-makers working for television in the 1950s and 1960s used this method.) It follows that sounds recorded in one place can be juxtaposed against images filmed in a completely different place. Images and sounds can be combined in a variety of ways, but mainly they either complement or counterpoint one another.

Most arts documentaries include specially composed background music, or quotations from classical or popular music, and a voice-over commentary. The character of the music employed normally reinforces the image/word contents. For example, an Open University programme about Manchester's Victorian town hall used brass band music in order to match the Northern theme. Even though many viewers may not even consciously notice its existence, music adds an emotional tone to a programme. Reviewers of programmes about the visual arts do sometimes complain that the accompanying music is inappropriate or obtrusive. Aside from the jingles associated with the title sequences that introduce television series, music is normally third in order of importance. However, as we shall discover when we come to discuss the drama-documentary films Ken Russell made for *Monitor,* there are some directors who prefer to prioritise music over spoken commentary.

Voice-over commentaries are normally dubbed onto film or videotape during the editing phase. They are sometimes read by those who wrote the scripts and sometimes by actors whose voices may well be familiar to the viewer-listener. The gender, accent and tone of voice of the reader all contribute to the character of the programme. If the person speaking is off screen, then the commentary has a disembodied quality: it carries authority but its source is hidden. (The effect, as Sean Cubitt put it, is like 'the voice of God'.) Traditionally, the commentary imposes a preferred interpretation of the meaning of the images, even though the contents of the latter may sometimes contradict or exceed it.

One cannot generalise about the weight of the voice-over commentary in relation to the imagery, because it varies from programme to programme and from segment to segment within programmes. There are certainly some TV documentaries that are script driven, where film-footage

appears to have been chosen from a film library simply in order to illustrate words written in advance. In fact, this often happens when the script is a particularly intelligent and literate one.

Besides voice-overs, arts programmes frequently employ presenters who talk directly to camera (they either use their memories or a Teleprompter). The number of words uttered during a fifty minute documentary is quite small. It is comparable to the number used in a magazine article rather than a book. The need for the commentary to be intelligible to a broad cross section of the public means that clarity, concision and fluency of expression are highly valued. Robert Hughes once praised the medium of television for its brevity. He added: 'Intelligent television encourages plain speech, an exceeding rare commodity in the artworld'.[8]

Words also appear in arts programmes in the form of titles, credits and captions. Increasingly, captions or subtitles are being superimposed over the moving flow of images. They add information without halting the flow. In certain programmes - those aimed at teenagers for example - excessive subtitling produces an overload of information, but as a way of identifying a speaker or conveying a brief item of information they are economical and effective.

Some further points about visual reproduction need to be addressed. Like the cinema, today's television has technical capabilities that far outstrip the ability of cameras to record the surface appearance of an art object. Two examples will clarify this point: first, the famous title sequence for the popular science fiction series *Dr Who* (BBC, 1963-). This abstract, 'psychedelic', black-and-white sequence was devised by Bernard Lodge, a designer who trained at the Royal College of Art. The pulsating patterns of light were generated electronically using feedback techniques such as pointing the video camera at the monitor (test signals are also generated by electronic circuits). The powerful music that accompanied the title was also produced electronically by the BBC's Stereophonic Workshop. The second example is simply one instance of the computer-generated imagery that became commonplace on TV screens during the 1980s. In a programme about Roman architecture in the series *Art of the Western World* (Channel 4, 1989), the structures of arches, barrel vaults, ambulatories and so on were vividly conveyed by means of a computer graphics sequence consisting of schematic, animated drawings that expanded, contracted and rotated.

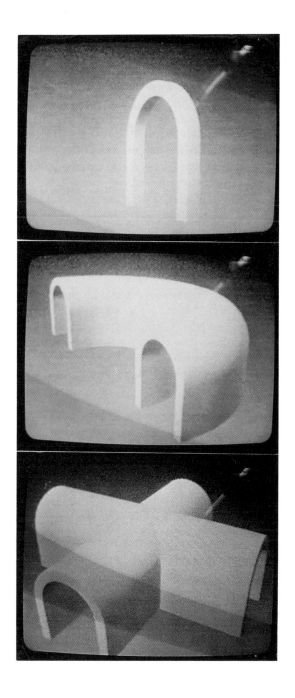

of computer graphics used in *Art of The Western World series,* Channel 4,1989. This series was a co-production between TVS, UK and WNET, New York , and the graphics were the work of Bayley Silleck Productions, New York.

PHOTO COURTESY OF BAYLEY SILLECK.

In addition, television can transform and animate still and moving images of existing works of art by means of animation, digital paint systems, rostrum camera techniques, electronic stills stores; and through the use of special effects made possible by video editing systems such as Abekas, Harry and Harriet. An operator using a video rostrum system with access to an electronic bank of digitalised images stored on compact videodiscs, for example, can call up, retouch and distort those images at will. It is even possible to combine live action pictures of an art historian with images of a canvas in such a way that the expert appears to be *inside* the painted scene he or she is talking about. (This is the TV equivalent of photo-montage.) Of course, the majority of television programmes still favour a naturalistic mode of representation.

Other programme makers - for example, the producers of the *Alter Image* series - realising that mediation and transformation are inevitable, have advocated a collaboration between themselves and contemporary artists in order to create a synthesis of art and television. Their aim has been to generate programmes capable of providing aesthetic experiences in their own right. It follows that arts programmes can be situated on a spectrum between two extremes. At one extreme are programmes whose prime aim is to do justice to the arts as activities independent of television (for example, a live broadcast of a concert), and at the other, are those programmes whose purpose is art television (for example, a video specially conceived for television). In mid-position are those programmes in which a pre-existing work - say a ballet - has been adapted to make it more suited to the medium of television.

In the main, it is video art - a form of visual art exploiting some of the same technology as broadcast television itself - that challenges and transgresses the medium's naturalism and transparency. Video artists foreground their medium and apparatus, they delight in formal experimentation, consequently their work subverts broadcast television's norms and conventions. For this reason video art troubles those who control television channels. For many years video art's existence was ignored and even now, when more and more examples are being shown, its position is still marginal and insecure.

Making images of works of art available in the home is not the only benefit television provides. The medium in general, and organisations like the BBC in particular, are socially influential, consequently they can open doors that would probably remain closed to the layperson. Viewers thereby gain access to precious objects in private or foreign libraries, archives and collections that they would normally never encounter. Interviews also introduce them to famous living artists, critics and scholars they would otherwise find difficult to meet. Camera crews are paid to travel to distant places many viewers cannot afford to visit. Even when an arts programme shows a place accessible and familiar to viewers, television's technical resources enable them to see more than would be possible with the naked eye alone. For example, the camera crew's lights

can illuminate the dark corners of buildings; their telephoto lens can enlarge part of a high ceiling. These are obvious points, but they are easily overlooked when the reproductive limitations of television in respect of works of art are cited.

Patronage

In Britain, television organizations are important patrons of the arts. As the Labour politician Mark Fisher explained in 1992: 'The BBC is not only the largest arts company in Britain, it is probably the largest in the world. It employs five orchestras and 400 musicians... 8,500 actors...'; and as Liz Forgan remarked: 'Channel 4 spends over £10 million a year on its art and music programmes...'.[9] The performing arts benefit most from television's largess but there are some examples of direct support for visual artists. For instance, in 1991 Channel 4 decided to sponsor the Turner Prize, an annual award of £20,000 made to a leading British artist via a televised award ceremony held at the Tate Gallery, London. Another example: in 1992 BBC 2 commissioned artists as disparate as Helen Chadwick, Roderick Coyne, Ian Hamilton Finlay, Paul Graham, Richard Hamilton, Damien Hirst, Howard Hodgkin, Richard Long and Bill Woodrow to devise images to be displayed on billboards. (The project was jointly sponsored by *Radio Times* and the billboard firm of Mills & Allen.) The resulting images were then featured in short, 'vox pop', programmes and a longer, more analytical documentary entitled 'Outing Art' (edited by Keith Alexander) was produced which examined the differences and similarities between art and advertising. Avant garde film and video makers have also benefited from the money and technical resources which television has provided.

In addition, the publicity arts programmes give to living artists undoubtedly helps their careers and sales. Clearly, whenever television succeeds in widening the audience for contemporary art, it increases the chances that more artists will be able to make a living. Even the art of the past can benefit: NTV, a Japanese television company, provided three million dollars to pay for the cleaning of the Sistine Chapel ceiling. For this sum they gained exclusive rights to film of the restoration work. Indirectly, coverage of the masterpieces of Greece, Italy, France and so forth contributes to the tourist industries of those countries. In short, television does far more than merely depict the visual arts.

Commissioning editors of arts series - Melvyn Bragg, Michael Kustow, Andrew Snell, Alan Yentob, and others - are also important patrons, if not of fine artists directly, then of researchers, writers, film directors and producers. Considering the money these editors have dispensed over the decades, they may be called 'the Medicis of the medium'. As the hundreds of hopefuls who have submitted programme ideas and proposals can testify, the power of such editors is considerable. In their role as gatekeepers, they control access to the most vital mass medium of the twentieth century.

fig 2 | Alan Yentob joined the BBC as a general trainee in 1968. He edited *Arena* from 1975-85, then became Head of Music and Arts. In 1987 he was appointed Controller of BBC 2 and in 1993 he became Controller of BBC 1.

PHOTO COURTESY OF THE BBC.

In Britain, arts programming periodically serves a useful, internal function as far as commercial TV companies themselves are concerned. Jeremy Bugler has called it 'the fig leaf function', that is, a proportion of programmes devoted to high culture serves as a fig leaf for more vulgar, trivial programmes and increases the chances of a company being awarded a franchise or having their existing franchise renewed.[10]

Programme genres or types

Several thousand arts programmes have been transmitted in Britain since the 1930s. Clearly, it is impossible to discuss the character and contents of them all. Some individual programmes will be described but the main emphasis will be on series and programme genres or types. (Evaluations only make sense when programmes of a similar kind are compared.)

Before listing the different genres let us consider the extent to which art is covered by non-art programming. To a limited extent the subject is reported on general news and business programmes; for instance, when a famous artist dies, or when a masterpiece is sold at auction for millions of pounds, or when a major art theft occurs, or when a well known work of art is vandalised, or when the Arts Council's annual budget is announced, or when the winner of a major arts prize is named. But, as with other events, art is only of interest to television journalists when it has a sensational or high, news-value.

Occasionally, art appears as one of the topics dealt with in television series concerned with other subjects. For example, Anthony Sampson's

series *The Midas Touch* (BBC, 1990) - about money - included a programme about the art market and the 1980s' boom in art collecting. Not all arts programmes, therefore, are flagged as such. It is also the case that allusions to the fine arts are regularly found in many of the adverts that appear on commercial channels. There are times when television's use of art is bizarre: in 1992 the Australian comedian Barry Humphries, in his guise as the Dame Edna Everage, twice appeared on British TV wearing an astonishing, pictorial dress based on Edvard Munch's famous 1893 painting *The Scream*. (At the time, an exhibition of Munch's work was taking place at the National Gallery, London.) A leading television entertainer thus transformed a historic emblem of alienation, angst and suffering into a sartorial joke.

Overwhelmingly, however, television's coverage of the visual arts takes place via specialist programmes. The advantage of having a quota of such programmes is that the arts are guaranteed some coverage. A disadvantage is that the programmes can constitute a kind of art ghetto which reinforces existing divisions between an informed minority and an ignorant majority. One method of widening the audience is to transmit short, art items at peak viewing times. In France, brief, humorous videos have been shown in a manner echoing the use of cartoons in newspapers.

As this text will reveal, in the decades following the first television transmission, British producers and editors periodically re-thought the way in which the arts were presented. They invented and evolved several different types or genres of arts programmes with the result that there is now a spectrum of types. The challenge facing new generations of producers is to infuse new life into old genres or to invent new ones; to match and, if possible, transcend the achievements of those major examples of the past like *Civilisation* - which already enjoy the status of television 'classics'.

John Dugdale, writing in 1985, divided the output of British arts television into three, broad categories or traditions:

1. documentary or reportage (a factual, journalistic kind of television);
2. film-making of a more subjective and artistic kind (often involving collaborations between film directors and the artists who are the subjects of the films). According to Dugdale, both these tendencies failed to incorporate criticism and evaluation, hence his last category:
3. polemical 'essays' (that is, series like *Ways of Seeing*).[11]

Two years earlier, John Wyver had identified five, more specific, kinds of programme:

1. the relay;
2. the illustrated lecture;
3. the filmed feature;
4. the quiz show; and
5. the magazine.[12]

This text proposes that there are twelve main genres or format types:

1. relays or transmissions of live performances;
2. quizzes about arts subjects;
3. how to draw, paint and sculpt programmes;
4. profiles of artists and interviews with them (profiles are normally filmed or videotaped in advance of transmission. Interviews can be live or recorded);
5. dramatised biographies and drama-documentaries about artists (again these are normally filmed or videotaped in advance);
6. programmes about works of art;
7. open-ended or 'strand' series about the arts (by which is meant, a set of disparate programmes appearing under an umbrella title like *Arena* or *The South Bank Show* appearing weekly or fortnightly for months at a time, and season after season, usually under the guidance of a single presenter/editor). Series of this kind resemble printed magazines in that they often contain a mix of items and they appear at regular intervals;
8. review programmes (these are very similar to open-ended series but they deal exclusively with current events);
9. discussion programmes about the arts;
10. educational programmes about the arts;
11. showcases for artists' work (that is, programmes that allow artists to present their work - usually films, videos and performances - direct to the public); in addition there are so-called 'art breaks' or 'interventions';
12. pundit series about the arts (that is, a limited number of programmes organised around a specific theme, written and presented by a noted scholar or expert; such series resemble illustrated, history of art, lecture courses).

It should be acknowledged that these categories are not specific to the arts - quiz programmes, for example, can be made about any subject - nor are they completely mutually exclusive; for instance, strand series often profile individual artists or perform a reviewing function.

As explained earlier, programmes relaying live, musical or theatrical performances have been excluded from consideration, nevertheless it is worth noting that this kind of programme has the power to transmit art images to vast audiences. For instance, in June 1988 television pictures of a rock music concert held at Wembley Stadium, London to honour the 70th birthday of Nelson Mandela were transmitted around the globe. The show's design was by Fisher Park Ltd (a rock set company established by the engineer Jonathan Park and the architect Mark Fisher).[13] Flanking the stage were several works of art created by a number of contemporary African, American and British artists. These works were seen by 72,000 in the stadium itself and, via international telecommunication systems, by an estimated audience of 500 million in 63 countries. Film and video pieces

by artists produced for the same event encountered censorship problems because of their radical, political content. This illustrates one negative characteristic of television: a tendency towards blandness and conformity.

In the chapters that follow, a historical progression has been adopted but the need to describe the emergence and evolution of particular genres and to analyse individual programmes of special significance has necessitated several departures from a strictly chronological sequence.

References

1. John Ellis writes: 'The history of the genre [arts programming on British television] has been the struggle between its High Arts origin and its Popular Art medium' ('Television and the Arts: another fine mess', *Modern Painters*, 4 (1), Spring, 1991, pp. 60-1). Ironically, within television itself a high/low distinction has emerged, that is, the difference between 'quality television' and the rest.

2. M. Ignatieff, 'Let élitists stand up and be counted', *The Observer*, December 1, 1991, p. 25.

3. M. McLoone, 'Presenters, artists and heroes', *Circa*, (31), November-December, 1986, pp. 10-4.

4. S. Cubitt, *Timeshift: on Video Culture*, London, Comedia/Routledge, 1991, p. 58.

5. P. Hayward, 'Beyond reproduction', *Block*, (14), 1988, pp. 55-9.

6. P. Chatterjee, 'Beating that spawned a winner', *The Guardian*, January 14, 1993, p. 19.

7. J. Roberts, 'Postmodernism…', *Picture This…*, ed. P. Hayward, London & Paris, John Libbey, 1988, p. 49.

8. R. Hughes, (Art on TV), *Art News*, 81 (9), November, 1982, p. 117.

9. R. Hewison, M. Fisher & L. Forgan, 'Pulling at the arts strings', *The Guardian*, January 27, 1992, p. 25.

10. J. Bugler, 'Art & good form', *The Listener*, 124 (3186), October 11, 1990, pp. 14-5.

11. J. Dugdale, 'A case of art failure?', *The Listener*, May 16, 1985, pp. 31-2.

12. J. Wyver, 'The arts on 2', *Prime Time*, (5), Spring 1983, pp. 12-13.

13. For an account of the work of Fisher Park Ltd., see S. Lyall's *Rock Sets: the Astonishing Art of Rock Concert Design*, London, Thames & Hudson, 1993.

participants. Front row, left to right: Frank Whitford, George Melly and Maggi Hambling; back row: Ken Price and Daniel Farson.

PHOTO COURTESY OF CHANNEL 4 TELEVISION.

Arts Programmes

chp.1

on British Television

At the time of writing - 1993 - Britain has four nationwide, terrestrial television channels: two in the public sector - BBC 1 and 2 (funded by annual licence fees) - and two in the private sector - ITV and Channel 4 (funded by revenue from advertising and sponsorship). In addition, there are various broadband, cable subscription services supplied to some urban areas by franchised operators and satellite services - BSkyB Television, UK Gold - offering three million subscribers up to fifteen channels. Satellite television buffs with the appropriate decoders can also watch programmes from abroad; these include hard core pornographic films via the channel called Red Hot Television or Red Hot Dutch. (Increasingly, television cuts across national boundaries.) There are also hundreds of video rental shops hiring out tapes (mostly American movies) for home viewing via video-cassette recorders. Videotapes of feature films, rock music, sporting events and other subjects can also be bought from record stores and other retail outlets. Even videotapes about the visual arts are now on sale in the bookshops of major museums and galleries.

Some experts predict a dramatic increase in the number of channels available to British viewers during the 1990s, up to the high level enjoyed by many Americans. Whether or not this increase occurs, it is clear a multi-channel environment already exists. The period since 1982, an era of expansion, diversification and de-regulation, has been called 'the third age of broadcasting' (the first age, up to 1953, was dominated by radio; the second age - 1953 to 1982 - was 'the golden age of rationed television'). However, Britain may be reaching saturation point in terms of television consumption. Virtually every home has one or more TV sets and the average adult already watches twenty-five hours per week. Many commentators are sceptical that further increases in the number of channels would result in more programme choice and some even fear a decline in quality as more and more companies compete for the same audiences and advertising revenues. In 1991 it was suggested that the BBC lose its special status and that a fund be established for public service broadcasting that commercial television companies could draw upon, so

that they too could afford to make a proportion of programmes with a public service remit. Before discussing the present, fluid situation any further, we must return to the beginning.

Curiously, the invention of television was anticipated by a graphic artist: a drawing by the Frenchman Albert Robida published in *The Illustrated London News* in 1869 showed a man reclining on a sofa at home looking at a large image on a wall; nearby was a sound machine. The image depicted a dancing girl taking part in a performance of *Faust*. A number of real, experimental television transmissions took place in several countries during the 1920s and 1930s. It was not long before the arts - in the form of variety turns, singing and dancing - were featured. Even a talk about pottery was given - by G. Holme, editor of *The Studio* magazine - at John Logie Baird's London premises in 1928. Between 1932 and 1935 further experimental broadcasts were made in London; several classical ballets were shown and some new dances were even specially commissioned for television. However, the first official, public, high-definition, television service transmitted to people in their homes began in Britain in November 1936. The service was provided by the BBC from studios located at the Alexandra Palace in North London. The television system invented by Marconi soon proved superior to that of Baird's. Transmissions could only be picked up in a thirty-mile radius and only a small number of sets, with tiny screens, existed to receive them.

From the outset, therefore, television imitated radio by adopting a centre/periphery mode of operation. Eventually, television reached a mass audience but unlike the mass spectator sports of the past, viewers did not congregate in one physical space: the crowd was atomised, dispersed in millions of homes scattered across the country. It was not until the 1980s, with the widespread availability of video cameras/recording/playback machines that this centralised model of television began to change.

By 1938 the number of sets owned had reached 5,000; the total audience was estimated at twice that number. By September 1939 the number of sets had increased to around 23,000. Programmes frequently featured the performing arts. From the very beginning television adopted a promiscuous attitude to culture, that is, it had no hesitation in mixing high and low: tap dancing and ballet, variety turns and opera, juggling and classical music.

The visual arts were also included: between 1936 and 1938 the English critic and artist John Piper (1903-92) - who was then a supporter of abstract art - often appeared in the Alexandra Palace studio to review paintings and sculptures lent by London dealers. He introduced works by leading modernists such as Henry Moore and Pablo Picasso and, along with Robert Medley, he discussed the relation between modern art and stage design. Piper also appeared with his wife Myfanwy Evans in a film about poetry and painting entitled *A Trip to the Seaside*. John Piper, it is clear, was the pioneer of arts television; he also made an effort to increase the viewing public's appreciation of modern art. However, it is equally

obvious that the television audience was tiny compared to today and limited both geographically and socially (only affluent people could afford the sets).

Art Quizzes

According to the memoirs of Kenneth Clark, one of the earliest arts programmes transmitted in 1937 took the form of a quiz in which poets attempted to identify details of paintings and art experts lines of poetry. (The poets won.) Clark's estimate of the size of the audience was 500! Quizzes and panel games - with their blend of facts and entertainment - were to prove very popular with television viewers in subsequent decades.

Given the popular appeal of the quiz, it might seem an effective means of encouraging an interest in the visual arts amongst those who normally shun galleries and museums. During the 1960s BBC 2 broadcast another quiz series entitled *The Art Game;* Lorna Pegram was the producer and Robert Hughes the chairman. *Gallery,* a more recent quiz, was produced in Bristol by HTV for Channel 4. The first of four series appeared in the Autumn of 1984. It was chaired by the writer and jazz singer George Melly, and directed by Kenneth Price. Two teams of contestants competed to identify paintings from details, hence *Gallery* was an unconscious parody of the Morellian technique of connoisseurship which involved identifying the creators of disputed works by examining details of style and handling.

One team was headed by the British figurative painter Maggi Hambling and the other by the art historian and critic Frank Whitford. The choice of protagonists acknowledged that a certain antagonism exists between practitioners and theorists. Via the television quiz, the real battle between the two groups was symbolically resolved by the victory of one team over the other.

Hambling's artistic career probably gained from her exposure on television, although her dealer Bernard Jacobson once remarked that her celebrity at first prevented him from taking her work seriously. Popular television requires a sprinkling of acerbic, 'untamed' characters who can counteract the medium's propensity for blandness. Gilbert Harding was such a figure in the 1950s. Hambling is another. She is a chain smoker and eccentric. She normally dresses in a mannish fashion and one week she sported a moustache to match that of Whitford's; it also served to upstage the loud, checked or striped suits Melly is fond of wearing. Apparently, this rebellious gesture was due to the artist's unease at being amongst academics and being subjected to the discipline and censorship (by editing) of television. 'The only anarchy left to me was how I look', she remarked.[1] Thus even on quiz shows artists feel compelled to dress outlandishly and to defy social conventions.

Each week *Gallery* featured a number of works of art (in slide form) and supplied basic information about them, while the panellists - who, besides the two 'experts', included 'celebrities' and art students - responded

intuitively. Given that the quiz only lasted thirty minutes, the time devoted to each work of art was short and the overall level of discussion superficial. Now and then sharp disagreements about the aesthetic merit of the works on view served to expose the relativity of taste and critical judgement.

Gallery was the brainchild of the writer and broadcaster Daniel Farson. In a book based on the series, Farson described himself as an 'enthusiast' not an 'art expert'. His research in galleries and museums around the country resulted in a crusade to persuade people to visit them. According to Farson, the quiz element was intended to make the programmes lively and to 'avoid the usual pretentiousness of art programmes' which, paradoxically, were 'all too Arty'.[2] Gallery was described as 'the first middle-class quiz', so its audience of five million may well have consisted of those already committed to the visual arts. The series' modest intention was to increase the level of art appreciation amongst the public, but its function as light entertainment was to provide an undemanding way of 'killing time' at the weekend. On reflection, it seems unlikely that this type of programme can foster a serious, long-term interest in the visual arts. Nevertheless, the final credits to the programmes made a point of listing the museums where the works of art illustrated were located in the hope that viewers would make the effort to see them.

Arts television in the 1950s

Between 1939 and 1946 the BBC's television service was shut down because of the Second World War. It resumed in June 1946. For the British nation, the late 1940s were years of hard work, austerity and reconstruction. In the evenings, most people relaxed by reading magazines like Illustrated and Picture Post, or by listening to the radio, or by visiting the pub or the cinema. The spread of television across the country was slow because of economic and technical reasons: it was some years before people could afford to buy the receivers and the aerials, and some years before sufficient, high-power transmitters were built to enable people in the regions to receive pictures. Television only became a mass medium in Britain in the following decade when working people began to earn more and the habits of the present consumer society - for example hire purchase and rental schemes - were established. Between 1950 and 1964 the number of TV sets owned increased from half-a-million to thirteen million. It was during the mid 1950s that rooftops throughout Britain sprouted metal, 'H' shaped aerials; their ugly appearance prompted complaints from environmentalists.

Two events in particular stimulated the sale of sets: first, the day-long coverage given by the BBC to the coronation of Queen Elizabeth II in 1953 (it was estimated that twenty million people watched the event on two-and-a-half million sets); and second, the appearance in 1955 of another channel - Independent Television (ITV). (Though it was not until 1958 that three-quarters of the population was able to receive the commercial channel.) Unlike the BBC, ITV had a federal structure: there were a number of regional organisations with the power to commission programmes.

The introduction of a second channel broke the monopoly of the BBC and once ITV had established itself and become profitable, the ensuing competition for audiences resulted in a wider choice of programmes and livelier, more innovative programmes.

During the 1950s the hours of television broadcast gradually increased: in 1954 the BBC transmitted six hours daily; by 1963 the figure for the BBC and ITV combined had reached sixteen hours per day.

Surprisingly, Sir Kenneth Clark (1903-83), Britain's leading art historian, played an important role in the founding of the second channel: he was the Chairman of the Independent Television Authority (ITA). Later he was to present many arts series for both ITV and the BBC. This was in spite of an initial suspicion of the medium that was shared by many intellectuals and members of the middle class. In fact, Clark made forty-eight arts programmes for Associated TeleVision (ATV) in the late 1950s on such topics as beauty, good taste, five revolutionary artists, Japanese art, famous cathedrals and temples, and British Royal palaces. The first programmes he made were live transmissions; the later ones were filmed. As a result of these experiences, he concluded that 'good' arts television depended upon three groundrules:

1. every word must be scripted in advance;
2. viewers require information not ideas;
3. the spoken commentary must be clear and economical,
 and the delivery energetic.

Television in the 1950s was mostly live, that is, studio-bound production. For this reason it was rather claustrophobic. The television picture was still black-and-white (or rather, shades of grey) and its reception was uncertain (controls at the back of sets constantly had to be adjusted to obtain a clear picture). Breaks occurred during the evening schedules so that young children could be put to bed (the so-called 'toddlers' truce') and any breakdowns or gaps between programmes - called 'interludes' - were filled by soothing images of a potter's hands shaping clay on a wheel or rural scenes of a farmer and horses ploughing. The medium soon demonstrated its power to arouse widespread public interest in unlikely subjects, such as archaeology and prehistoric art. (This was the era of Dr Glyn Daniel, Sir Mortimer Wheeler and the popular panel game *Animal, Vegetable, Mineral?* [BBC, 1952-59].) One early programme in the decade concerned the cave paintings of Lascaux (BBC, February 16, 1950).

Gradually rising standards of living during the 1950s encouraged many working and lower middle class families to improve their homes. Since professional decorators were expensive to employ, millions resorted to 'Do-It-Yourself'. As a result, 'DIY' manuals, magazines and shops were established. Television was also willing to offer basic, practical instruction in a variety of activities, including cookery and the arts.

'How to do it' arts programmes

This type of programme was designed to give advice and practical demonstrations to beginners, amateur artists and children. For instance, the artist Mervyn Levy presented several series offering viewers painting lessons. Levy was trained at the Royal College of Art; his 1954 BBC series *Painter's Progress* was aimed at the general public and attracted an enthusiastic audience of five million. His aim was to encourage what he later called 'pleasure painting'. Competitions were organised and the studios at Alexandra Palace were inundated with as many as 50,000 submissions. 'Passivity' and 'couch potato' are negative expressions associated with regular television viewing but, as Levy's series testifies, the medium has stimulated, on occasion, mass creativity.

Another British artist - Adrian Hill - presented for the BBC a fortnightly, twenty-five minute programme called *Sketch Club.* It began in 1955 and ran for a number of years. *Sketch Club* was aimed at boys and girls aged between thirteen and sixteen but it also appealed to many adults. Every month hundreds of children sent in examples of their work for praise and criticism and some of these were featured in the programme's 'Picture Gallery' spot. A hugely popular travelling exhibition was one spin-off from the series. *Sketch Club* reminds us that during its predominantly live broadcasting phase, British television developed an intimate rapport with its viewers.

fig **4** ┃ Adrian Hill with three minute - landscape drawing.

The Studio, 161 (814) February, 1961.

PHOTO COURTESY OF A. HILL.

Although their impact is now much more limited, 'how to do it' programmes are still provided from time to time as part of daytime children's programmes (witness *Art Attack* [TVS for ITV, July 1990]). Compared to the 1950s, their contents are disappointing. Presenters show children lots of gimmicks but there is no genuine instruction in the techniques of painting and drawing or in the appreciation of art. The idea that making worthwhile art might require a child to engage in long hours of practice with pencil and paper observing and recording a motif seemed to have been abandoned. However, in the Autumn of 1991 basic, traditional water colour painting methods were again demonstrated on television for the benefit of beginners by the artist Alwyn Crawshaw in his extremely soothing series of twelve, half-hour programmes entitled *A Brush with Art* (Channel 4, Green Apple TV for TVS; the series can also be purchased on video via Ingram Entertainment).

While instruction programmes may stimulate artistic activity, they are generally anachronistic in the kind of art they promote, that is, academic techniques, pre-modern conceptions of representation and art (though Levy claims to have taught colour theory and to have encouraged some experiments in abstraction). They also treat art as a part time hobby rather than as a full time profession. In the main, the medium of television has not set out to train artists but to transmit and report the arts and to foster their understanding and appreciation.

A survey undertaken in the 1990s revealed that the artist best known to the British public was Rolf Harris. (Rembrandt came second.) Harris (b. 1930) hails from Australia. He is a bearded, light entertainer who has appeared on many variety shows and children's programmes over the decades. As part of his routine, he sings, draws cartoons and paints. No one in the British artworld would regard him as a serious artist. His reputation as an artist with the general public is a tribute to the power of television to reach millions and to influence several generations of children. It is also a sign of the cultural distance arts television has to travel before more Britons have heard of Rembrandt than have heard of Harris.

References

1. A. Billen, 'Gallery's rogue', *Observer Magazine* October 7, 1990, pp. 28-9.

2. D. Farson, *Gallery: a Personal Guide to British Galleries and their Unexpected Treasures*, London, Bloomsbury, 1990, p. 11.

Artists' Profiles

During the early 1950s establishment figures such as Sir Kenneth Clark and Sir Gerald Kelly, president of the Royal Academy, escorted viewers on guided tours of art galleries. Kelly startled viewers and the press with his forthright opinions and his colourful language. Simultaneously documentary films about living artists directed by John Read (b. 1923) began to appear on television. Amongst the British people at that time there was considerable hostility towards modern art dating from the pre-war era. This climate of philistinism only slowly abated. Its departure was hastened by the advent, in 1958, of the prestigious BBC arts series *Monitor* presented by Huw Wheldon. *Monitor* will be described in detail later; before then, the work of John Read deserves consideration.

Read pioneered the filmed artist's profile on British television. His father was the art critic Sir Herbert Read, so he grew up in an environment that was sympathetic to modern art. John Read developed an interest in the medium of film and came to admire the British documentary film-makers of the 1930s: Robert Flaherty, John Grierson, Basil Wright, Paul Rotha and Humphrey Jennings. He was also impressed and moved by the 1940s art documentaries made by Luciano Emmer and Roman Vlad, European film-makers who used paintings to tell dramatic stories. A 1950 film called *Visite à Picasso* by Paul Haesaerts intrigued him. Years later he was to claim this film was one of the first to feature a living artist on screen.

After serving in the armed forces during the Second World War, Read worked for a time as a researcher for documentary films. Grierson helped him to obtain this job on the strength of an article Read wrote in 1948 entitled 'Is there a documentary art?' He then became an assistant in the Talks Department of BBC Television at Alexandra Palace. He produced a number of talks including one illustrated by still photographs of the Elgin Marbles, but he soon became dissatisfied with the studio-bound existence of live television. At that time there was no videotape and it was difficult to record television images on film. (It was only in 1956 that the Ampex Corporation demonstrated the first practical, broadcast black-and-white videotape recording machine (VTR) - the VR-1000 - in the United States. It was four years before this system came into regular use in Britain and only later, in the 1960s, that electronic editing of videotape - as against physically splicing it - became the norm.)

Live, outside broadcasts were perfectly possible but they were complicated to mount because television cameras had to be linked to the studio by cables. The complexities of live television can be indicated by reference to one of the most impressive theatrical events of the 1950s: the dramatisation of George Orwell's famous novel *1984* (BBC, December 12, 1954) starring Peter Cushing as Winston Smith. This play was a mix of live and pre-recorded elements. Twenty-eight sets were needed and the pre-recorded, filmed inserts were used to allow time for the actors and cameras to move from set to set. With live television everything had to work perfectly first time because there was no second chance.

Read came to the conclusion that the immediacy of live television was overrated, despite the fact that some analysts considered it to be the distinguishing characteristic of the medium. Film-making offered more editorial control, the chance to record reality outside the studio, and more opportunities for creative expression on the part of the director. Read felt that because film was a visual medium it was more appropriate to visual art than verbal or printed discourse and that, in addition, it had something unique to offer. Magical effects, he believed, could be achieved via the movement of the camera across the surfaces of paintings and sculptures.

In 1950 British broadcasters were reluctant to show films about art on television because of the medium's lack of colour and the fact that the formats of paintings had to be compressed to fit the small size and odd shape (a nearly square rectangle with rounded corners) of the TV screen. There was also the belief that, since television was in essence a live medium, showing films without informing the audience beforehand was a form of 'cheating'. In fact, the first film Read made for the BBC was a 'Demonstration Film', that is, a film made for transmission in the daytime so that shops selling TV sets had something to show potential buyers.

Another obstacle Read had to overcome concerned the sound commentary. Instead of critics or historians speaking about contemporary art, Read wanted to use the voices of artists. Clearly, he felt the first-hand information artists could provide was of more interest and value than second-order commentary. Accordingly, during interviews, it was the artist that counted not the questioner. Eventually, Read reached the conclusion that every shot showing an interviewer was a waste of precious airtime.

Disregarding the fact that he had no official qualifications or standing as an art critic or historian, Read wrote and directed a series of films about living British and foreign artists. The first, a full-length study of Henry Moore, dated from 1951. Subsequently, Read made five more films about the Yorkshire-born sculptor; he also wrote a book about him. Read's first Moore documentary won a prize at the Venice Film Festival but when it was broadcast it was criticised by the popular press for being too sycophantic. One reason for the adulatory approach to Moore, given by one of his biographers, is that post-Empire Britain needed new cultural heroes able to communicate to the outside world a positive image of the nation.

fig 5 | L.S. Lowry sketching in the streets of Salford, 1956.

PHOTO COURTESY JOHN READ.

Read went on to make films about John Piper, Arthur Boyd, L.S. Lowry, Naum Gabo, Peter Blake, Walter Sickert, Patrick Heron, Bernard Leach, Marc Chagall, Carel Weight and The Brotherhood of Ruralists. Some of these films were the first arts co-productions: the BBC collaborated with the Radio and Television Educational Center of Ann Arbor, Michigan.

In an article published in *The Studio* Read explained how he made his 1957, black-and-white film about Lowry.[1] The article is worth summarising because of the insight it gives into Read's working methods. He began by discussing the project with Lowry and sorting through photographs of the artist's paintings at his London gallery. He then grouped the photos by subject and scrutinised them considering what details and camera movements he might employ. The subsequent arrangement of the visuals, he said, was 'an entirely instinctive process'. Next, Read visited Lowry at home in Manchester and spent a week tramping the streets of Salford in search of typical Lowry motifs. He was then in a position to write a script and a commentary.

Shooting took ten days. A selection of Lowry's paintings were filmed plus the urban scenes which had inspired them. Lowry was shown at work in his studio at home and sketching in the street being watched by children. After viewing the rushes, Read spent several evenings interviewing Lowry with a tape-recorder. (Portable tape-recorders such as the ones made by Grundig became available to the public in the 1950s.) The upshot was that Lowry's own expressions replaced Read's written interpretation. It only remained to cut the film, to add linking commentaries, and to select some music that would 'increase the realism of the scene or heighten its emotional effect'. The film was shot on 35mm consequently it was impressive in terms of visual clarity and tonal values. Lowry, it seems, was happy with the result and the programme was watched by approximately two million viewers. A bonus for Lowry was the fact that a Manchester businessman called Monty Bloom saw it and as a result became one of the artist's chief patrons.

In January-February 1983 BBC 2 marked Read's retirement by screening a selection of his documentaries under the umbrella title 'Portraits and reflections'. Kevin Gough-Yates, writing in *Art Monthly*, praised Read's 'sense of proportion': 'there is always a feeling that the films are made within a wider and unstated context, a conscious sense of perspective'.

Read's films were informed by a belief that art was a vital catalyst, even in a society like Britain where the visual arts were not esteemed as highly as in certain other countries. Art, which involved the senses, the emotions and the imagination, had to be defended because it was threatened by an increasingly technological and materialistic society. (He seems to have forgotten that film and television are also technologies; indeed, all forms of art depend on technologies of various kinds.) What impressed Read about the new medium of television was not its live quality but its democratic potential as a mass medium of communication. He was committed to the public service ethos, to the independence of the BBC from commercial

pressures. Public broadcasting channels had a responsibility to communicate the arts to the people, but he also thought the arts had a reciprocal duty to communicate to society, otherwise the gulf between contemporary art and the general public would never be closed.

Documentary films about art and artists, it is clear, can be made for both the cinema and television. The advantage of television transmission is that it ensures an audience far in excess of those who would visit a gallery to see an exhibition. The positive and negative characteristics of filmed profiles of, and interviews with, individual artists were discussed in my book *Art and Artists on Screen,* so they will not be repeated here except to re-iterate the point that they are more or less bound to confirm the 'auteur' conception of artistic production (art is individual rather than social, it is the work of 'genius', etc.).

Two criticisms can be directed against TV profiles of living artists; first, there is a bias towards professionals. One of the few series which questioned this bias was *Everyone a Special Kind of Artist* (Riverfront Productions for Channel 4, 1983). It was produced by Jeff Perks and presented by the graphic artist Ken Sprague. It featured non-professional, spare-time creators from the working class such as Handel Edwards, an obsessive and highly skilled woodcarver. This series showed that creativity is not limited to a group of trained specialists, but its implications were not followed up.

Second, even within the ranks of the professionals, only a few have been considered worthy of attention. Celebrity was clearly a crucial factor influencing the producers' choices. Certain artists - David Hockney and Francis Bacon are the prime examples - proved more telegenic and entertaining than others, and so they were featured again and again to the despair of those who would like to see and make arts programmes about other, important but neglected artists (such as John Latham). Charged with the accusation that television is unoriginal and unadventurous in its selection of artists, producers are likely to reply that they merely reflect social reality, that they make programmes about Bacon, Hockney, Warhol, Koons and so on, because they are already 'big names' in the artworld. Yet, the producers need not slavishly follow the judgements of the art market, museums and art criticism. Television has the power to assign value as well as to reflect it, consequently it could seek out new or little known artists. Producers seem over-reliant upon the advice of outside art experts and too dependent upon the shows mounted by major museums and galleries.

One of the few programmes which did feature a virtually unknown artist - Harold Shapinsky, a minor American abstract expressionist - was *The Painter and the Pest* (Bandung Productions for Channel 4, June 2 1985). It provoked a sour grapes response from certain art critics, in part because television was promoting an artist who had not already been validated by art criticism and the art market.

As in the cinema, most of the artists selected were white males. Far fewer women artists have been featured on television than men. Given this situation, the mini-series *Five women painters* was something of an exception. The series of half-hour documentaries were produced by the Arts Council for Channel 4, and transmitted in the Autumn of 1989. The films, directed by Susanna White and Teresa Grimes, profiled five twentieth century women artists - Laura Knight, Dora Carrington, Nina Hamnett, Winifred Nicholson and Eileen Agar - whose work had been neglected by mainstream art history. While such a series served to redress the gender imbalance of arts television, it reiterated the individualistic conception of artistic production.

Another, under-represented group are black artists. Very few programmes have been devoted to the work of African, American and British black artists (unless they are famous performers in the fields of jazz or pop music) despite the growing number of black art galleries, magazines and group exhibitions. It was unfortunate, therefore, that one of the few programmes to tackle the subject - 'Hidden Heritage: the roots of Black American painting' (1990, broadcast August 6, 1991) - was a disappointment. The programme was in fact a Cue Production for the Arts Council and Channel 4. Its director was Andrew Piddington and its pundit/presenter was David Driskell, a black American professor. The commentary was shallow and the delivery lacklustre. To compensate for a lack of substance, the programme was padded out with old film clips and linking shots of Driskell travelling on trains or driving cars. A much more thorough study was Geoff Dunlop's 'Shooting star', a profile of the late, American, black artist Jean-Michel Basquiat (to be discussed in more detail shortly).

Artists from the world beyond Europe and North America rarely appear on British television and when they do it is often as parts of series that are designed for the ethnic minorities or about more general issues than the arts. The BBC 2 six-part series called *Homelands* (1990), produced by Diana Lashmore, was therefore exceptional in that it journeyed overseas to examine the relation between a number of artists, writers, musicians and their native lands, that is, Vietnam, Indonesia, Israel, Egypt, Nigeria and Mozambique. Adrian Pennink's film for the series, about the war-ravaged Mozambique (June 22, 1990) profiled Malangatana Valente Ngwenya, an African painter best known in Britain for his poster 'The eyes of the world' designed as a contribution to the Artists Against Apartheid campaign.

Ostensibly, the aim of the artist's profile is to illuminate the work of the artist but, as Denis Donoghue has argued in *The Arts without Mystery* (1983), there is in fact an anxiety about confronting actual works of art (masterpieces in particular, he says, are 'intimidating') and so television prefers to focus on their makers because it is easier and gives a more telegenic result:

> Television is restless with any object which asks to be looked at
> slowly and patiently. The span of willing attention to an image on
> television is a matter of seconds, not minutes. Then a new image

> must be given. When such programmes as *Omnibus* and *The South Bank Show* present an artist, they run away from his works and concentrate on him, an easier subject because he is responsive, mobile, unsecretive.[1]

All too often, what Donoghue calls 'a disproportion between artist and work' occurs. The power relation between the two is reversed as works of art become simply illustrations of the personality of the artist. These points are certainly valid, nevertheless some useful information is provided by artists' profiles. Furthermore, when so many modern artists are obsessed with the concept of self, present themselves as 'living sculptures', and use their bodies as material or subject matter, there is some justification for television's emphasis on the person of the artist.

Donoghue also seems to overlook the fact that there is a genre of arts programme which does focus upon works of art rather than upon artists.

References

1. J. Read, 'Artist into film', *The Studio,* 155 (780), March, 1958, pp. 65-9, 91.

fig **6** | Richard Long stone circle in the Sahara desert, Algeria.
Photo to publicize Philip Haas's documentary *Stones and Flies: Richard Long in the Sahara,* 38 mins, 16mm, colour, 25fps, 1987. A Methodact Production for the Arts Council of Great Britain in association with Channel 4 Television, HPS Films Berlin and Centre Pompidou, La SEPT, CNAP and WDR.

PHOTO COURTESY OF RICHARD LONG AND THE ARTS COUNCIL.

The Artist at Work

chp.**3**

Showing the artist at work has been a common feature of arts documentaries ever since Hans Namuth filmed Jackson Pollock in action in 1950 (for an account of this film, see my earlier volume *Art and Artists on Screen*). Undoubtedly, watching the making of a work of art is illuminating, especially for viewers without any direct physical experience of the materials, tools and processes involved. Philip Haas's 1987 Arts Council film *Stones and flies* about the British, land artist Richard Long, shown on television in 1991 to coincide with a Hayward Gallery exhibition, provides a clear-cut example of the strength and weaknesses of such documentations.

A direct, plain style of filming was employed to show Long alone in the desert of North Africa walking and making 'sculptures' by the simplest of means: drawing a spiral by dragging his heel across the ground; creating a circle by re-arranging stones. From time to time Long spoke direct to the camera or in voice-over to explain why he makes periodic journeys into wilderness areas and why he makes the kind of art he does. Anyone curious about how and why Long's art comes into being would find this film instructive, but what was missing was any critical voice, any independent evaluation of his work. Long does have his critics in the artworld and what the film ignored was the fact that it is this artworld - which operates in cities not wildernesses - which funds Long's excursions and validates his landscape modifications as art.

Arguably, what the layperson curious about art but ignorant of how it is made needs is basic information about materials, tools and processes, particularly in the more technologically complex fields of printmaking and sculpture fabrication/casting. One series which provided such information in relation to the art of painting was Anne James' *Four Artists and their Materials* (BBC 2, April 1983). The artists and materials featured were: David Tindle/egg tempera; Elizabeth Blackadder/watercolour; Robin Philipson/oils; and Bert Irvin/acrylic. However, information of a practical nature only takes understanding so far. New media technologies facilitate new modes of pictorial representation and their social functions cannot be understood except in relation to the people who fund and use them. The next step, therefore, is an account of the relationship between materials / technologies and aesthetics / ideologies, that is, the kind of

Quantel Paintbox image from *Painting with light* BBC 2, 1987. Series directed by David Goldsmith.

PHOTO COURTESY OF DAVID HOCKNEY, GRIFFIN PRODUCTIONS AND BBC TELEVISION.

fig 8 | Richard Hamilton, 'The subject', 1988-90. Oil on canvas, two canvases each 200x100 cm.

reflections on the relation between the emergence of the medium of oil painting and the property-owning classes of Europe John Berger made in part three of his 1972 series *Ways of Seeing.*

In 1987 an intriguing encounter occurred between a number of contemporary artists and some new technology: an electronic, digital 'paintbox' made by the international company Quantel (the machine made its debut in 1982). The results of this encounter were visually similar to Henri-Georges Clouzot's 1956 film - *Le Mystère Picasso* - about Picasso at work. Entitled *Painting with Light,* the series was made by Griffin Productions for BBC 2. Programme directors included Bob Lockyer, David Goldsmith and Geoff Dunlop. The artists featured were Jennifer Bartlett, Richard Hamilton, Howard Hodgkin, Larry Rivers, Sidney Nolan and, yes, David Hockney. Since they were novices as far as the machine was concerned, technical help was supplied by Martin Holbrook.

The Quantel Paintbox is an amazing electronic tool which enables artists and designers to draw and paint with an electronic stylus onto a blank tablet or work surface, their marks are then directly reproduced on the machine's colour monitor. Designs and colours can be changed rapidly and endlessly. Since colours are generated within the machine in the form of light they are pure and intense (they do not become muddied like watercolours). Hockney was impressed by the device and hailed it as a new medium. He described it as 'honest' in the sense that it acknowledged surface. A television image of a painting *reproduces* colours - usually imperfectly - whereas in the case of the Paintbox, colours are *produced* by the machine, hence they are its raw material.

Hamilton was also impressed by the Paintbox, especially by its ability to manipulate pre-existing imagery. He often constructs his paintings from a series of photographs, so he used the machine to call up images from a library of news stills and then to combine and rework them in various ways. The photos he selected were of the Orangemen and scenes of civil strife in Northern Ireland. What amazed the artist most was the Paintbox's ability to 'collage with soft edges', a task impossible when using scissors to cut out shapes from a photograph. Two paintings - *Countdown* (1989) and *The Subject* (it has also been called *The Orangeman*) (1988-90) - resulted from these electronic collage or photo-montage experiments. It was surely paradoxical that Hamilton's encounter with the latest image technology should culminate in traditional works of art. In his opinion, there is a 'hard copy problem' associated with the new technology. It is clear he believes the art of painting can still yield monumental icons which, when displayed in major galleries, are able to reach many generations of viewers.

Hodgkin's response to the Paintbox was less positive. He found the technology impersonal and he missed the tactile quality of oil paint on canvas. Surely it was a mistake on the part of the programme makers to invite six painters to play with the machine because they were bound to bring readymade aesthetics rooted in their previous experience of oil paint or pastels and then to complain when the Paintbox behaved differently. As

Philip Hayward noted, 'the exercise says a lot about the low self esteem of the medium that complete novices at a complex form of new media technology were invited to experiment with it'. He then asked the rhetorical question, 'Could one imagine a reverse situation where a group of cinematographers were helped to create their first ever oil paintings, the results of which were then packaged and promoted as exemplary practice in a major touring exhibition?'[2] The people best qualified to exploit the new medium to the full, would have been graphic artists who had worked with the Paintbox for many months using it for specifically televisual purposes.

Watching others labour can be a soothing pastime. In this respect, films of artists at work are part of the spectacle of television entertainment. Such films have played their part in popularising the idea that the artistic process is as important as the final product. The nature of performance art involves the execution of actions in the presence of an audience, so there is a synthesis of process and product. Many performances by fine artists have been filmed and videoed, but this kind of art has not had the exposure on mainstream television that one might have anticipated given its live and temporal character. At a conference held in 1990, the British video and installation artist Tamara Krikorian was highly critical of television's treatment of the kind of work she and other contemporary artists were making. She complained that producers were unwilling to allow the artist to speak directly to the audience and that the medium was impatient with the ambiguities, concepts and meanings of contemporary performance and video.

One performance artist who did receive plenty of media coverage during the 1980s was the American Laurie Anderson. She was profiled on *The South Bank Show* on February 26, 1982, but even television only managed to give a partial impression of her long, complex, multi-media stage shows. However, such is the hypnotic appeal of television that a recording of this programme playing in Anderson's ICA exhibition in London attracted more attention than her exhibits.

An innovation in the depiction of the artist at work occurred in May 1988. David Mach, a fashionable Scottish sculptor, was recorded by BBC cameras for ten minutes at a time, every day for a week, while he assembled a huge public work consisting of automobiles floating in a 'sea' made from thousands of surplus copies of *Radio Times* in the car park of the BBC centre in Shepherd's Bush, West London. Regular viewers could thus follow the progress of the piece and hear the artist talk about his intentions and the practical problems he was encountering. Some critical responses by passers-by were also shown. Mach is an extrovert who enjoys the risks and challenges of working in public and to deadlines, so this piece was as much a live event as a static structure. The short items were transmitted during the early evening and so may well have reached a wider audience than that which would have watched an arts programme devoted to Mach. For older viewers, they were a reminder of the days when much more of the BBC's output was live television.

TV profiles of living artists are dependent upon the good will and collaboration of their subjects. Some artists would like a far greater degree of creative involvement and editorial control. In fact, modern portable video equipment now makes possible televisual autobiographies as well as biographies. (An example was made by the British caricaturist Gerald Scarfe in the 1980s: 'Scarfe on Scarfe', *Arena* BBC 2, December 12, 1986). This equipment also enables individuals to keep a record of their daily lives in video form - hence the emergence of a new genre: the video diary. Andy Goldsworthy, the British site-specific sculptor, took a video camera with him to the North Pole in 1989 in order to record the journey and the making of ice sculptures. Lending such equipment to visual artists enables them to address audiences much more directly than hitherto.

Adulation or critique?

When John Read's films appeared on British television in the early 1950s it was refreshing and enlightening to see living artists in their homes and studios, but obviously the novelty quickly became a norm. Exaggerated respect for artists soon led to a situation where programmes about them came to resemble extended adverts for them and their work. Arts television became noted for its sycophantic celebrations. For a long time, the arts were exempt from the probing approach typical of investigative journalism and news reporting.

In recent years a more sceptical and iconoclastic approach has been in evidence. Three examples can be cited:

1. 'England's Henry Moore', (ICA TV Production for Channel 4, September 9, 1988), written by Anthony Barnett and directed by Hugh Brody. This unorthodox study of Moore's career attempted to situate him in relation to the social and political history of England and to identify Moore's failures as well as the reasons for his public success.

2. 'Shooting Star' a film by Geoff Dunlop of Illuminations for *Without Walls* (Channel 4, November 28, 1990), about the meteoric rise to fame and wealth in the 1980s of the black, American, post-graffiti artist Jean-Michel Basquiat. This artist died young from an overdose of drugs, so his lifestory fulfilled the stereotype of the gifted, tragic, self-destructive artist. (Though it wasn't poverty that drove him to his death but money and success.) Dunlop's intelligent study set out to undercut this stereotype by examining the reasons for the hype and myth that so quickly surrounded Basquiat. At the same time, the very fact that a whole programme was devoted to an artist some critics have judged 'a featherweight', tended to reinforce his mythic status.

3. The 'J'Accuse' programmes appearing periodically as part of Channel 4's 1990 arts series *Without Walls* were specially devised in order to puncture inflated reputations. Jeremy Bugler was the editor

of the series and they were made by Fulmar Television for Channel 4.[3] The first in the series - transmitted on October 3 - was dominated by the Leeds University art historian Griselda Pollock who bravely swam against the tide of the Van Gogh centenary industry by arguing that he was an overrated hero and a flawed painter. Paradoxically, Pollock is a leading Van Gogh scholar.

After decades of deference, any programmes aiming to demystify art are to be welcomed. It is important that television examines all the ideological, market and media reasons for a famous artist's reputation, however the emphasis on infrastructure and context does have a drawback: there is generally little time left over to discuss works of art.

It is significant that all three artists cited in the above programmes were dead. Arts television is still hesitant about providing objective, critical assessments of the work of living artists. This point was even confirmed by Muriel Gray's *Art is Dead...Long Live TV* (Channel 4, 1991), a mini-series that did embody and advocate a sceptical approach towards contemporary art. The difficulty of achieving this task even in the 1990s was illustrated by the fact that the avant garde 'artists' Gray interrogated and debunked all turned out to be fictional.

The need to distinguish between profound and shallow experimental art has never been greater, but anyone who finds fault with contemporary art runs the risk of being dismissed, by the modern arts establishment, as a philistine.

Interviews

Arts programmes dealing with the present and recent past frequently include interviews with artists, their friends and relatives, and with fellow artists, critics, dealers, historians, curators, collectors, and models. Indeed, some programmes consist of nothing but interviews. They are obviously a popular means of gathering information and impressions. As already explained, it was John Read who thought it essential to ask artists about their work and who tape-recorded their comments. A few artists refuse to give interviews (the German painter Anselm Kiefer, for example) but the vast majority are happy to invite camera crews into their studios.

Artist-interviews (either live or recorded) also became part of the standard fare of magazine-type programmes in the late 1950s. Huw Wheldon, the presenter of BBC's *Monitor*, conducted many such interviews. At that time it was normal practice to show on screen both the artist and the questioner: they interacted while the viewer observed from the sidelines. Clearly, in this situation there is a danger that the personality of the questioner becomes obtrusive: viewers may find the questioner's performance more engaging than the artist's.

Some directors have since adopted the habit of cutting out the questioner and the questions he or she asked: the viewer sees only the artist and has to infer the questions posed from the replies given. In the

series *State of the Art* (Channel 4, 1987) mirrors were used during filming so that artists appeared to be speaking direct to camera rather than to the questioner. Cutting out the questioner means that the artist is foregrounded and more time can be allotted to him or her.

Some contemporary theorists have doubted the implicit assumption of interviews that artists are fountainheads of wisdom in respect of their work. Clearly, artists possess vital information concerning their lives, sources of inspiration, intentions and studio practices, but they also vary considerably in their self-understanding, verbal fluency and willingness to explain. When Huw Wheldon asked Orson Welles about multiple interpretations of his films, he replied: 'The creative artist ought to hold his tongue'. When the same presenter asked Henry Moore in 1960 why his sculpted figures were virtually all female, he replied: 'I don't know and I don't want to know'. The sculptor then confessed he had stopped reading a Jungian interpretation of his work because he hadn't wanted to know more about his unconscious motivations. (Presumably because he feared such knowledge might interfere with the creative process.)

These examples show that even when artists agree to be interviewed, they often resist explanation. Wheldon also asked Moore if there was any point in talking about art at all. (This question haunts all commentaries on the arts.) Moore replied that he believed talk about art was useful but only 'up to a point'. One living British artist and film-maker who has no qualms about discussing his own work is Peter Greenaway. Indeed, he is so self-aware and articulate, he can manage perfectly well without the prompting of questioners or interviewers.

How expert should the questioner be about the artist's work? Most interviewers research their subjects before conducting interviews but presenters like Melvyn Bragg, who interview many artists from different fields, cannot be expert on them all. Expertise implies the ability to ask subtle and searching questions, but an expert might easily overlook obvious questions ignorant viewers might wish to hear answered. Wheldon had the ability to ask both penetrating and obvious questions. Normally interviewers treat artists with great respect; artists are rarely subjected to the tough, sceptical cross-questioning politicians sometimes receive at the hands of television journalists.

In spite of the problems of formulating intelligent questions, sycophancy, inarticulacy, etc., associated with interviews, many many interviews have been conducted with artists on television. Recordings of them will clearly be of value to the art historians of the future.

From time to time producers have attempted to broaden the appeal of interviews by inviting people from outside the artworld to conduct them. Sometimes this has resulted in a fresh perspective. For instance, in July 1984 the BBC asked the writer Germaine Greer to interview the Franco-British painter and designer Paule Vézelay. Since Greer is a feminist, she naturally raised the problems that face women artists because of their gender. The tactic of using outsiders has also resulted in some bizarre and

trivial encounters: Malcolm Muggeridge interviewing Salvador Dali (what intrigued Muggeridge most was Dali's absurd moustache); the journalist Bernard Levin conducting a reverential interview with Henry Moore for the BBC in August 1983; Jonathan Ross, the chat show host, interviewing Jeff Koons, the American master of kitsch art, in 1990.

References

1. D. Donoghue, *The Arts without Mystery,* London, BBC, 1983, p. 36.
2. P. Hayward, 'Beyond reproduction', *Block* (14), 1988, pp. 55-9.
3. see J. Bugler, 'Art and good form', *The Listener* 124 (3186), October 11, 1990, pp. 14-5.

fig 9 | **Monitor** Huw Weldon (editor of *Monitor*), Ken Russell (film director) and Peter
Cantor (film editor) confer in the early 1960s.

Monitor and other open-ended Series of the 1950s and 1960s

As explained earlier, open-ended or strand series appear weekly or fortnightly for months at a time, and for several annual seasons. Examples include: *Monitor* (BBC, 1958-65), *Tempo* (ABC Television, 1961-64), *New Tempo* (ABC, 1967), *Omnibus* (BBC 1, 1965-), *Aquarius* (London Weekend Television, 1970-77), *Arena* (BBC 2, 1974-), *The South Bank Show* (London Weekend Television, 1978-) and *Signals* (Channel 4, 1988-90). Each name really refers to a time slot within which programmes of various kinds by different producers and directors appear. To provide continuity, however, there is usually a chief editor and/or presenter: Huw Wheldon of *Monitor*, Humphrey Burton of *Aquarius*, Melvyn Bragg of *The South Bank Show*. Clearly, a recurring problem associated with series that run for years and have different editors, producers and film-directors, is to establish and maintain a distinctive approach or identity.

Open-ended series generally define 'art' very broadly: they feature architecture, painting, sculpture, opera, literature, music, theatre, dance, the cinema and, to lesser extent, folk or popular arts. No one presenter can be an expert on such a wide range of subjects, hence the 'sub-contracting' policy of commissioning directors (either in-house or from independent production companies) such as Bob Bee, Tony Cash, Julia Cave, Mike Dibb, Geoff Dunlop, Nigel Finch, Patrick Garland, Geoff Haydon, David Hinton, John Read, Ken Russell, John Schlesinger, Nancy Thomas and Nigel Wattis to make films for particular episodes. Such films may be used as part of a programme, or they can take up the whole programme.

Monitor, a crucially important early series that ran from February 1958 to July 1965, set the pattern for much that was to follow. The series was part of the output of the Talks Department and was made at the Lime

Grove Studios in West London. *Monitor* was edited and presented by Huw Wheldon (1916-86), an inquisitive Welshman with a craggy, Punch-like face and an incisive manner and voice. Before he joined the BBC in 1952, Wheldon's experience of the arts was rather limited. However, he had worked for the Arts Council from the mid 1940s to 1951, and organised a number of concerts for the Festival of Britain celebrations. At first he served in the BBC's publicity department; he then gained several years experience of production and presentation. For a time he presented a children's programme called *All Your Own.*

Wheldon wanted the fortnightly programmes of *Monitor,* transmitted on Sunday evenings, to appeal to a broad rather than a specialist audience. He believed there was a constituency of six to seven million Britons - 'the small majority' - who were interested in the arts. But viewers were assumed to have no previous knowledge about the arts. Wheldon's manner on screen resembled that of an earnest headmaster and he came to personify the paternalistic ethos of the BBC. Not only was he an effective script-writer, presenter and interviewer, he was also an inspiring, demanding leader of the other producers, film-makers and researchers who made up the *Monitor* team.

Wheldon's awareness of the contemporary visual arts was slight. He thought 'collage' was a person and when Nancy Thomas, an associate producer, suggested a programme about the French Dadaist Marcel Duchamp, it turned out Wheldon had never heard of him and was incredulous when he was told Duchamp's oeuvre included readymades such as bicycle wheels and urinals. Nevertheless, a programme about Duchamp was made (broadcast on June 17, 1962) in which the artist was interviewed by another artist and admirer: Richard Hamilton. Wheldon was also ignorant of popular culture: while viewing the rough cut of a Ken Russell film he failed to recognise the voluptuous figure of Brigitte Bardot.

Monitor's introductory graphics were simple and modern in character: the camera sucked the gaze inwards by zooming forward into a void framed by a white linear structure recalling the constructivist, wire and nylon thread sculptures of Naum Gabo. The set was also austere and modern; it featured an abstract, scaffold-like spaceframe designed by Natasha Kroll. The graphics, set and Wheldon's style of suit remained identical for the whole series.

At first the programme consisted of five items. This proved too crowded and so the number was reduced to three. Periodically whole programmes were devoted to a single subject. In 1960 David Robinson reviewed the first sixty programmes consisting of about two hundred items.[1] A rough breakdown according to content revealed that painting and sculpture received the most coverage with 28%. The other figures were: theatre 21%, music 17%, literature 12%, ballet and opera 7%, cinema 6%, miscellaneous 7%. The most neglected art, with 2%, was architecture. A list of some of the specific topics *Monitor* tackled will give an impression of the breadth of its coverage. Amongst the writers featured

were: John Betjeman, Lawrence Durrell, Dürrenmatt, E. M. Foster, Robert Graves, Georges Simenon and Tolstoy; amongst the musicians were: Bartók, Elgar and Prokofiev; amongst the visual artists were: Jacob Epstein, Oskar Kokoschka, Bruce Lacey, Henry Moore, Auguste Rodin, Vincent Van Gogh and Ossip Zadkine. Dance was represented by Dame Marie Rambert and the cinema by Orson Welles.

Besides 'big name' artists, *Monitor* provided portraits of powerful arts administrators such as Rudolf Bing of the Metropolitan Opera house in New York. Humour was not overlooked: the 'goon' Spike Milligan appeared and there was a satirical piece about the craze for hi-fi and stereo recordings. Items on brass bands, child art, the American 'outsider' artist Simon Rodia, the circus and buskers, indicated that the popular arts were also considered worthy of attention.

Wheldon had a mission to inquire and explain: in addition to supervising the work of others, he introduced programmes, did voice-over commentaries and conducted interviews. For introductions, he wrote his own lines and then learnt them by heart. Those items that were broadcast live had to be prepared and planned with military precision, yet the results had to look natural. According to Humphrey Burton, the effect sought was 'rehearsed spontaneity'. When interviewing an artist or novelist Wheldon favoured direct, simple questions. To informed viewers, his questions often seemed naive and obvious but, clearly, Wheldon saw himself as the representative of the curious layperson. His commentaries were extremely skilful mixtures of basic information and interpretation suggestive of deep emotional responses. Items concerning music were usually the province of Burton, who had previously been a studio manager for sound radio. Another young assistant whose name was later to become famous was Melvyn Bragg.

Monitor also served as a platform for outside experts; for instance, the British neo-romantic painter Michael Ayrton spoke about a Michelangelo sculpture, the art critic John Berger talked about four Bellini Madonnas, and the conductor Sir Thomas Beecham was interviewed by Edmund Tracey about the music of Frederick Delius. As already suggested, interviews - both live and recorded - were a staple ingredient of *Monitor,* but in addition there were specially commissioned films.

Wheldon, it has been claimed, ran a British film school. He certainly employed and guided several young, talented film directors who were later to become noted in the cinema; for example, John Schlesinger, John Boorman and Ken Russell. In the cutting room it was Allan Tyrer who edited and dubbed most of *Monitor's* films. Schlesinger, before joining *Monitor,* had made brief documentaries for the innovative, current affairs programme *Tonight.* It was one of his films - an impressionistic study of circus performers - that opened the arts strand.

Russell was perhaps the most unusual of the film-makers because he was verbally inarticulate, untutored and inexperienced; he had a strong visual sense but he was virtually incapable of writing a script or a

commentary. (Russell would have been happy to leave out words altogether: his particular skill was to film dramatic and poetic sequences of images and then combine them with emotional passages of music.) Yet it was he who shot the most vivid and memorable documentaries. For example, Russell's elegiac, romantic 1962 film about Elgar (produced by Humphrey Burton), which included shots of the composer as a boy riding a white pony on the Malvern Hills, impressed and moved all those who saw it. In one, bitter sequence the stirring sounds of 'Land of hope and glory' accompanied footage of a shuffling line of blinded, First World War soldiers. As a result of the broadcast, sales of Elgar's records soared and later opinion polls revealed that 'Elgar' was the most remembered arts programme of the 1960s.

'Elgar' was half-documentary and half-drama. Five actors played the part of the composer at different ages but he was always seen in long shot and there was no dialogue - Elgar's lifestory was told by Wheldon in voice-over. It is common in dramatised biographies and drama-documentaries for actors to play famous dead artists, but Wheldon disliked the idea because he thought this was 'cheating'; he was convinced documentaries should contain no inventions. There was a long tussle between him and Russell about dramatised biographies. Step-by-step Russell introduced more and more reconstructed elements. Russell's subsequent exploitation of the bio-pic genre in his self-indulgent feature films about musicians and artists (for example, *Savage Messiah* [1972] about the French sculptor Henri Gaudier-Brzeska), shows how valuable was the restraining discipline imposed by Wheldon during the early 1960s.

Russell's films about the visual arts included studies of the naive painter Le Douanier Rousseau (played by the Yorkshire, naive artist James LLoyd), the two neo-romantic, Scottish painters Robert Colquhoun and Robert MacBryde, and the Spanish, art nouveau architect Antonio Gaudi. He also directed a lively film about the then topical subject of British pop art and youth culture: 'Pop goes the easel' (March 25, 1962). Pop music had been featured on television before, but this was the first arts programme to address the pop art of the period. The four artists featured in it were all associated with the Royal College of Art: Peter Blake, Derek Boshier, Pauline Boty (1938-66) and Peter Phillips.

Russell had previously worked in an art gallery but the pictures on sale had been about apples, so he was excited when he discovered there were artists exploiting the brash popular culture he had enjoyed in his youth. The subject, he has since claimed, liberated him from the over-reverential, solemn attitude towards art *Monitor* generally fostered; it also encouraged him to transcend the stolid documentary style. The film, shot by the cameraman Ken Higgins, was experimental in its approach: there was a dream sequence and abrupt cuts and changes of pace; clips from newsreels and Hollywood musicals were included plus cinéma vérité passages of a street market and an artschool party where the dance was 'The Twist'. Sounds too played a vital role: radio quotes, voice-overs, pop

songs, modern jazz, the noises of pinball machines. The film's form, Russell later argued, echoed that of its subject matter.

Only now and then did the pop artists speak. Mostly the film concentrated on the mass culture sources of their work's iconography: badges, targets, slot machines, the circus, fairgrounds, comics, girlie pin-ups, sci-fi and horror magazines, film and pop music stars, American cars, wrestling, the space race, etc. Pauline Boty made surreal photo-montages but she also wanted to be a professional actress. In the film she acts out a nightmare in which she is pursued along a corridor by a sinister woman in a wheelchair; this sequence prefigured her tragically early death from leukaemia in 1966. 'Pop goes the easel' was above all a vibrant celebration of the West London lifestyle of four young artists and the pleasure they took in consuming popular culture; there was no critical evaluation of their work. When Wheldon saw the rough cut, he instructed Russell to add a coda showing the artists painting to indicate that they were serious, hard-working professionals. In what was surely a sardonic gesture, Russell employed some classical music for the soundtrack at this point.

In terms of viewing figures *Monitor* was a successful series: it usually attracted an audience of two to three million. No one could deny its ground-breaking achievements, nevertheless, it became a target for parody (*Punch* called it 'Janitor' and its editor 'Hugh Wellbred') and some cultural historians found it bland. Christopher Booker, for example, in *The Neophiliacs* (1969), summed it up as 'deferential, never critical Instant Culture, pre-dating the Sunday colour magazines by four years'.[2] It certainly could have been bolder but for Wheldon's puritanical attitude towards homosexuality. Paul Ferris's 1990 biography of Wheldon discloses that he would not permit anyone 'overtly queer' to appear on the programme, nor would he permit a reference in one of Russell's films to lesbians on the grounds that his 'mother-in-law didn't understand the meaning of the word'. Given the fact that many many artists have been and are gay, this ban was a form of censorship.

In 1962 Wheldon compiled a book about *Monitor* which was published by MacDonald & Co. Two years later he gave a talk about arts television in which he identified three important editorial principles:

1. responsibility towards the subject matter: television must be true to the subject, it should not distort or belittle;
2. responsibility towards the audience: television should try to be accessible, it must not condescend;
3. responsibility to the medium of television itself: the medium should be used constructively and creatively.

When Wheldon at last relinquished the post of editor, he brought in Dr Jonathan Miller, a 'bright young man' from the *Beyond the Fringe* revue, to infuse new life into the series. Miller, who had a stutter to overcome, took over in the Autumn of 1964. He thought Wheldon favoured a 'great heroes and trophies' approach to the arts whereas he, Miller, was more

interested in complex, abstract ideas and the social context of art. Wheldon was a hard act to follow: he had covered so much ground and been so closely identified with the series, that the change of editor-presenter met with much adverse criticism. According to T. C. Worsley, TV critic of the *Financial Times,* Miller's attempt to 'jazz up' the programme was a failure, in part because of a pretentious discussion about camp taste with 'a walking parody of the contemporary intellectual (American style)' who, according to Worsley, provoked English viewers to 'ribald laughter'.[3] The unfortunate intellectual in question was the distinguished American writer Susan Sontag. Over a decade later she was to earn the respect of British viewers with a thought-provoking programme about the nature and social functions of photography.[4] Another North American intellectual Miller interviewed was Marshall McLuhan, the guru of the mass media during the 1960s. Surprisingly, McLuhan turned out to be so boring the interview was shelved. Miller also continued the tradition of specially commissioned films: he dispatched George Melly with a film crew to Belgium to record the surrealist painter René Magritte in his studiously conventional, bourgeois home.

Worsley's low opinion of Miller seems to have been shared by the BBC: *Monitor* was soon replaced by a new series called *Sunday Night.* To his credit Miller was not discouraged by his lack of success at *Monitor.* He saw no reason to be ashamed of being an intellectual and he continued to believe that some viewers would welcome 'talking heads' discussing serious ideas on television. Miller has since proved his point by presenting several, scholarly series about aspects of medicine and drama.

Wheldon went on to become, in 1969, Managing Director of the BBC and he was eventually knighted. In 1986, the year of his death, BBC 1's *Omnibus* paid a tribute to him via a programme entitled 'Huw Wheldon by his friends'. It was produced by Leslie Megahey and celebrated Wheldon's achievements as leader of the *Monitor* team. Five years later, another television homage to Wheldon's years as *Monitor's* editor was paid by Humphrey Burton when he made him the subject of the annual Royal Television Society lecture. This talk, broadcast by BBC 2 on September 28 1991, was illustrated by clips from archive recordings. Television rarely reflects upon itself - the two programmes about Wheldon are amongst the very few arts programmes that have examined the subject of arts television.

Pop music and satire programmes

During the 1950s teenagers became important as a social category and as consumers. Various youth subcultures emerged - teddy boys and girls, rockers, beats - and these groups were enthusiastic about traditional and modern jazz, skiffle, rock 'n' roll and pop music. Television responded to this new audience by introducing such series as *Cool for Cats* (A-R, 1956), *6.5 Special* (BBC, 1957), and *Juke Box Jury* (BBC, 1959). They were followed in the early 1960s by *Ready, Steady, Go!* (A-R, 1963) and *Top of the Pops*

(BBC 1, 1964-). These popular music programmes were more exuberant and informal than serious art programmes although there were some overlaps, as Russell's film about British pop art demonstrated. The style and iconography of the animated title sequences and sets of the pop music shows - *Ready, Steady, Go!* in particular - directly reflected the influence of pop painters like Peter Blake and Derek Boshier.

British television in the 1940s and 1950s was typified by deference to authority: politicians were treated with kid gloves and the Royal Family was worshipped. However, many young people became impatient with this state of affairs and by the late 1950s the Angry Young Men and the supporters of the Campaign for Nuclear Disarmament had made their dissenting views known. The various subcultures with their distinctive music, dance and fashion styles acted as vehicles for rebellion and a hedonistic pleasure in consumerism that was in marked contrast to the years of austerity and rationing. By the mid- 1960s a wider anti-establishment movement - the counter culture - had emerged. On television it was heralded by *That was the week that was* (BBC, 1962), an irreverent, satirical show broadcast late on Saturday evenings. Ned Sherrin was the producer and David Frost the compere; regular performers included Eleanor Bron, Roy Kinnear, Bernard Levin, Millicent Martin and William Rushton. This show was an immediate hit and it attracted audiences of between ten and fourteen million.

In 1950 television licenses numbered a quarter of a million. A decade later, the figure had reached ten million. So, by the 1960s, television had become the nation's most popular pastime. (Over the same period, cinema attendances had declined dramatically.) Increasingly, television featured the pop and counter cultures of 'the swinging sixties' but, as will become clear when Clark's *Civilisation* (BBC 2, 1969) is analysed, paradoxically, it also remained an important means of conveying and affirming traditional and establishment values. Television historians have claimed 'a golden age' of broadcasting occurred during the 1960s, that there was a liberal consensus at the BBC during the regime of Hugh Carleton Greene (director-general from 1960 to 1969). The limits of that consensus can be illustrated by the fact that Peter Watkins' anti-nuclear war film 'The War Game', which was due to be shown in 1966, was banned from TV screens for the next twenty years.

Tempo was commercial television's first magazine programme about the arts. The series of fifty-minute programmes began in October 1961 and appeared fortnightly on Sunday afternoons until the mid-1960s. (A second series called *New Tempo* consisting of six programmes directed by Dick Fontaine, Denis Postle and Mick Hodges was transmitted in 1967.) Various editors were employed by ABC TV but the first and best known was the brilliant theatre critic Kenneth Tynan (1927-80).

Items featured on *Tempo* included: Laurence Olivier interviewed by the Earl of Harewood; Gordon Craig interviewed by Tynan; the influence of Oxbridge on the arts; Kingsley Amis on pop culture; Graham Sutherland at

work filmed by Peter Newington; a film about psychotic art by John McGrath; satire by the *Beyond the Fringe* team; the Flamenco dancing of Maria Abaicin; an item on New Wave cinema in which John Osborne attacked the British film industry; an interview with Truman Capote; Dick Williams on the history of the cartoon film; a symposium on the Irish and the arts; a film about British architecture by Jill Craigie; a discussion amongst French writers including Françoise Sagan and Nathalie Sarraute about the artist's responsibility during the political crisis of the Algerian war; a film about the face of Christ in art with a script by John Whiting and narration by Cecil Day Lewis; Jonathan Miller talking to the violinist Isaac Stern.

Tynan, who edited the first fifteen programmes, once described himself as a 'talent snob' and he was happy to follow a directive to seek out 'big names'. He was less happy with the resources management provided: poor technical facilities, a tiny production team and budget. Unfortunately, a strike by members of the actors' trade union Equity prevented him from exploiting his specialist knowledge of, and contacts with, the British theatre to the extent he desired. He felt that the time of transmission (Sunday afternoon) was a handicap and he also encountered censorship: a proposed study of eroticism in the arts was banned. Another difficulty the series never overcame was finding a regular presenter, one with the authority of Wheldon. Nevertheless, Tynan felt *Tempo* did make some stimulating programmes and he later claimed that the series was the first to experiment with whole programmes devoted to a single theme or issue.

Some editions of *Tempo* adopted the 'fly on the wall' style of social documentaries. 'A tale of two talents' (1965), for instance, was shot on location with a hand-held camera. The film, directed by James Goddard, compared and contrasted the work and lives of two young, 1960s performing artists: the female, ballet dancer Lynn Seymour and the male, pop music singer Tom Jones. Camera and microphone recorded their daily routines, while contextual information was provided by means of voice-over. Filmed in close up, the two artists were also interviewed, but the questioner remained out of shot. The idea of comparing ballet and pop music turned out to be illuminating; it enabled the differences between a high, traditional artform and a modern, commercial artform to be highlighted.

Like *Monitor, Tempo* has a book - by Angus Wilson - devoted to it.

Omnibus (BBC 1), *Monitor's* long-term replacement, began in 1967 and is still regarded as the 'flagship' of the BBC's arts programming. The aim of the series was to produce 'television to remember'. Over the years various formats have been tried. *Omnibus* has performed a reviewing role, produced artists' profiles and dramatised biographies, relayed concerts and ballet, and commissioned filmed documentaries. Its editors have included Christopher Burstall, Norman Swallow, Mike Wooler, Barrie Gavin, Leslie Megahey, Christopher Martin and Andrew Snell. Sometimes it has

employed presenters - Henry Livings, Humphrey Burton, Richard Baker and Barry Norman - and sometimes not.

Notable programmes about the visual arts have included: Mai Zetterling's 1972 film about Van Gogh (to be discussed in more detail shortly); 'For love or money' (1977) a two part documentary about the art market and art institutions directed by Julia Cave; 'Mark Gertler' (1981) a film directed by Phil Mulloy with Anthony Sher as the artist; 'Georg Grosz enemy of the state' (1987), written and directed by Andrew Piddington with Kenneth Haigh playing the part of Grosz; 'The bull in winter' (1988), a film by David Sweetman about the late work of Picasso and the legal and financial complications resulting from his death; 'From bitter earth' (1988), a film directed by Paul Morrison about the various kinds of art produced by Jewish victims of the Holocaust; 'Vision of Britain' (1988) a critique of modern British architecture written and presented by Prince Charles; Peter Adams' two part study of Nazi visual culture: 'Art in the Third Reich' (1990); a fascinating and illuminating film examining the paintings of Piero della Francesca and the problems of interpreting them (1992).

Two, especially memorable editions of *Omnibus* focused upon single poems. First, Burstall's early black-and-white film 'Tyger Tyger' (1967), a detailed investigation of the power and meaning of William Blake's famous poem; and second, 'Whale nation' (1988), Heathcote William's epic and moving defence of whales - read by Roy Hutchins - plus documentary film clips of whales swimming in the ocean.

Omnibus's willingness and ability to tackle popular culture subjects has been demonstrated several times. Examples include 'Cracked actor - David Bowie', a film by Alan Yentob made in 1974; 'Madonna: behind the American dream' (December 7, 1990), a film produced by Nadia Hagger about the career and work of the famous American singer and movie star; and a profile of the British film director Ridley Scott (October 13, 1992).

Normally an audience of two to three million watches *Omnibus*. Exceptionally, over seven million saw the programme about Madonna. In an article celebrating the series' 25th anniversary, Laurence Marks identified the strengths of the series as 'a spirit of adventurousness' and 'intelligibility'[5].

BBC 2 and *New Release*

A second channel was launched by the BBC in April 1964. The advent of another public broadcasting channel obviously enabled more time and money to be allocated to arts programmes. BBC 2 enabled more specialist interests and minority tastes to be satisfied. Arts programmes could afford to take more risks, to tackle more offbeat subjects and to experiment with their forms of presentation.

New Release, a new arts programme established by BBC 2, ran for four years (1964-68). It performed a reviewing role and covered a wide spectrum of topics: George Melly interviewing Heinz Edelmann (a German poster artist) about the 1968 Beatles' animated cartoon film *Yellow*

Submarine; a production of King Lear; a Marcel Duchamp retrospective at the Tate Gallery; Robert Hughes on the pop art explosion in New York; a study of the radical architectural group Archigram; Barbara Hepworth in Cornwall; Tolkein in Oxford; a Jean-Luc Godard documentary about the Rolling Stones; the film directors Jean Renoir and Federico Fellini at work; and the Canadian expert on the mass media - Marshall McLuhan.

Also during 1964 the British television system changed from 405 to 625 lines, thus giving sharper pictures. Three years later BBC 2 was the first British channel to transmit images in colour. (This was a somewhat belated technical development given the fact that colour transmissions had been made by John Logie Baird as early as 1928 and the fact that CBS in New York had begun broadcasting in colour in 1951.) The other two channels followed suit in 1969 but obviously to receive colour pictures viewers had to have the appropriate receivers. It was some years before the number of colour sets overtook those that were monochrome. To take advantage of colour, ambitious and expensive new pundit series were commissioned, the most famous being Clark's *Civilisation.*

Important, strand series of the 1970s will be discussed shortly, but first it is essential to consider the drama-documentary genre.

References

1. D. Robinson, 'Monitor in profile', *Sight & Sound*, 30 (1), Winter 1960-1, pp. 41-3.

2. C. Booker, *The Neophiliacs: a Study of the Revolution in English Life in the Fifties and Sixties,* London, Collins, 1969, p. 133.

3. T. C. Worsley, 'Art', *Television: the Ephemeral Art*, London, Alan Ross, 1970, pp. 147-8.

4. S. Sontag, 'Its stolen your face', *Omnibus,* (BBC 1, 1978).

5. L. Marks, 'The men on the BBC Omnibus', *The Observer,* August 23, 1992, p. 63.

fig **10** | **Michael Gough** as Van Gogh in Mai Zetterling's filmed dramatized biography 'Vincent the Dutchman' broadcast on *Omnibus* BBC1, October 1972.

PHOTO COURTESY OF JOHN BULMER, *RADIO TIMES* AND THE BBC.

chp.5 Dramatised

Biographies and Drama-Documentaries

As emerged during the account of *Monitor* in the early 1960s, it seems to have been Ken Russell who instituted the vogue for dramatised biographies of artists and musicians filmed for television. Of course, this genre had existed for much longer in the realms of literature, the theatre and the cinema.

Television producers generally employ the dramatised biography and the docudrama genres when dealing with dead artists: famous artists of the past are played by actors and actresses wearing period clothes. Real, outside locations and old buildings are used, or historical sets are constructed inside studios. Staged reconstructions of events are often intercut with shots of real works of art that have survived from the past. The dialogue between characters is invented or, alternatively, there is a voice-over commentary based upon diaries, journals, manifestoes and letters. Evidently, this kind of programme is very similar to profiles of living artists. It lays comparable stress upon the private lives and personalities of exceptional, gifted individuals. Where it differs is in a greater degree of fictionalisation and frankness.

As in the case of feature films about artists, much depends upon the intelligence of the script, the suitability of the actor and how sympathetically he or she interprets the part. Because the artist is dead and cannot protest, directors of such programmes feel freer to indulge themselves. Emotion-stirring music is often liberally employed and the flavour of the artist's work is sometimes communicated by a more metaphorical approach making use of, say, fantasy or dream sequences. Three, contrasting examples, dating from the 1970s and 1980s, will give a fuller picture of what the genre entails.

'Vincent the Dutchman' was a 52 mins, 16mm colour film produced and directed by the movie star Mai Zetterling. It was shown on BBC 1 (*Omnibus*, October 15, 1972) and on American educational television. At the time Zetterling lived in an old farmhouse in Provence and, inspired by the landscape and Van Gogh's letters, she decided to make a movie about Vincent's creative struggle in the 1880s. David Hughes - her husband - wrote the script; John Bulmer was the cameraman, and the part of Van Gogh was played by British character actor Michael Gough. For five months the crew lived simply in Provence trying to simulate Van Gogh's way of life in order to gain an insight into his experience. The only paintings by Van Gogh which appeared in the film were his self-portraits. Dialogue and commentary were derived from Vincent's letters and the memoirs of artist friends. Zetterling's film was exceptionally self-reflexive in its construction, shifting back and forth between the past and the present: it began with Michael Gough being interviewed about the role he was about to play. Documentary-style passages were also intermingled with fictional recreations and dream-like scenes. Although Zetterling's film was shown on television in Europe and the United States and received several awards, it did not recover all its production costs.

'The Rothko Conspiracy' (1982) was an offbeat arts programme because it employed the drama-documentary mode to examine the financial scandal and court cases associated with the legacy of the late American abstract expressionist painter Mark Rothko. The programme began dramatically with the suicide of Rothko in 1970, intercut with scenes of the auctioning of a Van Gogh for over a million dollars. The opening served a double purpose: it established a link between Rothko and Van Gogh (both killed themselves) and the relation between art and money. A large number of unsold Rothkos remained after his death but instead of passing to his wife and children they came under the control of the Mark Rothko Foundation run by the artist's three executors - Morton Levine, Theodore Stamos and Bernard Reis. The purpose of the Foundation was to keep the paintings together and to display them publicly, but instead the executors sold the best works cheaply to Frank Lloyd of the Marlborough Gallery. Only a determined investigation by Gus Harrow of the New York Attorney General's office exposed the cynical commercial exploitation of Rothko's estate. A court case followed and eventually most of the paintings were recovered.

The character of Rothko, the nature of his art, and the events leading up to the scandal were shown in flashback and a few voice-overs were also used to give contextual information. The programme, broadcast on BBC 2 on February 6, 1983 (also shown on PBS in the United States in the Spring of 1983), evinced some of the characteristics of crime series and courtroom dramas. The script was written by Michael Baker and the director was Paul Watson. Rothko was played by Larry Hoodekoff, Bernard Reis his untrustworthy tax advisor by Barry Morse, Frank Lloyd his greedy dealer by Ronald Lacey, and Gus Harrow by Douglas Lambert.

In a detailed review of the programme the American critic Howard Singerman attacked its representation of Rothko on the grounds that it relayed the stereotypical image of the bohemian artist and presented a 'pathological analysis', that is, identified the work with the artist's 'abnormal' personality.[1] Nevertheless, the drama was worthwhile because it exposed the business dimension and sharp practices of the artworld (aspects television had ignored for many years). Since Rothko's paintings were intended to embody transcendental or spiritual values, the contrast between his artistic ideals and the squalid profiteering to which his work was subject after his suicide was especially poignant.

Our third example, *Artists and Models* (BBC 2, 1986), was a mini-series of three films set in a Paris studio during a period of revolutionary change. They focused upon the careers of the painters Jacque-Louis David, Jean-Auguste Ingres and Géricault, hence they were concerned with the relation between art and politics and the stylistic clash between classicism and romanticism. Since arts programmes so rarely consider the important role played by academies, artschools and the private studios run by artists, it was valuable to have this aspect represented.

The films, written and directed by Leslie Megahey, were fascinating because of their technical ingenuity and their post-modern approach to portraying history. In the programme about David, for instance, extracts from old silent movies about the French revolution of 1789 were used as if they were newsreels of the event. Transitions were then made from such cinematic quotations to contemporary reconstructions using actors and sets. At one point a striking transition occurred: the action of an old black-and-white movie sequence was carried over into a modern reconstruction shot in colour. The programmes also featured a more conventional voice-over commentary based on nineteenth century memoirs plus stills of David's paintings. The total impression was of a rich intertextuality in which different kinds of representation were played off against one another, with the result that it became evident that, for the contemporary historian, the past (that is, before living memory) consists of nothing but texts of various kinds.

Presumably, dramatised biographies are popular with viewers because they make the subject of art more human and approachable. The genre's popularity amongst TV producers varies, however, from decade to decade. At the time of writing, British producers seem to be avoiding it - probably because it is more expensive than other genres. [2] Docudramas about sensitive political subjects have also provoked heated debates in recent years because of the vexed issue of how truthful they are to reality. (Writers who wish to expose scandals and corruption in high places, frequently resort to the genre as a way of circumventing censorship and the law of libel.) It is apparent that even today many people share Wheldon's distrust of the genre and find its hybrid nature, its blend of fact and fiction, disturbing.

Because artists' personalities and private lives tend to be given priority over their work and the social context, from the art historian's perspective there is something inherently unsatisfactory about such programmes even when they are made with care and intelligence. But when they are done badly they are excruciating. A case in point was the crass, six-part, historical costume epic *Goya* (RTVE, 1985) directed for Spanish television by José Larrez and shown on Channel 4 in Britain (with dubbed voice-overs) in the summer of 1988. This imported series deserved the same fate as the Spanish Armada.

References

1 H. Singerman, 'Tainted image: Rothko on TV', *Art in America*, 71 (10), November, 1983, pp. 11-5.

2. Effective dramatised biographies of artists can be made without enormous expense. A case in point was the Arts Council film *Käthe Kollwitz*, (1981, 44 mins, 16 mm, production company: Cinecontact), directed by Ron Orders and Norbert Bunge. Music was supplied by Arpad Bondy and the British actress Brenda Bruce played the part of the German, socialist print-maker and sculptress. In terms of production and design the film was extremely simple and economical: the only actress used was Bruce; no elaborate sets were constructed; just two locations - Germany and Belgium - were employed; the Nazi era was evoked by the use of the sounds of a Hitler speech superimposed over contemporary footage of a 1930s stadium; no archive film was found necessary apart from a brief clip of the real Kollwitz shown as part of the end credits. Bruce gave a superb performance and the result was an informative and very moving film.

fig 11 | Ken Morse with one of his rostrum cameras, London 1990.

PHOTOS: OLIVER WATTS, REPRODUCED COURTESY OF KEN MORSE.

Programmes about

works of art

While the artist is probably the most popular subject of arts television - for the reasons identified by Denis Donoghue - there are some programmes which concentrate upon groups of art objects or just single works of art. Past examples include: *Canvas* (BBC 2 1966-70), *One Hundred Great Paintings* (BBC 2, 1980), *The Secret Life of Paintings* (BBC 2, 1986), *Looking into Paintings* (Channel 4, 1986), *Masterworks* (Channel 4, 1987) and *Building Sights* (BBC 2, 1988).

This category could also be stretched to include the long-running BBC 1 series *The Antiques Roadshow,* a popular programme in which connoisseurs identify and value items of furniture, ceramics and other decorative artifacts owned by members of the public. A pilot for the *The Antiques Roadshow* was produced by Robin Drake of BBC Bristol in 1977 and the first series of eight programmes was transmitted in the Spring of 1979. (As the term 'roadshow' indicates, the programme travels around the country and is broadcast from a different city or town each week.) Viewing figures soon reached thirteen million and as a result, Arthur Negus (1903-85) - the programme's affable, resident expert - became a household name. Negus was no stranger to television: he had previously introduced *Going for a Song* (BBC 1, 1965), the first regular series about antiques.

The Antiques Roadshow provides basic information of the reference book variety, but it is made tedious by the repeated expressions of astonishment by members of the public when they learn their heirlooms would fetch more at auction than they imagined. According to Jack Shamash, a highly critical reviewer, the show is a prime example of British snobbery and class prejudice because the desire to own old, distinguished objects indicates an ambition to belong to old, distinguished families.[1]

The usual formula for programmes about single works of art is a museum or church setting with an art historian or critic pontificating in front of them. As he or she talks, the camera closes in to show details or, in the case of sculptures, circles them to reveal different facets. When such a

programme is pre-recorded, it is possible to vary the basic formula of gallery and expert by inserting clips from archive film and/or shots of contemporary footage (of, say, a motif) but, aside from expensive special effects capable of placing the expert 'inside' paintings, it is hard to imagine a different approach. The format is often a recipe for dull television but, of course, everything depends upon the intrinsic interest of the object of study, the quality of the script, and the manner of delivery.

There are many challenges facing camera operators when filming and lighting paintings, sculptures and architecture in situ. 'Tubby' Englander, a skilled BBC cameraman who worked on Clark's *Civilisation* series, spends a chapter of his book *Filming for Television* (1976) describing the various problems he encountered and the solutions he devised. Problems included: reflections off the surfaces of glass, mirrors and canvases; perspectival distortions when filming large murals; 'stagger' (a juddering of the image) when panning; extremely large or dark interiors that proved hard to illuminate. (Inside some buildings, slow-motion photography had to be employed to gain sufficient exposure.) In his book Englander also cites the benefits the cameraman's abilities can supply:

> In some instances he provides a view of unparalleled quality, providing an opportunity to view a work under ideal conditions when in fact it might be normally invisible. With his lights he can show in all its brilliant colour a great painting hanging on the dark walls of a baronial hall; through the cameraman's telephoto lens are revealed carved details in a ceiling boss high up among the ribs of some gothic vault in central Europe.[2]

When filming three-dimensional structures like sculptures and buildings the ability to move the camera smoothly around and within the object of attention is clearly important. Movement can be achieved by means of cameras mounted on dollies on tracks, or on cranes, or by the use of hand-held cameras. This kind of filming has become much easier in recent years as a result of the advent of the Steadicam. This device was invented by Garrett Brown in the mid-1970s. It is worn by the operator and allows a stable and accurate frame to be achieved.[3] A Steadicam is also essential if a moving object or person is to be filmed. Long, flowing shots in which the camera closely follows actors or presenters as they move around have now become commonplace in TV programmes and movies.

If access to the original work of art is problematical, then a colour reproduction or transparency of it can be filmed or videotaped in studios via the use of a rostrum camera (such as the Oxberry). The latter is a mechanically-powered camera mounted vertically so that it can move up and down. It is linked to a horizontal platform - upon which the flat artwork is placed - that can move north, south, east and west, and rotate through 360 degrees. This set-up enables intricate movements in all dimensions to be achieved. The speed with which the camera moves can also be varied and movements can be computer-controlled and

memorised. What the camera 'sees' can be displayed live on monitors. It follows that much greater precision is possible with a rostrum camera than with a normal camera filming a painting on a gallery wall. Rostrum cameras also have the ability to fade, mix and superimpose images. Computer-control has also enabled special techniques such as 'streak-timing' and 'slit-scan' to be devised. The former exploits motion control on each frame to generate an effect of streaks or blurs of light, while the latter involves shooting the artwork through a narrow slit in order to distort the image.

Arts programme makers normally supply the rostrum camera operator with semi-transparent overlays marked to indicate the details and movements required; timings are also given to match the length of the music or commentary that is to accompany the sequence. In Britain, the best known operator of the rostrum camera is Ken Morse (he has been described as 'the most credited man on British television' and he has even been the subject of a item on an arts programme: *The Late Show* [BBC 2, March 13, 1991]). Morse does not slavishly follow the instructions he is given, consequently he often makes a personal contribution to the final result. Essentially, the role of rostrum camerawork in television arts programmes is to animate the still image, to supply the movement that viewers have come to expect of the medium.

It has been argued that good rostrum camera work involves fluent, smooth movements that seem as if the human eye has viewed the artwork. This raises the question: what is the the best way of representing still works of art? Film-makers differ in their answer to this question: some favour extensive camera and lens movements - pans, tracking shots and zooms - while others prefer no movements at all. Some show the whole picture and no details, while others oscillate between whole and parts. Some add music and commentary while others prefer silence. In the case of sculptures, lighting offers film-makers many additional opportunities for emphasis and interpretation.

As mentioned in *Art and Artists on Screen,* European arts documentary film-makers of the 1940s such as Luciano Emmer, Enrico Gras and Alain Resnais pioneered the use of camerawork to animate and narrativise paintings. The rostrum camera greatly facilitates the fragmentation of images for these purposes. TV producers are reluctant to show still images so that viewers can scan them as they would like, because the small size of the screen means that detailed pictures cannot be seen properly and because producers are afraid of boring the audience. Large-screen, high-definition television may in the future encourage arts programme makers to show more still images of whole paintings.

Picasso's mural-scale painting *Guernica* (1937) is one of the most important, famous and documented works of twentieth century art and so it is not surprising that it has been the subject of several programmes (there is also an interactive video, hypergraphics version - 'Guernica: one picture... a thousand worlds' - by the American Robert Abel, of AND Communications, Los Angeles).[4] Arguably, *Guernica* is the ideal subject for

an arts programme because of its complex iconography, specific historical content and political significance. Since the painting was photographed at various stages during its production, there is a unique record of its genesis. Plenty of newsreel footage exists too of the artist and the Spanish civil war, so this could be drawn upon to situate the canvas in its historical context. The return of the painting from New York to Madrid following the death of General Franco also permitted more contemporary footage exploring the mixed reactions of the Spanish people.

As its title indicates, *One Hundred Great Paintings* was a series of one hundred, ten minute programmes shown on BBC 2 at 7.30 pm, one painting a night, five nights a week, in blocks of four weeks, beginning on June 16, 1980. It has been claimed that this series - a co-production with the German arts producer Reiner Moritz - was 'the biggest ever series devoted to art'. In total over sixteen hours of television were generated. The selection of paintings was undertaken by Edwin Mullins and amongst the experts he invited to talk about them were Sir Hugh Casson, George Melly and Richard Cork. The artist David Hockney was also called upon to speak about Van Gogh's *Cafe at Night*. For the sake of greater coherence, each week's paintings were related thematically, that is, pictures concerned with light, or cities, or hunting, or touch, and so on. The brevity of the items made them easily digestible and their timing. and regularity encouraged the casual encounter rather than planned viewing.

In conception and level the series was somewhat old fashioned - a television version of introductory, art appreciation, colour-plate books. (During the early 1960s, BBC radio had also established a precedent for this kind of series: the *Painting of the Month* broadcasts, which supplied listeners with reproductions of famous paintings for them to study while experts talked about them.) What remained unquestioned was the priority given to the medium of painting and the very idea of a canon of great works.

Much more substantial was the mini-series of five, hour-long programmes called *The Secret Life of Paintings* (BBC 2, 1986). An article in *The Listener* accompanied the series and a tie-in book was also published. The programmes were presented by the art historian Pamela Tudor-Craig (Lady Wedgwood) and discussed five complex, Medieval and Renaissance paintings in exceptional detail. The last programme, for example, focused upon Holbein's 1533 painting *The Ambassadors* (National Gallery, London) one of the most densely coded images ever made. What Tudor-Craig - dressed somewhat bizarrely in knickerbockers - provided was a step-by-step investigation of its content, symbolism, meaning and historical origins. As in a good detective story, every detail of the scene was intensely scrutinised, clues identified and evidence gathered. Gradually, the secrets of the painting were uncovered. The programme was a fascinating and convincing demonstration of the methods and value of the Warburgian mode of iconographic analysis (much of the research for the programme had in fact been undertaken in the library of the Warburg Institute in London).

fig 12 | Dr Pamela Tudor-Craig (Lady Wedgewood) on the set for the programme about Holbein's 'The Ambassadors'. *The Secret life of Paintings* series, BBC2, 1986.

PHOTO COURTESY OF BBC TELEVISION, PRODUCER DICK FOSTER AND DR P. TUDOR-CRAIG.

Tudor-Craig's commentary was dependent upon the specialist knowledge gathered by earlier generations of historians and Holbein scholars, nevertheless the programme synthesised this information and made it accessible to a non-academic public. Visitors to the National Gallery can certainly appreciate the Holbein painting aesthetically without knowing anything about the artist or the sixteenth century, but what the programme did make clear was how historical and cultural knowledge can add immensely to one's understanding of the content of a work of art.

The other case studies in the series were Botticelli's *Primavera,* Jan Van Eyck's *Madonna and Child,* Uccello's *St George and the Dragon,* and Hieronymus Bosch's *Christ crowned with Thorns.* On the whole these were not quite so successful because Tudor-Craig became over-intoxicated with alchemy, folklore, heraldry and Jungian symbolism. One critic - Kevin Gough-Yates - accused her of talking down to viewers and found the whole conception of the series safe and conservative. He also complained about Richard Foster's style of production saying it resembled that of a Hammer horror film. In an attempt to enliven the standard format, certain visual gimmicks were employed: the presenter magically appeared from a puff of smoke and technical wizardry enabled her to enter the pictorial

space of the Holbein. When the subject matter and the script are gripping enough, such flourishes are superfluous.

Building Sights (BBC 2, 1988-89) was a series of ten minute programmes about outstanding and offbeat examples of British architecture (mostly dating from the twentieth century). The programmes provided brief, undemanding but enthusiastic appreciations of the selected buildings. A wide range of building types were examined: houses, seaside pavilions, offices, arcades, law courts, pumping stations, football stands, etc., and various presenters were used; besides architects, they included critics, writers and artists. It was refreshing to hear the responses of people who were not specialists. In the case of Charles Rennie Mackintosh's Glasgow School of Art building for instance (BBC 2, November 29, 1988), the presenter was the brash Scottish artist Bruce McLean. He was an apt choice because he had been trained in the building and was thus able to speak authoritatively about its functionality and its influence upon art students. Edward Cullinan, Nigel Coates and Piers Gough were amongst the architect-presenters who appeared on screen. Another was Sir Norman Foster, the master of high-tech. He stretched the definition of architecture by praising the engineering and design of Boeing's 747 jumbo jet aircraft. Patrick Uden was the director of this film.

By illustrating the diversity of British architecture and by demonstrating the importance of evaluating individual examples, *Building Sights* served as a corrective to the blanket condemnations of modern architecture so fashionable in the 1980s. The introduction of ten minute arts programmes such as *Building Sights* may have had more to do with the flexibility they lend to scheduling (they fill awkward gaps between longer programmes), than to an intrinsic interest in the subject matter; they were none the less welcome for all that. A follow up series dealing with examples of European architecture - *Building Sights Europe* - was transmitted in the Autumn of 1992.

Perhaps the most remarkable television study of a single work of architecture was the series *Skyscraper* produced by Karl Sabbagh of InCA (Independent Communications Associates, Ltd, London) shown on Channel 4 in 1989. The programmes followed the progress of the design and construction of a new skyscraper in New York - *Worldwide Plaza* designed by the architect David Childs - over a period of years. They explored in exceptional detail not only the subject of architectural style and design, but also the 'fast-track' construction method, engineering problems, the manufacture and transportation of materials, questions of development, planning and finance, selling space to future occupants, supply and finishing problems. Viewers encountered many of the people involved in the project from the moneymen to the native American steel erectors who are famous for their ability to work at great heights. Although the building itself was a lacklustre example of contemporary commercial architecture, the programmes and the accompanying book succeeded in communicating a mass of information about an extraordinarily complex human endeavour.

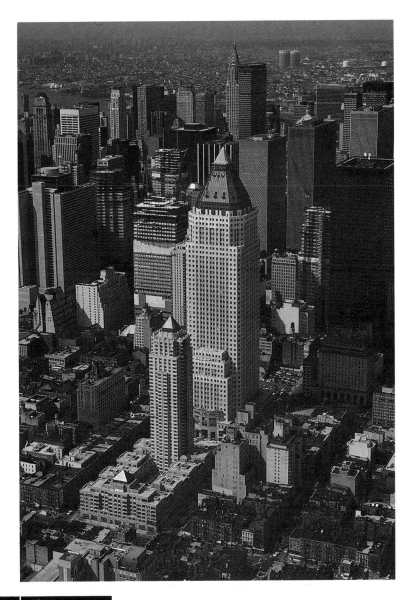

fig 13 | **Helicopter view** of the Worldwide Plaza skyscraper, New York, 1989.

PHOTO JOHN W. ALEXANDER REPRODUCED COURTESY OF KARL SABBAGH, INCA, LONDON.

The value of in-depth studies of individual works of art is evident. However, a problem of decontextualisation can occur as a result of the detachment of the object from the rest of the artist's oeuvre, or from other objects belonging to the same genre or style. Of course, it is perfectly possible to produce a TV series about a particular genre of art, witness *Changing Faces*, a six part series of half-hour programmes about portraiture produced by Nimrod for Channel 4 in 1987.

In the case of architecture, there is also the environmental context to consider - individual buildings in towns and cities are only parts of a totality. Even mediocre buildings can contribute to a successful townscape, so the tendency to concentrate upon exceptional examples can mislead viewers as to solutions to poor architecture and town planning.

Valuable in this respect were the two popular series *Six English Towns* and *Six more English Towns*, subtitled *A Pattern of English Building* (BBC 2, 1978, 1981). They were conventional pundit films enlivened by footage shot from a helicopter. Their writer-presenter was Alec Clifton-Taylor, a historian with a keen interest in building materials and craft techniques. He provided informed architectural tours of such ancient towns as Berwick, Ludlow and Warwick. The programmes were pleasurable and useful because Clifton-Taylor was concerned not just with the history, materials and styles of key public buildings and houses, but with vistas, the layout of streets and with the appearance of street furniture; in short, the urban texture as whole.

Another congenial guide to the towns and villages of Britain was Ian Nairn (1930-83). He was the architectural journalist who coined the term 'subtopia' in the 1950s and who drew the nation's attention to the outrages being committed by planners and developers against Britain's townscapes. During the 1970s he made several filmed series for television in which he travelled around Britain and Europe commenting on buildings and places. In *Nairn across Britain* (BBC 2, 1972, a series produced by Alex Marengo), for example, he trundled around the country in a sturdy Morris Minor evaluating the changing appearance of the nation's urban environment. One journey took him from London to Manchester via minor roads. (This film was produced and directed by Barry Bevins and the cameraman was Bob Sleigh.) On the way he praised and condemned buildings and developments from many different periods - he was attracted to buildings of character no matter what their age or style. A constant concern of Nairn's was that buildings should be 'plugged-in', that is, connected to the rest of the town by such means as staircases and walkways.

As Jonathan Meades pointed out in an introduction to a repeat of the London-to-Manchester programme, Nairn was an eloquent, passionate critic whose speech was 'vivid, demotic and vital'.[5] He was such a thoughtful and caring guide, he disarmed the criticism that has been directed at programmes constructed from the viewpoint of an individual, male expert.

As we shall see shortly, extended analyses of particular works of art are also characteristic of educational arts programmes.

References

1. J. Shamash, 'Reputations: hidden fortunes', *Weekend Guardian,* June 13-14, 1992, p. 38.

2. A. Englander & P. Petzold, *Filming for Television*, London & New York, Focal Press, 1976, p. 229.

3. The Steadicam is a complicated mechanism. For a description and an account of its use see: T. Churchill, 'Steadicam: an operator's perspective', *American Cinematographer,* 64 (4), April, 1983, pp. 36-9. 113-20.

4. *'Guernica* - the long exile', (*Arena* BBC 2, 1981); Tony Aldgate's '*Guernica* - the making of a myth', (Open University, 1982); and Francis Frascina's 'Picasso's *Guernica',* (Open University, 1983). Robert Abel's interactive version of the painting was featured in a TV programme about hypertext/graphics: Douglas Adams' 'Hyperland', (BBC 2, September 21, 1990); Abel also presented it at the 'IMAGE '89' conference held in London in 1989. At the time of writing it has not been 'published' commercially because of copyright clearance problems.

5. J. Meades, 'Nairn's travels', (BBC 2, September 10, 1990).

Pundit Series

Pundit series about the visual arts can be regarded as the television equivalent of illustrated, history of art, lecture courses. Each series is concerned with a specific theme or body of material. A pre-determined number of programmes are carefully planned in terms of examples, scope, period and place, and filmed or videotaped in advance of transmission. They are usually expensive, prestige productions; however, they can recoup their heavy costs and make profits by being sold internationally. In the realm of art, the best-known examples are probably *Civilisation, Ways of Seeing* and *Shock of the New,* but others include *The Secret Life of Paintings, A Love Affair with Nature, Architecture at the Crossroads, Three Painters* (Sir Lawrence Gowing talking about Giotto, Turner and Rembrandt, BBC 2, 1988).

A well-known scholar, art historian or critic is responsible for the intellectual substance of the programmes and he also presents them. He - the pundit, guru or expert tends to be a white, middle-aged male - supplies a running commentary by speaking direct to camera and/or in the form of a voice-over. Besides being articulate, the man must be reasonably handsome and personable to be acceptable as a presenter. Edwin Mullins, the guide to a series about British landscape art - *A Love Affair with Nature* (Television South [TVS] Production for Channel 4, 1985) - is something of a male sex symbol: he is lithe, sun tanned, wears close-fitting jeans and short-sleeved shirts to expose bare arms, a gold chain, and has an urgent, intense voice and body language. Michael Wood, the chief presenter of *Art of the Western World* and several other series, is a similar physical type.

During 1992, the search for a telegenic female art critic ended with the discovery of Sister Wendy Beckett, an eccentric, 62-year-old, Carmelite nun whose home is a caravan. Her opinions about art were already familiar to those in the artworld because she had contributed to Peter Fuller's magazine *Modern Painters.* Sister Wendy proved very popular with some viewers. In the first of a series of ten minute, art appreciation programmes entitled *Sister Wendy's Odyssey* (BBC 2, November 20, 1992), she toured the Walker Art in Liverpool giving her reactions to various paintings. As a virgin and follower of Christ, one expected she would have something censorious to say about a Hockney painting celebrating the bottom of a naked young man emerging from a swimming pool, but her only objection was that Hockney's style was 'too diagrammatic'!

A visual cliché of the pundit series, is a long shot of the presenter talking while slowly descending the staircase of a Greek-style temple. 'Pundit descending a staircase', it might be called; it is the art programme equivalent of the shot in Hollywood romances in which the heroine sweeps down the marble staircase of a mansion.

Having a single presenter humanises the electronic medium, facilitates viewer identification and fosters the impression of a face-to-face conversation or dialogue, even though viewers cannot literally interrupt or ask questions. However disparate the material discussed in different programmes, the pundit's presence ensures uniformity and continuity. It is the pundit's verbal discourse which connects and makes sense of the montage of images/sounds and which propels the narrative forward. In Hollywood-type cinema, stars are crucially important in the appeal and marketing of movies; television's output is not quite so dependent on stars but it does foster 'TV personalities' around whom popular shows are built. As Julian Petley has pointed out, magazines like *Radio Times* and *TV Times* contribute to this process by carrying features about leading TV actors, comedians, chat show hosts, news readers and so on.

According to Petley, even the tone of voice in pundit series and documentaries has certain recurrent characteristics and ideological implications:

> When voice-over is employed, the characteristic tone is moderate, assured, reasoned. It is appropriate to a 'community' which is presented as neutral, objective, normally harmonious, disinterested and working for the good of humankind. Humour, irony, paradox and rhetorical questioning are rare, as are invitations to the viewer to dissent, criticise or respond... [1]

Predictably, there are few pundits with regional accents.

Certain recurrent characteristics are associated with pundit series:

1. there is a single author (this is in spite of the fact that the script probably involved the research and ideas of several people and the production required the skills of a team);

2. what is being offered is 'a personal opinion', one individual's point of view (this is the liberal pluralist idea that society consists of individual 'atoms' rather than social groups and that there are many opinions within society, all equally valid. The argument that some are more valid or truthful than others is not likely to be put even though the employment of an expert implies it). By ascribing the views expressed to the presenter, the television institution disclaims responsibility for them even though it has commissioned them and is relaying them;

3. the statements of the presenter are authoritative (a sense of omniscience tends to be associated with the pundit's screen presence and commentary because he or she benefits from the

weight and resources of the television institution concerned, even if the latter does disclaim responsibility for the views expressed. Unless the pundit deliberately cites alternative views or provides interviews with other experts holding different opinions, then the pundit's will prevail.) Other television history series have employed two historians holding different political views, to demonstrate that the past can be interpreted in different ways, that it is a site of political struggle.

Although the programmes of a pundit series are of primary importance, there are usually supplementary versions or tie-ins in other media in order to maximise public response. For instance, in the cases of *Civilisation, Ways of Seeing* and *Shock of the New* there were articles in *The Listener* magazine immediately after each broadcast and books produced by the BBC or in association with commercial publishers. Soon after its transmission, *Ways of Seeing* could be hired in the form of four, 16mm films and, later still, it could be purchased as four video-cassettes. Clearly, in the case of pundit series, what confronts the analyst are multi-media packages. Comparisons reveal there are often significant differences of content in the various forms of communication making up a particular series.

In addition to these first-level materials, there are also secondary types of literature generated in response to the series, that is, letters, reviews, articles and even, in the case of *Ways of Seeing,* paperback books and special issues of magazines.

By the mid-1980s the pundit series format had become a cliché and for some viewers its ideological effects had become suspect. As we shall see later, the 1987 series *State of the Art* deliberately broke with its conventions. Before then three key pundit series - *Civilisation, Ways of Seeing* and *Shock of the New* - will be reviewed in detail.

References

1. J. Petley, 'Gurus: the cult of the TV personality', *Prime Time*, (5), Spring, 1983, pp. 14-17.

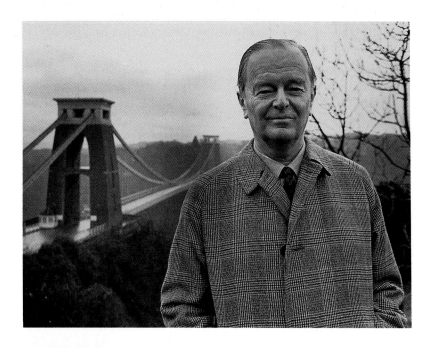

fig 14 | **Kenneth Clark** in front of the Clifton Suspension Bridge, Bristol. Publicity still for *Civilisation* BBC 2, 1969.

PHOTO COURTESY OF BBC TELEVISION.

Civilisation (1969)

chp.**8**

'Civilisation'... an ambiguous term, denoting on the one hand enlightened and progressive development and on the other hand an achieved and threatened state, becoming increasingly retrospective and often in practice identified with the received glories of the past. (Raymond Williams.) [1]

The BBC 2, thirteen-part series *Civilisation* presented by Kenneth Clark in 1969 was a landmark in the history of British television's coverage of the visual arts. Though it should be made clear at the outset that the scope of the series was wider than painting, sculpture and architecture: it also included material on writers, musicians, poets, religious thinkers, philosophers, engineers and scientists. *Civilisation* was the first of the 'blockbuster' pundit series; it also set the precedent for tie-in books. The logistics involved in its making were themselves remarkable: research, filming and editing took three years (1966-69); the film crew of twelve travelled 80,000 miles, visited eleven countries and used 117 locations; £130,000 was spent; objects in 118 museums and eighteen libraries were filmed; 200,000 feet of film was shot - enough to make six feature-length movies. The directors of the series were Michael Gill and Peter Montagnon. Ann Turner was the main researcher and she also directed one programme.

Civilisation was filmed on 35mm in colour to ensure the highest image quality. Arthur 'Tubby' Englander and Ken MacMillan were the senior cameramen. Englander's contribution to the visual dimension of the series was described earlier. Besides including an account of the camerawork and lighting for the series, his book *Filming for Television* (1976) contains a location and filming schedule for *Civilisation* that reveals a gruelling itinerary.

It was David Attenborough, controller of BBC 2, who in October 1966 invited Clark, then aged 63, to present and write *Civilisation* for a fee of £10,400. BBC 2 became a full-colour service in 1967 and Attenborough's idea was to have 'a really prestigious series to show off colour' by filming 'all the loveliest things that human beings have made in Western Europe over the last 1,000 years'.[2] Kenneth Clark (1903-83), later Sir Kenneth Clark, later still Lord Clark, was a leading member of the British art establishment, a respected art historian, writer and patron of contemporary British art. He was also a skilled broadcaster; he used the modern means of communication to popularise art. He was, as one obituary put it, 'the peer who took art to the people'.

In his autobiography Clark claimed that he was always apolitical. He made important contributions in terms of public service and was progressive in some of his ideas but his comfortable position within the British élite indicated that, on the whole, he was content with social arrangements as they were. The arts gave him the most enduring pleasure and they were, for him, the redeeming feature of humanity. Clark never lost his faith in the civilisation which had generated the masterpieces he so admired though, like many others in the mid-1940s, he was shaken by the revelations of the horrors of the Nazi extermination camps and by the advent of atomic bombs. Both the latter, unfortunately, were equally the products of that same 'civilisation'. It is this contradiction which, if confronted honestly, proves such a challenge to European intellectuals.

As explained earlier, Clark was no stranger to television. His experience of making so many programmes for ATV in the late 1950s had enabled him to feel at ease in front of the camera and given him time to develop his threefold recipe for 'good' arts television.[3] *Civilisation's* theme was Western European culture from the fall of the Roman Empire to the age of industry. Because its timespan was so long and its subject matter so vast, only a limited number of buildings and works of art from any one period could be featured and, of necessity, they had to be summarily treated. In fact, the series was not about works of art directly: their function was to illustrate the various phases of European civilisation. In one interview Clark defined *Civilisation* as 'the history of ideas as illustrated by art and music'.

Amongst the architectural edifices filmed were Chartres, Cluny Abbey, St Peter's and St Paul's, and amongst the famous individuals discussed were Brunelleschi, Beethoven, Delacroix, Bernini, Dante, David, Dürer, Giotto, Goethe, Géricault, Holbein, Handel, Leonardo, Michelangelo, Massacio, Raphael, Jefferson, Luther, Mozart, Brunel, Rembrandt, Rodin, Vermeer, Van Gogh, Watteau, Wordsworth, Wren, Constable, Turner, Voltaire and Napoleon. Marx was hardly mentioned though reference was made to one of Engels' books. Clark's pantheon of great thinkers did not include Freud, the author of a famous text on the very subject of the series - *Civilisation and its Discontents*, (1930) - which one might have expected him to have considered. Nor did Clark mention Clive Bell, Oswald Spengler or Arnold Toynbee, all of whom have discussed the concept of civilisation.

Artists and artifacts needed to be situated in their historical and social contexts but this was hardly possible to the extent demanded by professional historians but, of course, the series was not designed for them but for laypeople.

As already explained, pundit series are the television equivalent of an art historian delivering a course of lectures illustrated with slides. Some of Clark's critics saw this as a limitation because they considered the lecture form a stuffy means of imparting information. Clark's commentary generally consisted of a little history, a little biography/psychology of the artist, a little discussion of patronage, techniques and style, a little

iconography plus a dose of praise or celebration. In short, the commentary was a sophisticated kind of art appreciation. As in most art programmes, solemn classical music was employed on the soundtrack to reinforce the impression of grandeur.

To overcome the problem of an hour's continuous verbal commentary, the directors varied their approach as much as possible. In the final programme, for example, there was contemporary film footage with just music, then Clark on location talking to camera, then still images or archive film with voice-over commentary, and so on. In this way a certain pattern and rhythm was achieved, even though by contemporary standards the pace of the programmes was stately. For most of the time the film cameras recorded artworks in a straightforward, 'naturalistic' manner, but now and then more elaborate techniques were used in order to to heighten the impact of a fine art image. In programme five, for example, Leonardo's apocalyptic drawings of the deluge were shown with a revolving camera movement so that its literal movement echoed the depicted swirl of the waters in the drawing; the soundtrack reinforced the effect by featuring the sounds of wind and rushing water. This sequence demonstrated the power of an audio-visual medium such as television to animate the still, fine art image.

A compelling aspect of the series was its narrative flow: the seemingly effortless transition from place to object, object to person, person to idea, idea to event, event to place. Clark provided an overview, a logical and coherent account of material and epochs which more cautious scholars would never dream of attempting. Only when he reached the present did Clark's certainty desert him. Like E. H. Gombrich, another traditionalist, Clark found it difficult to come to terms with modernism and contemporary culture (he liked the work of Victor Pasmore but not that of Picasso). At one point Clark referred to 'the chaos of modern art' and on another occasion he admitted: 'I am completely baffled by what is taking place today'. Programme thirteen encompassed the industrial revolution, slavery, Victorian values, the great engineers, the post-impressionists and Einstein. Instead of referring to this period as 'the industrial age' or 'capitalism' he used the expression 'heroic materialism'.

Clark had a distaste for abstract thought and so he shied away from a theoretical discussion of the central concept of the series. (Even so, there were particular concepts and theories of art and culture underpinning his discourse.) It suited him, therefore, that television - predominantly a fast-moving medium of entertainment - was also resistant to theoretical debates. Before the advent of the home video-recorder, the relentless flow of television's sounds and images meant that the viewer seldom had time for reflection.

The title of the series implied there was only one civilisation and that turned out to be the Christian civilisation of Western Europe. So, the religion and art of a particular continent and two classes (the aristocracy and the bourgeoisie) were presented as universal while those of the rest of

the world were either ignored or dismissed. The only non-European country featured was the young United States of America. Within Europe Spain was virtually ignored (one Goya and one Velasquez were cited); this meant that the contribution of the civilisation and religion of Islam to the mainland of Europe was not credited.

Clark's Eurocentrism bordered on racism: he rejected 'the Negro imagination'. In his book masks made by African tribes were acknowledged to be impressive works of art but, unlike Greek and Roman sculptures, they could not be regarded as manifestations of civilisation because they signified darkness and superstition rather than rationality.[4] No evidence was marshalled to support this highly contentious value judgement apart from the stylistic contrast between the two kinds of artifacts.

As Clark's opening remarks to the series made clear, what concerned him were the achievements of 'Western Man'. Women, according to the contents of the programmes made almost no contribution to European culture or thought. Virtually the only women mentioned were Saint Teresa of Avila and Elizabeth Fry, the Quaker and prison reformer.

Civilisation's aim, Clark subsequently explained, was to entertain viewers rather than to educate them. On reflection, however, he considered these two aims need not be incompatible because one learns 'through delight'. The series may have set out to entertain but it was certainly not, for that reason, innocent of ideological ballast. The ideological agenda of the series can be discerned from certain remarks which occur towards the end of his book: 'I have tried to define civilisation in terms of creative power and the enlargement of human faculties ... Above all I believe in the God-given genius of certain individuals, and I value a society that makes their existence possible'.

Clark's purpose, then, was to affirm a society which encouraged the emergence of exceptional individuals. His method of history-writing was opposed, therefore, to Marxist and social history of art approaches. As he himself said afterwards:

> My approach to history was unconsciously different from that
> now in favour in universities, which sees all historical change as
> the result of economic and communal processes. I believe in the
> importance of individuals, and am a natural hero worshipper. Each
> programme had its hero... The majority of people share my taste
> for heroes...[5]

At one point he described a painting by Seurat as 'the creation of an artist independent of social pressures'.[6] There was a contradiction here because Clark's own account was not simply a sequence of biographies of individuals, there was information too about economic and technological matters and social structures. He remarked: 'although one may use works of art to illustrate the history of civilisation, one must not pretend that social conditions produce works of art or inevitably influence their form'.

Apparently then, it is legitimate to treat works of art as symptoms or exemplifications of a civilisation but not to 'read' them for evidence about the social circumstances in which they were produced. The problem of how art relates to society remained, in Clark's series and text, unresolved.

In the foreword to his book *Civilisation* Clark explained it was the word itself which prompted him to undertake the task. He wrote: 'I had no clear idea what it meant, but I thought it was preferable to barbarism', and added, 'and fancied that this was the moment to say so'. He did not enlarge on what he meant by 'the moment', but it was, in fact, the mid-1960s: the war in Vietnam was raging; in the United States there were peace and civil rights movements; Britain was the centre for a thriving popular culture, while in the visual arts the vogue for pop and op art was being replaced by new generation sculpture and American minimalism. While *Civilisation* was being made, the student unrest in France and in British art schools took place and the women's liberation movement was re-activated.

As director of the National Gallery during the Second World War and head of the Arts Council during the post-war era of welfare-state capitalism, Clark had demonstrated his support for public institutions dedicated to making high culture available to the British people. (Since Victorian times it had been assumed that a knowledge and appreciation of the arts would have a civilising effect on the philistine business class and the ignorant labouring class.) But during the 1950s he also assisted in the founding of a commercial TV channel and later, at a time when many intellectuals despised the medium and refused to purchase a 'goggle box', he was willing to appear on it to talk about art. It is clear from his roles in both public and private sector institutions that Clark was a pragmatist and also that he was willing, when others were not, to exploit the new mass medium of television in order to further his civilising mission.

According to Clark, one of the signs of a civilisation as against a mere culture, was 'a sense of permanence'.[7] In retrospect it seems clear that Clark felt out of tune with the ethos of the 1960s with its pop and underground subcultures, its rapid political and social changes, its consumerism and positive attitude towards expendability. The radical ideas of the artists and intellectuals who made up the Independent Group (they held meetings at the ICA during the early 1950s), which came close to fulfilment in the 1960s, were particularly threatening to Clark's position because these proposed 'a long front of culture' in which the hierarchical, high/low distinction was abolished.

Evidently, Clark thought of the TV series as a bulwark against the ever-present threat of barbarism. His message was fundamentally positive and optimistic. This probably explains the series' great emotional appeal to so many viewers. However, Clark did not ignore the issue of barbarism altogether. In the final programme, for instance, he made a point of discussing slavery, poverty, war and alienation but he did it in such a way as to end with a silver lining. By citing Wilberforce and the anti-slavery movement, he was able to overlay the negative with the positive. In this

way, the 'civilisation' which profited so much from slavery was redeemed by its willingness to abandon it.

What Clark seemed unable to contemplate was the idea that there could be a symbiotic relationship between culture and oppression. This idea is found in Walter Benjamin's observation that there is no document of civilisation which is not simultaneously a document of barbarism. For instance, the civilisation of Ancient Greece was made possible, amongst other reasons, because Greece was a slave society. In some works of European art the two aspects are present simultaneously: Goya's *Disasters of War* series of etchings (1810-14) are examples of the highest artistic quality and skill, but they are also images of atrocities which unflinchingly and bitterly indict the inhumanity of humanity.

In spite of all the evidence of European barbarism, Clark was anxious to present its civilisation in a positive light. This was because he believed civilisations could decline not only as a result of external invasions, but also through a lack of faith in themselves. Self-doubt, one might say, was for Clark 'the enemy within'. There seemed to be an implied warning against the much more pessimistic critique of contemporary civilisation undertaken in the 1960s by the Frankfurt School philosopher and intellectual guru of the counter culture, Herbert Marcuse.[8]

Civilisation excited a remarkable public response both at home and abroad: it received many awards and the BBC, in the years that followed, sold it to over 60 countries. In Britain, an estimated two-and-a-half million viewed it in 1,363,000 homes. The tie-in book of the series became a bestseller - it sold a million copies in the United States alone. For a while Clark received forty to fifty letters a day from people who ranged from 'simple' folk to cabinet ministers. Nine people said they had been on the point of committing suicide and that the series had dissuaded them!

In the United States *Civilisation* had an especially rapturous reception. (Xerox, the American sponsor, paid the BBC $450,000 for a single film compiled from the series.) Clark became an overnight celebrity and when he visited America he had to contend with the kind of mass hysteria normally reserved for movie and pop stars. So crowded and emotional was the ceremony in honour of Clark and the series held at the National Gallery of Art in Washington in November 1970, that Clark had to flee to the gents toilet in order to weep.

Back in Britain conservatives greeted *Civilisation* with sighs of relief. John Sparrow, the Warden of All Souls, was inspired to write a major polemical article for *The Listener* on the theme of contemporary civilisation.[9] A year earlier the student-led events of Paris and the student occupations of the London School of Economics and Hornsey College of Art had taken place. It was also the period of hippies, the drug culture and the 'alternative society'. Sparrow disliked these developments; he had no hesitation in labelling student unrest and revolt as the enemy of civilisation. A leading article in *The Times* (May 17, 1969) also referred to the rebellion of youth. *Civilisation*, it argued, was perhaps the answer to the young rebels who wanted to reject the past.

It would appear that Clark's series served to confirm the establishment's faith in its own values after the shocks of 1968. And since *Civilisation* was also 'popular television', it was a response in kind to the mass culture of the 1960s too. Colin McArthur has argued that television programmes are popular to the extent they reinforce the ideological position of the majority of the audience.[10] If this contention is correct, then the success of *Civilisation* must have been due to its profound affirmation of a social democratic, middle-class worldview. Clark himself half-suggested this when he wrote: 'I used to think the success of *Civilisation* in the USA and Canada was due to the re-assurance it gave to bourgeois values. But this does not account for its equally great success in Poland and Romania.'[11]

In Britain the response of left-wingers was naturally much cooler: Raymond Williams was contributing a TV review column to *The Listener* at the time. He noted the 'old dinner-table style', the 'Europocentrism', the slow turning of 'decorated pages'. *Civilisation,* in his view, was intense propaganda for a noble past, a means of rejecting the world of today. He characterised it as: 'a long last gathering-up, by sad and polished minds, of an Edwardian world-view; an enacting of pieties learned very young and very hard, and now with all the emphasis of a public corporation'.[12]

Within the British artworld, responses tended to vary from the negative to the positive according to whether the writer's/magazine's commitment was to modernism or to tradition. Tim Hilton, reviewing Clark's book, in the pages of *Studio International,* unkindly dismissed him as old and out of date: 'as far as taste is concerned, it belongs to 1910 ... for all its wide knowledge, its glossy readability, its genial manner ... there is yet an old fashionedness that makes it curiously irrelevant to a modern audience'. Hilton's final insult was his admission that he had chosen the book as a Christmas present for his eighty-year-old granny.[13]

The Connoisseur's anonymous reviewer, on the other hand, was fulsome in his/her praise:

> The author proved to be an incomparable guide. It is impossible to praise too highly the breadth of learning lightly worn, catholicity of taste, acute perception, sympathy and compassion that the talks revealed; while the pleasure they afforded to a vast audience was greatly enhanced by the effortless ease of the delivery.[14]

Years later, criticisms of *Civilisation* were made on more theoretical or methodological grounds - 'the presenter as hero' and positivism - criticisms that are, in fact, applicable to other pundit series. Critics have argued that not only did Clark celebrate heroes, he became a hero himself: 'the presenter as hero'.[15] History was filtered not just through the medium of television, but also through the person of an urbane, omniscient man who had the power to dominate all the content. Presentation is not - as the word implies - simply a neutral, objective activity; it is selection, emphasis, interpretation.

As Roy Armes has pointed out, what the device of the presenter involves is a direct mode of address to the audience.[16] The device is typical of the news or documentary programme in which an eye-witness reporter gives a first-hand account from the scene of an event. *Civilisation*, of course, was not live television, but the presenter speaking direct to camera fostered the illusion of an immediate, intimate encounter. Clark appeared to be talking to the viewer on a one-to-one basis but, unlike a real conversation or lecture situation, the viewer could not interrupt or ask questions afterwards. One consequence of the single presenter device was that it obscured the extent to which the production was a team effort. The subtitle 'a personal view' reinforced this impression and served as an institutional disclaimer as far as the BBC were concerned even though the series had all the resources and authority of the corporation behind it.

Regarding the charge of positivism, John Wyver has observed:

> For Clark and (most of) his followers, the acquisition of knowledge
> is dependent upon the direct *experience* of a place or a canvas or a
> fresco. Hence the familiar filmic device of showing the narrator
> in the Pazzi Chapel, or the Louvre, or Chartres. Such involvement, it
> is implied, gives him, and by extension you the viewer direct
> access to a 'truth' about the Renaissance. And so the words of
> the narrator, or lecturer, and his overall thesis, are validated in
> the most convincing manner possible ... Knowledge in this
> system, then, is not problematic. There is little room for
> complexity and contradiction, and knowledge is certainly not
> seen as a *construction*.[17]

This charge seems to be justified since at the beginning of the series Clark claimed that although he couldn't define the concept of civilisation in abstract terms, he could recognise it when he saw it, that is, when he saw cathedrals like Notre Dame in Paris. One reviewer referred to Clark's reliance on 'the sovereignty of the eye'. This ability was that of a connoisseur like Bernard Berenson and Clark acknowledged, in an interview given in 1969, that *Civilisation* was indebted to the approach to art favoured by the noted scholar of the Italian Renaissance.[18]

In spite of all the shortcomings *Civilisation's* critics have identified, its scale and ambition remains impressive. Like the monuments it celebrated, the series itself is now a historic monument of 1960s television culture.

References

1. R. Williams, *Marxism and Literature,* Oxford, OUP, 1977, p. 15.

2. R. Twist, 'Considering all the risks', *The Observer*, April 16, 1989, p. 41.

3. Biographical details about Clark derive from two sources: 1) his autobiography *The Other Half: a Self-Portrait,* London, J. Murray, 1977; and 2), M. Secrest's biography, *Kenneth Clark,* London, Weidenfeld & Nicolson, 1984.

4. K. Clark, *Civilisation: a Personal View,* London, BBC/J. Murray, 1969.

5. Clark, *The Other Half,* p. 226.

6. Clark, *Civilisation,* p. 341.

7. Clark, *Civilisation,* p. 14.

8. See H. Marcuse, *One Dimensional Man,* London, Routledge, 1964/Sphere Books, 1968, p. 200; *Eros and Civilisation,* Boston, Beacon Press, 1955/London, Sphere Books, 1969, p. 23.

9. J. Sparrow, 'Civilisation', *The Listener,* 81 (2093), May 8, 1969, pp. 629-31.

10. C. McArthur, *Television and History,* London, BFI, 1978, p. 40.

12. R. Williams, 'Television: personal relief time', *The Listener,* 81 (2086), March 20, 1969, p. 399; 'Television: a noble past', *The Listener,* 81 (2090), April 17, 1969, p. 543.

13. T. Hilton, 'Civilisation' (Book review), *Studio International,* 179 (920), March 1970, pp. 125-6.

14. R. E., 'Civilisation' (Book review), *The Connoisseur,* 175 (703), September 1970, pp. 62-3.

15. M. McLoone, 'Presenters, artists and heroes', *Circa,* (31) November/December, 1986, pp. 10-4.

16. R. Armes, *On Video,* London, Routledge, 1988.

17. J. Wyver, 'From the Parthenon', *Art Monthly,* (75), April, 1984, pp. 22-5.

18 'Sir Kenneth Clark talks to Joan Bakewell about the *Civilisation* series', *The Listener,* 81 (2090), April 17, 1969, pp. 532-3.

British Arts
Television in the 1970s

Decade-type histories of art give the impression that the moment a new decade arrives a brand new spirit or style of the age comes into being. This is rarely the case. For instance, it can be argued that the economic boom and the hedonistic, optimistic mood of the 1960s continued well into the 1970s, until in fact 1973 when an Arab-Israeli war resulted in an oil embargo which in turn caused an economic recession in the West. In 1970 a Conservative government under Edward Heath was elected and three years later he led Britain into the European Economic Community. By 1974, however, the Conservatives had been replaced by a Labour government (with a tiny majority) under Harold Wilson. Rising inflation and unemployment, civil strife in Northern Ireland, a sense of 'no future', led to a harsher social atmosphere exemplified by the angry, rebellious, anarchistic Punk movement of the mid-1970s. For a short while there was a swing to the Left amongst artists and intellectuals but, by the end of the decade, the forces of the Right had recovered the initiative and the era of monetarism and Thatcherism began with the election, in 1979, of a more extreme Tory government headed by Mrs Margaret Thatcher.

In retrospect some art critics found it difficult to characterise the art of the 1970s. Either they said there was none to speak of, or they said it was too diverse to sum up. Certainly, there was not a single, dominant style nor a logical sequence of movements. The death of Picasso in 1973 symbolised the fact that the era of modernism and the avant garde had come to an end; it was then that the concept of pluralism made its appearance. However, much new British art of the 1970s did have a distinctive character due to Left-wing politicisation. It was during this decade that artists attempted to implement a range of radical ideas conceived in the 1960s. There were developments in conceptual art, feminist art, ecological art, artists' placement, community murals, critical photo-montage and photo-text works, performance and video art, indeed all forms of art with a sense of social purpose. One of the reasons these kinds of art did not appeal to the existing artworld was the fact that they

challenged and sought alternatives to the gallery system based on the sale of art objects/commodities to the wealthy. As we shall see shortly, John Berger's critique of Western European art in *Ways of Seeing* was influential in the politicisation of many artists and art students. However, it has to be said that for the most part arts television ignored the political art produced during the second half of the 1970s.

Unlike the preceding and following decades, the 1970s did not witness the founding of a new terrestrial channel. Nevertheless, there were a number of new technological developments and programming initiatives: lightweight, hand-held video cameras became available that facilitated electronic news gathering and independent/community television; in 1970 all three channels provided colour and by 1973 six million colour television sets were in use; by 1977 the 625-line UHF system was available to virtually all the population; computers began to play a role in the electronic editing of videotape; the first cable television stations were established; and towards the end of the decade, the video-recorder for home use began to alter the British public's viewing habits. An indication that the feminist movement of the 1970s was having an impact on the male establishment of the BBC was the fact that in 1975 a woman - Angela Rippon - was permitted to read the News for the first time.

Three important, open-ended, arts series were established during the 1970s: *Aquarius* (LWT, 1970-77), *Arena* (BBC 2, 1974-), and *The South Bank Show* (LWT, 1978-). Alec Clifton-Taylor presented the first of his popular townscape series *Six English Towns* (BBC 2, 1978) and the newly-founded Open University produced its first educational programmes about design and architecture. Also, during the 1970s, BBC 2 commissioned two of the decade's most significant pundit series: *Ways of Seeing* (1972) and *Shock of the New* (1980). Both deserve to be examined in some detail.

fig **15** | John Berger in *Ways of Seeing*, 1972.

PHOTO SIMON BRADFORD, REPRODUCED COURTESY OF BBC TELEVISION.

| chp.**10** | *Ways of Seeing* (1972) |

Ways of Seeing, one of the most influential and controversial arts series ever made, consisted of four, thirty-minute films that were transmitted on BBC 2 in January 1972. John Berger wrote the scripts and presented, Michael Dibb produced and directed, David Gladwell was the editor and Peter Middleton the cameraman. Coming three years after the first, major, pundit series *Civilisation,* Berger's series was bound to be seen in relation to it. According to Dibb, the series was not designed specifically as a riposte to Clark but it came to be perceived as such. Berger's neo-Marxist approach to art was certainly in sharp contrast to Clark's connoisseurial celebration. Compared to *Civilisation, Ways of Seeing* was modestly funded: its total budget was less than the cost of one episode of the 1969 series.

John Berger (b. 1926) is a British novelist, poet, critic and scriptwriter, now resident in France, who has a particular interest in the visual arts and photography. In the late 1940s he trained as a painter at Chelsea School of Art and then, during the 1950s, he wrote art criticism for *The New Statesman.* He became notorious in the mid- 1950s for supporting the 'kitchen sink school' of painters and calling for a new type of social realism in art. Berger's TV experience began with items for *Monitor* about Bellini and Frisco Ten Holt (a Dutch, semi-abstract painter). Then, in 1965, he presented two films directed by Michael Gill about the French painter Fernand Léger and the French 'outsider' artist and postman Ferdinand Cheval. The study of Cheval indicated Berger's willingness to look beyond the canon of great artists. A later film - 'An artist in Moscow' (BBC 1, 1969) - about the contemporary Soviet sculptor Ernst Neizvestny, also signified his willingness to look beyond the confines of Western Europe and to examine the work of an artist unknown in Britain. As Berger himself put it, in a book about Neizvestny, 'criticism is always a form of intervention'.

Berger is a socialist by conviction. Although never a member of the British Communist Party, he was associated with it in the 1950s. He is best described as an independent, neo-Marxist intellectual.[1] There are many Marxist texts on the subjects of art and culture but since Marxism was primarily a critique of political economy, its founding fathers - Marx and Engels - paid little heed to the subject. Art and culture have proved difficult for Marxists to account for, nevertheless writers such as Lenin, George Plekhanov, Georg Lukács, Walter Benjamin, Theodore Adorno,

Herbert Marcuse, Francis Klingender, Frederick Antal, Max Raphael, Arnold Hauser, Ernst Fischer, Adolfo Vázquez, Raymond Williams and others have provided many useful insights. Antal, a Hungarian art historian who emigrated to Britain in 1933, had a particular influence on Berger; for a time Berger was his unofficial pupil. It was Antal's *Florentine Painting and its Social Background* (1948) which showed Berger what a social history of art might look like.

However, the immediate intellectual stimulus for *Ways of Seeing* was Benjamin's 1936 essay 'The work of art the age of mechanical reproduction'. (An English translation had appeared in 1970.) Benjamin's essay was crucial not only because it directly inspired the content of the first programme but also because the issue of reproduction's impact upon the traditional fine arts and upon our perception of art, applied to the series as a whole and indeed to all arts broadcasting. If Benjamin was correct when he suggested that the invention of photography had changed the very nature of art, then it would no longer be possible to treat the media of film and television as transparent windows on the world of art. The revolution in knowledge was equivalent to that of the theory of relativity in which no explanation of the external world can be valid which does not take account of the presence of the observer and the language in which observations are communicated.

Programme 1: the perception of works of art in the age of mechanical reproduction

Viewers of the first programme quickly realised that the series had been planned and produced with an exceptional degree of care and self-consciousness because film as a form/medium was used in such a way as to exemplify pictorially the arguments being forwarded verbally. For example, at one point Berger reminded the viewer that he was located within a studio; immediately the film cut from a close up to a long shot in order to reveal the lights, camera crew and studio set up. Berger often informed viewers when a cut was about to take place or when music was to be added. Via an archive film quote taken from Dziga Vertov's *Man with a Movie Camera,* he also showed the film editing process. In a pre-title sequence he cut a square patch from Botticelli's *Venus and Mars* - actually a reproduction of the masterpiece - hanging in the National Gallery, London - actually a studio set. This detail - a portrait of a young woman - was then shown being printed as a postcard in vast quantities. Berger thereby dramatised the extraction of details via photography and film, a process of decontextualisation which alters the meanings of the details. The way the significance and meaning of images can be altered by montage was then demonstrated by adding an emotive caption to a Van Gogh, by switching channels, and by adding different types of music to film sequences of a Caravaggio that had been cut in such a way as to match the music.

Berger also called attention to the character and limitations of the medium of television, that is, the different home contexts in which the programmes were being received and the one-way nature of the communication. Finally, he stressed the ideological character of all communications and warned viewers to be sceptical of his own arrangements of words and pictures. Systematically then, the first programme set out to demystify the mechanics of film and television. Berger did not do this for aesthetic or formalist reasons but to lend authority to his critique of orthodox art history and to legitimise his alternative strategy revealed at the end of the first programme.

To summarise Berger's arguments after Benjamin:

1. how we see paintings depends upon habits and conventions;
2. how we see the paintings of the past is different from the way contemporaries saw them;
3. perceptions of paintings have been irrevocably altered by the invention of photography;
4. the 'aura' of traditional works of art has been damaged by the reproduction and mass replication of images;
5. art works as images have become a form of transmittable information and their meanings and uses have drastically changed as a result;
6. two possibilities arise: exploitation of past art for commercial and/or reactionary ends, or appropriation of past art for radical, progressive ends.

In order to communicate Benjamin's difficult concept of the aura of a work of art, shots of religious murals as part of the fabric of a church building were shown and also shots of a church service in which worshippers paid homage to God via an icon. Film of a Leonardo drawing displayed behind bullet-proof glass in a dimly lit room of the National Gallery served to illustrate the replacement of cult value with exhibition value.

Towards the end of the programme Berger criticised conventional, bourgeois art history on the grounds that it was obsessed with issues of authenticity and provenance because this kind of knowledge was useful to owners of works of art. Citing a recently published monograph about Frans Hals, he also accused art history of formalism: bourgeois scholars employed a mystificatory jargon when analysing Dutch portraits and they ignored the human and social content of such works. He then showed a reproduction of a religious painting by Caravaggio to a group of children in order to prove how acute perception could be unencumbered by art-historical scholarship. Arguably, Berger's 'innocent eye' thesis was a dubious one because even the children's recognition of the Christian theme of the Caravaggio required familiarity with a specific body of cultural knowledge. Both these examples implied that the historical gap

separating modern viewers from an old master could be overcome by reading the body language and gestures of depicted figures, because these codes remained the same for centuries.

Berger concluded the first programme by explaining his intention, in the rest of the series, to use images of past works of art in ways never intended by their makers, that is, as 'words' in a language, and to use those 'words' to construct new statements. Old works of art have a double existence: they are historical artifacts and contemporary ones. The both belong and don't belong to the present time. In the first programme a conflict emerged between a historical understanding of past works (describing what they meant at the time they were made - the task art historians normally perform), and their contemporary significance - what they mean to us now, and the political uses they can serve when reproduced. *Ways of Seeing* never quite resolved the tension between past and present, history and politics.

For the most part, Berger was a persuasive orator. Standing, informally dressed, in a plain studio, he spoke to the camera/viewers with directness, conviction and a sense of urgency (in the paperback this emphatic quality was represented by means of bold print). What Berger wanted to achieve was a critique of rhetoric but, paradoxically, his act of persuasion necessitated the use of it (which only goes to show that no one can step outside rhetoric).

Programme 2: Images of women and patriarchy

The second programme concerned images of women in the double sense of pictures (photographs, paintings, mirror reflections) and mental conceptions that both men and women have of the female sex. In particular the programme examined how representations of women in art and in mass culture embody and reinforce patriarchy. Before the title sequence there was a prologue consisting of a series of short film clips showing women in various social guises and roles. Economically, this prologue established the themes and contradictions which were to form the subject matter of the programme: women were on display all their lives; they existed as sights for men; the issue of beauty and the contrast between women at work and at leisure.

Turning Clark's distinction between the naked and the nude on its head, Berger explained how the concept of the nude in Western European art masked the real, concrete nature of women as individual human beings and transformed them into ideal-types and sexual stereotypes which, via pin-ups, satisfied the lascivious gazes of male voyeurs. He criticised the hypocrisy and double-think of men in excusing their desire to see undressed female bodies by representing women as vain and narcissistic: women were shown preening themselves before mirrors while being observed by men. Male domination of women was traced back to the Biblical story of Adam and Eve and it was also illustrated by means of Lely's erotic painting of Charles II's mistress: the King possessed her body and, through Lely's skill, he also owned her appearance.

Juxtapositions of Rubens' painting of the judgement of Paris and modern beauty contests, oil paintings of female nudes and contemporary girlie magazine photographs, served to demonstrate the fact that ancient male attitudes persist into the present and that there was a continuity in the representations of females made for, and addressed to, male spectators. Some years later, Berger was to be criticised for making these equations between old paintings and modern photographs even though he was not trying to deny the material differences between the two. What he intended to show, and succeeded in showing, was that the erotic character and function of these images were very similar and that both were sexist and repressive. However, what Berger did not examine were the implications of this inheritance for living female and male artists.

One aim of *Ways of Seeing* was to consider the tradition of Western European painting as a whole, that is, typical, average works and not just masterpieces. Later, Berger admitted that in his eyes the chief weakness of the series was its failure to explain the existence of exceptions to the tradition. In fact, in programme two a few pictures were exempted from Berger's accusations of sexism, one of which was Rubens' full length portrait of his young second wife. If the male artist loves the women in question then, Berger reasoned, he will paint her with affection, and as a particular individual, not as an ideal-type or sex object. Arguably, Berger could also have cited at this point images of women by artists who were class conscious, artists such as Van Gogh and Camille Pissarro who were sympathetic to the condition of women in society (particularly poor, peasant women), and who were thus able to produce compassionate pictures of them.

A recurrent theme of the second programme was the passivity of women as depicted by male European artists (summed up by the aphorism 'Men act and women appear'). In order to show that not all cultures have depicted women as passive creatures, Berger utilised some oriental erotic images showing women participating in the sexual act with a relish equal to that of their male partners. Experts on erotic art have argued that comparable images exist in the tradition of Western European art, but that these images are not well known because they have been censored or hidden away. Berger's use of an Indian temple carving of a female figure was altogether too glib; it was not placed within a social and historical context. And since such images were the mythical counterparts of the sacred prostitutes whose task was to service male worshippers, they could hardly be cited as contributing to the cause of women's emancipation.

Given the aim of programme two - characterised by Clive James in a letter to *The Listener* as an attempt 'to redeem the Western artistic tradition for Women's Liberation' - Berger felt obliged to allocate some space and time on his programme to living women; especially since all the makers of the series were men. This was achieved by means of an informal studio discussion with five women of different ages and with various attitudes towards feminism. The flow of the argument was thus halted so that

women could comment on what had already been shown. In other words, the second part of the programme existed in a meta-linguistic relation to the first part. It emerged during the course of the discussion that the women generally agreed with Berger's analysis. While the debate continued, a pretty participant seemed to attract the cameraman's attention more than the plainer women. It should also be noted that the remarks made by the women were excluded from *The Listener's* follow up article and from the *Ways of Seeing* paperback.

Programme 3: pictures, possessions, property, power

In programme three Berger presented a neo-Marxist analysis of the history of European oil painting from 1500 and 1900, but without employing the technical vocabulary of Marxism. Emphasis was placed on the medium of oil painting as a new technology which made possible the recording of appearances with an unprecedented degree of realism. This enabled the two ruling classes of the period - the aristocracy and the bourgeoisie - to make visible their particular worldviews. Those who owned goods, slaves and land were able, via the agency of oil painting, to gain possession of the appearances of their various properties in the form of still life, portraits and landscapes. Their conception of reality and their lifestyle were reflected back to them as in a mirror, and their rights of ownership were thereby naturalised and legitimised.

Berger's intention was not to deny the insights provided by conventional art history in respect of the oil painting tradition, but to expose a normally ignored dimension. By considering the development as a whole, he was able to show the links between the growth of capitalism, its class structure, ideologies and inequalities, and the form and content of individual paintings, plus the function of portable easel paintings in general. Berger's social critique of European art was valuable and illuminating but, regrettably, it was not brought up to date, except via the promise that advertising was going to be considered in the final programme. This subject was chosen because Berger regarded the medium of colour photography as the logical extension of oil painting. He also considered modern advertising images, with their celebrations of commodities, as contemporary versions of the still life pictures of the past.

At one point Berger claimed the poor could not be featured in his film because they were excluded from the oil painting tradition. This was surely incorrect: throughout the period in question some paintings of poor peasants and beggars were made and later, during the nineteenth century, paintings of urban workers and the lumpen proletariat of the cities appeared. What is true, of course, is that such people were hardly ever represented from their own class standpoint, or from a revolutionary perspective. In the subsequent paperback, the omission was remedied, to some extent, by the telling pairing of a Victorian photograph of a miserable orphan girl and a reproduction of a Murillo oil showing a 'poor but happy' urchin.

In order to demonstrate the connection between the art of oil painting and the depiction of material goods in the short time available to him, Berger was compelled to 'read' certain historical works - for example Holbein's *The Ambassadors* and Vermeer's *Lady Weighing Gold* - in a highly selective manner. His 'readings' were not invalid but they did not do justice to the full complexity of the works in question, particularly in regard to their use of 'disguised' symbolism.

One of the key examples cited by Berger was Gainsborough's portrait of Mr and Mrs Andrews in a landscape setting (National Gallery, London). He read a quote from Clark about the picture which evaluated it in terms of artistic skill and aesthetic qualities. Berger did not deny the validity of Clark's remarks, but claimed they were inadequate because they said nothing about the social function of this image as a statement of land ownership. To drive the point home the film-makers inserted a notice - 'Trespassers Keep Out' - on the tree behind the couple. This political interpretation of a Gainsborough disturbed orthodox art historians and provoked a 'corrective' letter from Lawrence Gowing. Because some time elapsed before the paperback was published, Berger was able to incorporate a reply to Gowing in its text. As in programme two, Berger cited instances of pictures which seem to transcend the limitations of the tradition as a whole and which, therefore, constitute a kind of 'counter-tradition'.

Inevitably, some general theoretical questions were left hanging by programme three. For example, what is the precise relationship between ideology and representation? Is there always an exact correlation between the way of seeing of the patron class and the way of seeing/representing of the artists who normally come from a different class? Furthermore, is there not a danger in this kind of analysis of reducing art to ideology? In this respect, the exceptions to the tradition serve as a kind of escape clause because they show that not all art was simply a pictorial embodiment of ruling class ideology. But what remains undeveloped is how these exceptions come about. Arguably, the split between the few and the many - masterpieces/the rest - is too simplistic; it needs to be rethought.

Programme 4: publicity, glamour and politics

The final programme was perhaps the most impressive of all since it was the most confidently made and the most seductive in terms of pictorial rhetoric: the burden of the argument seemed to be carried more by the images than by the voice-over commentary. Camera movement was extremely fluent and the image-chain almost hypnotic in its rhythm. Appropriately, the skill of the programme-makers rivalled that the photographers and film-makers who work for advertising agencies.

Berger's arguments were as follows:

1. publicity images saturate our environment;
2. there is a continuity between the oil painting tradition and

modern advertising: both celebrate possessions and property;

3. besides quoting works of art, publicity also appropriates the pictorial rhetoric developed by painters over the centuries;

4. publicity employs the means of the past to disseminate glamorous, dream images of an ideal lifestyle, visions of a better future, which it promises can be achieved by buying consumer goods;

5. publicity substitutes consumption for genuine democracy;

6. publicity is, therefore, a 'political phenomenon of great importance'.

Special attention was paid to the phenomenon of glamour. In a location sequence, female models posing for a fashion photographer in the grounds of an old country house were shown and compared to oil paintings of nymphs and goddesses disporting themselves in nature. Contemporary commerce and publicity, it was argued, exploited the heritage of aristocratic modes of life and drew upon the iconography of classical mythology. Yet, besides pointing to similarities, Berger also cited differences between the past and the present: glamour was a modern phenomenon based on social envy.

In analysing how advertising images work, Berger made a series of assumptions about audience responses. No market research evidence was cited in support of his ideas, so one can only conclude that he universalised his own reactions. People interpellated by advertising are not, however, simply passive consumers - they can resist, disagree and reject the blandishments of the advertisers. Lived experience is the strongest antidote to adverts as the film itself revealed when it contrasted the fantasy worlds of the billboards with their dreary, inner city sites.

Further contradictions between rich and poor, between the Third World and the developed countries, were revealed when colour supplement adverts for expensive goods were compared to the horrific documentary photos which so often accompany news stories of war and famine. Another telling sequence showed women workers in a factory engaged in repetitive, tedious labour in a noisy, ugly environment and then the glamorous females who populate perfume adverts. This contrast was especially ironic because the factory workers were engaged in manufacturing perfume.

At one point three common dreams promoted by publicity were explored:

1. male/female romance, sexual success;

2. the pleasure of the skin and textures;

3. travel or escape to another, more exotic or primitive world. In these sequences backed by music, the rostrum camera sensuously explored a series of still adverts. Almost in spite of itself, the film paid a backhanded compliment to the seductive power of modern

advertising imagery. Berger's argument that the benefits promised by adverts are always deferred, was somewhat undercut by the immediate, aesthetic pleasures adverts offer viewers in return for attending to their messages.

Adverts which extol the political concepts of freedom and revolution in order to sell commodities were then cited in order to show how publicity appropriates and recuperates even the language of radical and progressive forces. While panning across a large billboard depicting fake revolutionaries selling beer, the camera picked out a small, crude flyposter about the American radical, Angela Davis. This indicated the existence of an alternative, guerrilla rhetoric.

Reactions to *Ways of Seeing*

When it was first transmitted *Ways of Seeing* attracted a small audience but few viewers switched off or over once they had started watching, and the programmes were repeated soon afterwards in response to popular demand. The series had a long afterlife because of the several spin-offs associated with it: *The Listener* published articles based on the programmes and later on a paperback was issued by the BBC and Penguin Books (in the book other researchers are credited besides Berger). During the 1970s *Ways of Seeing* was widely shown in art colleges in the form of hired 16 mm films. With the advent of video-recorders, the series became available in video-cassette form and these were purchased by many educational institutions. The fact that the series appeared in so many different media exemplified one of Berger's contentions: the technical reproducibility of art works makes possible their dissemination in a variety of media and contexts.

The paperback is still in print and it appears on hundreds of reading lists (by 1988 the number of copies sold had reached 448,086.) To compensate for the lack of moving images, several pictorial 'essays' were inserted between chapters. These may well have owed their origin to Aby Warburg's project for an atlas of memory in the form of panels of cross-related reproductions.

Ways of Seeing was significant in several respects. It was the first arts series to present a materialist analysis of European art to a mass audience in an accessible form, the first to reflect the influence of the emerging women's movement of the late 1960s/early 1970s (via its contribution to the feminist 'images of women' debate), and the first to incorporate a decoding of advertising imagery. Its seminal importance is revealed by the fact that all these themes were subsequently developed in more depth by other authors and TV producers.

What was also remarkable about Berger's and Dibb's series was the amount of discussion it provoked. There were numerous letters in *The Listener,* many newspaper and magazine reviews, and later on a special issue of the journal *Art-Language* (1978) (containing a virulent attack on

Berger by a group of ultra-Left, conceptual artists), and a booklet in praise of it by then socialist art critic Peter Fuller (*Seeing Berger* [1980].). My own paperback *Art in the Age of Mass Media* (1983) was intended as a contribution to the debate initiated by Berger. By considering modern and contemporary art, it sought to repair the major omission of *Ways of Seeing.*

In 1988 the controversies aroused by *Ways of Seeing* were re-opened when Fuller recanted his earlier opinions and attacked the series for what he regarded as its negative influence on contemporary art and values. However, he did admit that these negative effects had not been intended or anticipated by Berger. Fuller's second re-evaluation of *Ways of Seeing* involved a new, positive re-evaluation of Clark's *Civilisation.*[2]

Fuller was right in at least one respect: *Ways of Seeing* was not merely influential in the realm of theory. It was also influential in the realm of artistic practice. Fine artists in Britain and North America were encouraged by Berger's analysis to undertake their own critiques of mass media images and to use them to make critical photo-montages, films, photo-text and slide-tape works, and posters. At the same time, Berger cannot be blamed for the political and moral content of the photo-murals and films of artists like Gilbert and George (bête noires of Fuller's), because once any knowledge produced by a theorist about the way images work enters the public domain, it can be utilised by artists of various political persuasions, and also by graphic designers working for the advertising industry.

References

1. For a study of Berger's work see Geoff Dyer's *Ways of Telling: the Work of John Berger*, London, Pluto Press, 1986.

2. A whole book would be needed to explore in detail the issues raised by Berger's work and by the late Peter Fuller's responses to it. Interested readers can consult: P. Fuller, 'The value of art', *New Society*, January 29, 1988, pp. 14-6. See also Berger's sarcastic response: 'The confession', *New Society*, February 12, 1988, pp. 18-9, and Mike Dibb's 'A letter to Fuller', *New Society*, April 22, 1988, pp. 13-4. See also: P. Fuller, 'Overweening treachery, and such like', *Art Monthly*, (116), May, 1988, pp. 10-2, and P. Fuller, *Seeing through Berger*, London, Claridge Press, 1988.

British Arts Television

in the 1970s continued

The infamous *Warhol* documentary

Andy Warhol (1928-87) was the archetypal pop artist of the 1960s but it was not until the early 1970s that his work and persona received detailed coverage on British TV via a fifty-minute documentary film entitled *Warhol* (ATV, 1973). The fuss this programme aroused tells us much about the degree to which the permissive values of the 1960s had changed British society.

TV arts documentaries do not normally excite public controversy and prompt legal proceedings: the Warhol film produced by the British photographer David Bailey, and directed by William Verity, was the exception. It had the dubious honour of being the first ITV programme whose screening was challenged in the courts of England. Bailey proposed a film about the American artist to the Midland company ATV in 1971 because they were in the habit of commissioning documentaries from freelances. Initially, the idea was resisted because it was thought Warhol 'was not sufficiently well known'(!) to merit a major programme.

Bailey was paid a producer's fee of £2,000. With a director, two cameramen and two sound engineers, he visited New York in January 1972 to interview Warhol (some of the interview took place in a bed) and to record, on 32,000 feet of colour film, the weird goings on in the artist's superstar Factory/studio. In the final programme, clips from several of Warhol's underground movies were also included. Verity claimed the aim of the film was to 'amuse and confuse' (the shooting and editing style set out to imitate the informal manner of Warhol's own films). Critics responded by describing the documentary as an 'arbitrary patchwork' and several dismissed it as 'boring'. The contents of *Warhol* included material likely to offend, that is, examples of foul language, nudity and transvestism; plus a female painter who used her naked breast as a paintbrush.

In the United Kingdom the body responsible for standards on commercial television at that time was the IBA (Independent Broadcasting

Authority). IBA executives viewed the rough cut and asked ATV to delete certain scenes. Finally, in December, approval for transmission in the 10.30 pm *Tuesday Documentary* slot was given. The programme was scheduled to be shown during January 1973 but because journalists who had seen an early version called it 'a permissive shocker', the conservative author and publisher Ross McWhirter (a member of the National Viewers' & Listeners' Association) obtained a court injunction stopping the transmission on the grounds that an offence against good taste and public decency was about to be committed; in other words, he sought to ban a film he had not even seen. When Warhol was told about the proposed ban, he remarked: 'How quaint'.

A legal wrangle followed but eventually, after a six-week, cooling-off period, the programme was shown on March 27, 1973. As a consequence of all the media attention, an estimated fourteen-and-a-half million people watched the programme. According to a survey, 9% of viewers found it 'interesting', 70% found it 'boring'; 80% thought there had been 'a fuss about nothing'; only a minority, it emerged, considered it 'offensive'. Ironically, what the censorship attempt had achieved was a great deal more publicity for Andy Warhol and his work than would otherwise have been the case.

Open-ended series of the 1970s
Aquarius

David Frost's London Weekend Television needed an arts programme to fulfil its promise to provide quality programming. The result was *Aquarius,* an hour-long programme, edited and presented by Humphrey Burton. It appeared on Saturday evenings for approximately twenty weeks in the years from 1970 to 1977. Although it was shown throughout the ITV network, it tended to be scheduled at different times in each region. Burton's main interests were music and the performing arts. He had worked for *Monitor* in the 1960s and was head of the BBC's Music Department at the time he was recruited by LWT. He was willing to move because a higher salary was offered and because he thought the BBC had become smug and set in its ways. He saw himself as 'a Trojan horse' inside commercial television, bringing culture to the masses. Burton wanted *Aquarius* to appeal to a wide spectrum of viewers, so anything highbrow was to be excluded. It was to be 'an experiencing rather than a critical programme'. *Omnibus,* he thought, paid too much attention to the past - it resembled a museum; his series aimed to be more contemporary.

Critics judged *Aquarius's* quality as 'variable' and one thought it 'marred by a succession of supercilious presenters'. Burton was a competent, if uninspiring front man. Even he admitted he was 'a faceless face', that is, the series did not make him a celebrity - he was not recognised in the street. After a time, Burton resigned from LWT over a question of principle, but later he was re-employed on a freelance basis.

Later still, he returned to the BBC to become head of the Music and Art Department (1975-82).

One of Burton's finds was Russell Harty (1934-88), an extrovert who later became a TV personality and chat show host. Harty worked on *Aquarius* first as a researcher and then as an interviewer. One of his triumphs was 'Hello Dali' a documentary film about the Spanish surrealist that won an Emmy award. Another of his programmes was about two musicians - William Walton and Gracie Fields - who both happened to live on the island of Capri. Amongst other famous names profiled by *Aquarius* were Pablo Casals, Stanley Spencer and Edna O'Brien.

In 1975 Sir Peter Hall, director of the National Theatre, was persuaded to present *Aquarius*. As a result, the media criticised him for taking on two jobs. Variety was the keynote of the series: topics covered included Hall interviewing Peter Brook; the architect Denys Lasdun on a Greek theatre at Epidarus; the story of the Scottish Opera written by Stephen Fay; a study of the dancers Nijinsky and Isadora Duncan; the work of the painter Euan Uglow; the furniture design of John Makepiece; a film by Jeremy Marr about British reggae. Entries in Hall's published diaries reveal that he felt self-conscious in front of the cameras wearing the new suits LWT had paid for. He was to remain unhappy with his performance as a presenter.

By 1977 *Aquarius* had lost its way. For a time its producer Derek Bailey toyed with the novel idea of an arts programme without a presenter. It was certainly one way of reducing costs. In the end the idea was dropped and *The South Bank Show* was conceived as *Aquarius's* replacement.

Full House

During the early 1970s, BBC 2 also experimented with a multi-disciplinary arts strand called *Full House* (launched October 14, 1972). The plan was to present a variety of (mainly) live performances to an invited studio audience who would then be encouraged to participate. Bill Morton and Tony Staveacre were the editors, Vernon Lawrence was the director, and the main host or 'ringmaster' was the actor Joe Melia. Three other actors or 'clowns' either helped or hindered him. *Full House* was transmitted late on Saturday evenings at four-weekly intervals. The length of programmes varied, but it was sometimes as long as two hours.

The series drew upon the expertise of a team of producers and its scope was very wide: polemics, comedy sketches, discussions about paintings, filmed reports from exhibitions, theatrical and musical performances. One edition was broadcast from Newcastle upon Tyne, and in another all the performers were children. Drama was provided by such leading writers as Howard Brenton, Sam Shepherd and Tom Stoppard; satire by Adrian Mitchell; events by Le Grand Magic Circus and Red Buddha Theatre; music by such diverse groups as the Amadeus String Quartet, Soft Machine and Gladys Knight and the Pips. Among the visual artists featured were the Italian Futurists, Caspar David Friedrich (whose

paintings were discussed by David Hockney), Stuart Brisley and Sidney Nolan. In order to prompt a live response, works of art were sometimes brought into the studio and then a debate with the audience about them was instituted.

It is clear from the above summary that *Full House* attempted to cover a range of artforms, classical as well as popular, and to package them in an entertaining manner. In fact, 'entertainment medley' was how one newspaper characterised the series. In spite of *Full House's* enthusiasm and innovations, it was dropped after only one season. According to Tony Staveacre, the series was 'scuppered by compromise' and 'undone by the very wideness of its brief'. Anna Ridley worked on the series as a designer. In her opinion, its visual style was limited by directors whose experience was with the single camera set up typical of the cinema, that is, it lacked directors with experience of electronic, multi-camera, live reproduction.

Press reaction to the series was negative too. Stanley Reynolds of *The Times* (October 16, 1972) scorned the 'make art fun' strategy and he accused Joe Melia of 'desperate mateyness'. Leaving aside the issue of presentation, the problem with multi-arts, multi-item programmes is that viewers interested in one art/item may not be interested in the others. A proportion of viewers probably resent having to sit through items of little or no interest to them, in order to catch the one item they are interested in. Well prepared, single subject arts programmes may lack the immediacy and topicality of live, magazine-type programmes, but they are almost always more satisfactory. However, subsequent arts series - such as *The Late Show* and *Without Walls* - have shown that a magazine format can work providing the number of topics per fifty-minute programme is limited to two or three.

Arena

Arena, Art & Design (BBC 2, 1974), later contracted to *Arena* (1976-), is an open-ended series which merits special attention because of its longevity, because so many of its editions have been of exceptional quality, and because of its experimental, offbeat approach to the arts. From 1981 the series had an especially memorable title sequence - a floating bottle inside which was the word 'Arena' illuminated in neon - accompanied by haunting music created by the rock/avant-garde musician Brian Eno. *Arena* was commissioned by Humphrey Burton, head of the BBC's Music & Art Department, and initially it was intended as a thirty-minute, topical, review or magazine programme. Later, Alan Yentob was appointed as editor and Nigel Finch and Anthony Wall were employed as executive producers. One of their first decisions was to avoid the device of a regular presenter or host. The magazine format with several short items was failing to attract viewers, so they substituted a thematic approach. This enabled ideas to be developed at greater length, and since BBC 1's *Omnibus* was covering the major artists, *Arena* could afford to specialise and to innovate.

fig 16 | Title sequence for *Arena*. Idea: Nigel Finch; graphic designer: Glenn Carwithen.

PHOTO COURTESY OF BBC TELEVISION.

A list of some of the topics it has covered will give an impression of *Arena's* rich, diverse fare: Salvador Dali, Mark Boyle, the Mona Lisa, the Chelsea Hotel in New York, a Brian Eno/Russell Mills collaboration, David Inshaw, Four Rooms (interiors designed by Howard Hodgkin, Richard Hamilton, Anthony Caro and Marc Chaimowicz), the Cable Street Mural, John Byrne, the painters John Hoyland and Robert Natkin. A notable early programme broadcast in March 1976 dealt with video art; it featured tapes specially commissioned for the programme. Another was Finch's 'My Way'(1978), a documentary film devoted to a popular song which asked a range of personalities - including the Labour politician George Brown and the Welsh rugby star Barry John - about the meaning and significance of the song's maxim 'I did it my way' in their lives. The unforgettable climax of the programme showed Sid Vicious - of the Punk group the Sex Pistols - on stage murdering the song and blazing away at the audience with a revolver. Hilariously funny in places, this film was also a sly critique of the ideology of individualism celebrated in the song's lyric. 'My way' proved very successful: when it was repeated on BBC 1, it was watched by nine million people.

As the subject matter of 'My way' indicated, *Arena* was as much concerned with popular culture/design/music as with fine art. In the decade 1978-88, programmes were made about the Ford Cortina motor car, the radio series *Desert Island Discs,* and the pop music bands/singers Dire Straits, the Everly Brothers, Buddy Holly and Bob Marley. The art of the cinema was represented by lengthy and memorable studies of the careers of Luis Buñuel and Orson Welles, while literature/poetry/drama were represented by profiles of Jean Genet, Osip Mandelstam, Joe Orton, Dennis Potter, Isaac Singer and Jorge Luis Borges. The programme makers constantly demonstrated a willingness to surprise in their choice of people asked to contribute. For instance, a 1987 item about Joseph Beuys' *Plight* - a gallery installation made from felt - included a reaction from the mineworkers' trade union leader Arthur Scargill. He found parallels between the artist's environment and the silence and darkness of the pit.

Arena's producers did not regard their series as a means of shepherding people into galleries and theatres. Arts programmes, they felt, should provide televisual experiences that were valid in their own right. This explains their willingness to experiment with both form and content. Risk-taking resulted in a number of self-indulgent programmes lacking any kind of critical perspective, but in the main they succeeded admirably in their avowed aims.

The South Bank Show

The South Bank Show (LWT, 1978-) was commercial television's answer to BBC 1's *Omnibus.* Programme title sequences are a minor, undervalued televisual/musical artform. Their function is to grab and hold the viewer's attention, to sum up the mood, contents and character of a series and to

give it an identity. The memorable forty-second one used by *The South Bank Show* involves a mélange of images ranging from Michelangelo to the Beatles. In fact, since it was originally designed in 1977 the sequence has been revamped several times. Pat Gavin was LWT's graphic designer in the 1970s (more recent versions have been designed by Gavin and Richard Markell of EMP [English Markell Pockett]). Gavin's brief was to 'make the arts look accessible'. The most striking image he devised was a close up of God's and Adam's hands - quoted from Michelangelo's Sistine Chapel ceiling - with a spark arcing in the small gap between their fingertips. Apparently, this was an image Gavin had been carrying around in his head since 1960. For Gavin, the spark had multiple connotations: 'the spark of life, of knowledge, of communication and of the creative art ... the transmission of the broadcast signal'[1] The music that accompanies the cel animation sequence was composed by Andrew Lloyd Webber who based it on Pagannini's *Theme and Variation.* At the end, the sixteen beats of the music perfectly match the sixteen letters of the series' name.

The title sequence's mixture of traditional and modern, fine art and popular culture imagery immediately signifies that this weekly, Sunday evening series adopts a broad, pluralistic approach to culture. The first two words of the name of the series derived from the complex of arts facilities situated on the South Bank of the River Thames in London, while the third had connotations of entertainment and showbusiness.

Melvyn Bragg, the series' long-serving editor and presenter, was selected by Nick Elliott, head of features at LWT, in 1977 on the grounds that he had the ability to cope with both traditional and contemporary artforms, with both 'high' and 'low' culture. Bragg had gained valuable experience of arts television by working for several years as a writer and editor on *Monitor* and *New Release.* His chief expertise is literature (he is a respected novelist), consequently he generally conducts interviews with famous writers. Sometimes he questions visual artists but often he simply gives short introductions to films made by others. Besides the distinctive nasal sound of his voice, one of Bragg's appealing characteristics is his intellectual modesty: he admits he is not an expert on many aspects of avant garde art (he is often at sea when interviewing contemporary abstract artists like the British sculptor Anthony Caro). This may enable ignorant but curious viewers to identify with him and to accept his invitation to watch with an open mind.

At first *The South Bank Show* was very uneven because it tried to combine a magazine format with a considered film (the two divided by a commercial break). An in-depth, single-theme approach was soon substituted and this proved far more effective. Programmes were tightly budgeted; they often required months of research but once the preparation phase was complete, they were made rapidly: each programme was allowed only a few days for shooting. Bragg has explained that research is inexpensive in comparison to filming on location. Like *Omnibus, The South Bank Show* has adopted many different approaches to

its subjects. As Bragg put it: 'The attack has varied from the interview to the free-flow documentary, from the objective process film to the committed and commissioned essay, from the individual portrait to a lecture, a seminar or a group depiction of a company...'[2] In addition, there have been films based largely on archive footage, dramatised documentaries and journalistic reports making use of an outside broadcast unit. Several hundred hours of arts television have been generated. There is thus some justice in Bragg's claim that in terms of 'quantity and steady aim', the output of *The South Bank Show* is comparable to that of a major Hollywood studio of the 1930s.

Bragg's overall objective has been to make arts programmes that are both 'serious and entertaining, rigorous and accessible'. Three principles guided his editorship:

1. respect the integrity of your subject;
2. respect the audience;
3. be professional and skilful in your use of the medium.

These were clearly acquired from his early mentor Sir Huw Wheldon.[3]. In regard to the second principle, the challenge is to satisfy what Bragg calls 'parallel audiences', that is, those in the know and those who know little or nothing. He sees the main constituency for the series as the kind of people who read the quality daily and Sunday newspapers. On the one hand, the programme reaches more people than those newspapers do but, on the other hand, it cannot provide the same quantity of information and degree of detail typical of the arts sections of a Sunday paper.

Since 1978 *The South Bank Show* has received many awards at international television festivals. Its ability to present the performing arts of ballet and music was demonstrated by the three Prix Italia awards it won in its early years for programmes about Kenneth MacMillan, Benjamin Britten and William Walton. One of its innovations was to recognise the work of leading TV dramatists such as Dennis Potter, Colin Welland and Alan Bleasdale.

Over the years many visual artists of modern and contemporary times have been profiled by means of films and interviews. The list includes Laurie Anderson, Frank Auerbach, Francis Bacon, Glen Baxter, Anthony Caro, Patrick Caulfield, Marc Chagall, Ian Hamilton Finlay, Barry Flanagan, Anthony Green, Patrick Heron, David Hockney, Howard Hodgkin, Jeff Koons, Roy Lichtenstein, John Piper, Graham Sutherland, Henri Toulouse-Lautrec, Andy Warhol and Andrew Wyeth, while the list of directors employed includes Bob Bee, Tony Cash, Hilary Chadwick, Geoff Dunlop, David Hinton, Tony Knox, John Read, Andrew Snell and Nigel Watts. Bragg realises the media of film and television find it difficult to do justice to paintings. When films of paintings are made he tries to ensure they avoid 'bewildering close-ups and melodramatic music'. *The South Bank Show* often performs a publicity or review function in that many of the programmes about visual artists are timed to coincide with large-scale exhibitions of their work.

fig 17 | Melvyn Bragg with the British painter Anthony Green. Publicity still for
The South Bank Show, 1987.

PHOTO COURTESY OF MELYVN BRAGG AND LONDON WEEKEND TELEVISION.

Arts television pays much attention to public galleries and museums but it is not often they return the compliment. In 1988 the British artworld, in the form of the Tate Gallery, honoured the achievements of *The South Bank Show* by mounting a tribute entitled 'Ten years of *The South Bank Show:* a celebration of modern British art'. The Tate's curators organised a month-long series of lectures and screenings of programmes featuring British artists.

Despite its longevity and awards, *The South Bank Show* is not without its critics. They have complained it is bland and relentlessly middlebrow, that it takes few risks, that it is too soft on its subjects and unwilling to make value judgments. They say it is the TV equivalent of the quality Sunday newspapers' colour magazines. Left-wing academics have also attacked the show on the grounds that its celebratory approach and its emphasis on famous individuals obscures the social nature of art, its material and institutional determinants, and the fact that some contemporary artists regard their artistic practices as contributions to an ideological and political struggle. Bragg once commissioned a programme from two such critics, but then cancelled it at the last moment.

Bragg has no problem in placing articles in magazines and newspapers, consequently he is able to defend himself in print. His essays on arts television frequently serve as a means of justifying the approach taken by *The South Bank Show.* He thinks there is no point featuring artists in order to attack or denigrate them, consequently the mere fact of selection is a sign of approval and endorsement. He regards himself as a journalist rather than a scholar or critic, and he acknowledges that the aim of the series has been to present artists and their works, to emphasise appreciation and demonstration rather than critical assessment and interpretation.

It is hard to imagine *The South Bank Show* without Bragg. However, there are some British video and performance artists who object to the use of presenters because in their view explainers, mediators and interviewers prevent them from addressing the public directly. A number of TV producers have also questioned the need for presenters and some have learnt to make arts programmes without them.

New open-ended series founded during the 1980s will be considered shortly.

References

1. P. Gavin, quoted by D. Merritt in *Television Graphics: from Pencil to Pixel,* London, Trefoil Publications, 1987, p. 26.

2. M. Bragg, 'Something to brag about', *Sunday Times Magazine,* January 10, 1988, pp. 41-5.

3. M. Bragg, quoted by D. Docherty in *Running the Show: 21 years of London Weekend Television,* London, Boxtree, 1990, p. 138.

Robert Hughes with paintings by Richard Hamilton. Publicity still for *Shock of the New.*
BBC 2, 1980.

PHOTO COURTESY OF BBC TELEVISION.

Shock of the New

The title of Robert Hughes' major pundit series about modern art was rather misleading because it contained little that was either shocking or new. This was because by 1980 modern art had become very familiar, an accepted part of official culture. The series consisted of eight, hour-long films made by BBC 2 in association with Reiner Moritz (RM Productions, Munich) and Time-Life Films, New York. The programmes were transmitted in Britain during September-November 1980. They took three years to make and Hughes - their writer and presenter - travelled thousands of miles during the course of production. The cost of the series was £1.25 million and in the United States financial support was provided by a corporate sponsor - the oil company Exxon. Lorna Pegram was the producer and she also directed three of the programmes. The other directors were David Cheshire, Robin Lough and David Robinson. John McGlashan was the chief cameraman and the picture/film researcher was Robert McNab. Versions of the script appeared weekly in *The Listener* and an illustrated tie-in book (with an expanded text) was published by the BBC.

Hughes (b. Australia, 1938) is an art critic and historian who lives and works in New York. In his youth he studied architecture at Sydney University and then resided in Europe from 1964 to 1970. His books about art include *The Art of Australia* (1966) and *Heaven and Hell in Western Art* (1969). His TV experience encompassed *Landscape with Figures* (a ten part series for ABC TV in Australia) and BBC programmes about Caravaggio, Rubens and Bernini. During his stay in Britain, Hughes made an outstanding contribution to the *Canvas* series (1966-70), namely, a fifteen-minute talk about Leonardo's *Mona Lisa* (the programme was produced by Leslie Megahey). Hughes' purpose was to de-mythologise the famous icon and to explain the role of the mass media in creating the cult that surrounds it. His commentary anticipated the kind of analysis found later in Berger's *Ways of Seeing*.

Since 1970 Hughes has been the art correspondent of *Time* magazine, consequently he is a critic and journalist rather than a theorist. Even so, his writing is rugged and intelligent. It is characterised by vivid aphorisms and scepticism towards the exaggerated claims made for so much avant-garde art: Hughes is prepared to debunk as well as to praise.

Anyone who writes for *Time* must be able to explain and to popularise. *Shock of the New* was designed as a popular series and its makers mobilised all the resources of film and television - location shooting, newsreel footage, clips from other arts documentaries, interviews with artists, rostrum camera work, formal manipulations of the television image, the use of jazz and pop music on the soundtrack - to generate programmes blending information and entertainment. At times though, the mix of disparate materials was over rich.

In Hughes' opinion the medium of television did not lend itself to 'abstract argument or lengthy categorisation'. What 'the Box' did well, he thought, was to 'show things and tell'.[1] He recalled that while the programmes were being assembled, Pegram often remarked: 'it's a clever argument Bob, but what are we supposed to be looking at?' Despite the subordination of intellectual substance to illustration and description, Hughes did manage to insert some stimulating ideas. To a considerable extent the format of the series was modelled on Clark's *Civilisation* but, as we shall see later, it was also influenced by Berger's *Ways of Seeing*. The series' opening - brief shots of Hughes in front of a number of European monuments in different countries while wearing different suits - poked fun at the globe-trotting pretensions of blockbuster TV series. However, in most instances, Hughes appeared in linking passages rather than standing before works of art pontificating.

Shock of the New was not, according to its writer-presenter, the standard history of modern art, nor a tour of its monuments, but an attempt 'to see the twentieth century through the lens of its art' and 'to evoke its spirit by showing how it has acted upon society'. Instead of providing a single-strand, chronological and comprehensive survey of the subject, Hughes opted for a selective, thematic approach: eight filmed 'essays' on different facets of modern art (from the 1840s to 1970s). *Shock of the New*, in fact, was the first of several reconsiderations of modern art undertaken during the 1980s. The Open University's 'Modern Art & Modernism' course (1983) was another example and in addition there were books by Norbert Lynton and by John Russell. These summations were a sign that the era of modernism was reaching its end. Another sign was the increasing use of the term 'post-modernism'. In a sense, therefore, *Shock of the New*, was television's obituary notice for modern and avant-garde art. Hughes, indeed, had earlier written an article entitled 'The decline and fall of the avant garde' (*Time,* December 18, 1972).

The contents of the eight programmes were as follows:

1. 'Art's love affair with the machine.' Technology and inventions at the end of the nineteenth century; art in the period before the First World War: cubism, futurism, Picabia and Duchamp.
2. 'The powers that be.' Covers the period 1914 to 1930s. Art and politics. Dada in Zürich and Germany. Art and the Russian revolution and the fascism of Mussolini's Italy.

3. 'The landscape of pleasure.' 1870s to 1950s. Art and aesthetic pleasure. Impressionism, post-impressionism, the fauves, Bonnard, Braque and late Matisse. The Mediterranean landscape.

4. 'Trouble in utopia.' 1890s to 1960s. The modern movement in architecture. The city, art nouveau, futurist architects, Sullivan, skyscrapers, Mies van der Rohe, Le Corbusier, Lloyd-Wright, Bauhaus, Gropius, de stijl, Mondrian, Brasilia.

5. 'The threshold of liberty.' 1880s to 1940s. Naive art, the surrealists in Paris, De Chirico, Ernst, Douanier Rousseau, Cheval, Miró, Dali, Magritte, Cornell, early abstract expressionism.

6. 'The view from the edge.' 1830s to 1970s. From romanticism to expressionism. Van Gogh, Munch, Toulouse-Lautrec, Die Brücke, Kokoschka, Soutine, Bacon, De Kooning, Der Blaue Reiter, Klee, Brancusi, Pollock, Kandinsky, Motherwell, Rothko.

7. 'Culture as nature.' 1910s to 1970. Mass culture and pop art. Cubist collage, Joseph Stella, Stuart Davis, Rauschenberg and Johns, Hamilton, television, Warhol, Lichtenstein, Rosenquist, Oldenburg, Las Vegas.

8. 'The future that was.' 1840s to 1970s. Modern art and museums. Courbet, Kienholz, Frankenthaler and Morris Louis, Bridget Riley, 'instant' art, the art market, performance art, Hockney, the end of modernism.

Viewers unfamiliar with the chronology and geography of modern art may well have been baffled by the shifts back and forth in time and place from programme to programme. Also, several episodes were ragbags into which certain artists fitted very awkwardly. Having one programme (number two) specifically devoted to art and politics implied that the art in other programmes was non or a-political which, of course, is absurd, especially in the case of the surrealists some of whom advocated a communist revolution. Problems of selection and organisation beset the final programme which fell between two stools. On the one hand, it made a half-hearted stab at describing some recent trends in art and, on the other hand, it attempted to bring the series to a conclusion by considering the fate of modernism.

Like *Civilisation,* the emphasis of *Shock of the New* was on the visual art of Europe and, to a lesser extent, that of the United States. Some reference was made to the art of Germany and the Soviet Union but there was no mention of any Australian artists or the work of the Mexican muralists (though Diego Rivera made a belated appearance in the tie-in book). The latter, serious omission is typical of far too many histories of modern art. Supporters of British art were also disappointed at the coverage given to British artists: only Bacon, Hockney, Riley and Hamilton were mentioned. For Hughes, Paris and New York were the crucial cities of modernism not London. Again like *Civilisation,* women hardly counted as artists though Hughes did illustrate the work of a few female painters. While on the topic

of omissions, it seemed strange that no reference was made to John Heartfield in the programme about art, politics and dada (he was cited in the book). However, Hughes did at least see the need to include the fascist art and architecture of Germany and Italy.

Programme four, about modern architecture, had a unity and a worked-out thesis, namely, that the utopian visions of modern architects had been disastrous for housing and town planning. Although it was over-ambitious to tackle a century of architecture in just an hour. This particular programme provoked a flurry of angry letters to *The Listener* from supporters of modern architecture. James Read rightly claimed that Hughes condemned the failures of the moderns without explaining the reasons for their social idealism (for example, the need to rehouse millions and to replace unhealthy slums). Hughes' disillusionment with modern architecture was widely shared and so attacks on it were to proliferate and intensify throughout the 1980s.

Arguably, the most coherent and satisfying programme of the series was number seven: 'Culture as nature'. This was because Hughes, as a person who had lived through the 1960s, as a resident of New York, and as a writer for a mass circulation magazine, was thoroughly at home with the subject matter, that is, the mass media/consumer society and the response of pop artists to it. The material also lent itself to the medium of television in a way other subjects did not. For these reasons, this programme deserves to be described in detail.

In a pre-title sequence the camera zoomed across the canyons of New York to focus upon the small figure of Hughes high above the ground, dwarfed by a huge, electric sign in Times Square. The title of the series then appeared on the sign and Hughes introduced the programme. After the title-sequence proper, there were shots of rural and urban environments to sum up the radical change industrialisation has brought about: people in the past lived close to nature, whereas we live in a manufactured world of cities, machines, products, images and signs. Some remarks by Apollinaire about the popular printed media of the early twentieth century were quoted and the cubist use of collage was cited. From Paris we moved to New York and Joseph Stella's painting of the Brooklyn Bridge. This image provided Hughes with an emblem of America's new technological civilisation. Then, as a precursor of pop art, the packaging- and jazz-inspired canvases of Stuart Davis were featured (with the sounds of a traditional jazzband).

The narrative then jumped to the 1950s and the junk assemblages of Robert Rauschenberg. To show the enormous quantity of waste a modern consumer society generates, Hughes paid a visit to New York's extensive rubbish dump. Then the young Rauschenberg explained his interest in discarded materials and his working methods in a clip from an old interview. Next, Johns' target paintings were illustrated and, in order to clarify the difference between viewing targets as signs and targets as art, Hughes was shown firing a pistol at a target on a gun range. (There were

hints of the theories of semiotics and Russian formalism in the commentary at this point.)

To acknowledge Britain's contribution to pop, Hughes included film of Richard Hamilton talking about its origins in the 1950s. A quaint, washing-powder TV commercial - a whiter-than-white Tide advert - served to convey the flavour of the mass media in that decade. Hamilton introduced his expensive, witty multiple *The Critic Laughs* (1971-72) and then showed the bizarre, amusing film intended to publicise it. This film simulated the style of a TV commercial; the female star of the 'advert' was Loraine Chase. (It seems Hamilton had not wanted to be interviewed and so, as an alternative, he had suggested the idea of a spoof advert. This was how the film came to be specially made by the BBC for *Shock of the New.*)[2] Hughes missed a chance here to highlight the differences that still persist between mass culture commodities and works of pop art.

To set the scene for Warhol's 'electric' colours and his particular use of media images, Hughes demonstrated the unstable character of television pictures in a bravura sequence in which his own image was subjected to a series of transformations and degradations. The multiplication and repetition of images - 'sameness within glut' - made possible by mechanical reproduction was also cited. Credit was given to Walter Benjamin and, at this point, the programme's self-reflexive demonstrations paid a clear tribute to part one of Berger's *Ways of Seeing.* Film of Warhol from the 1960s Factory period was then shown and also his 'disaster' series of paintings. Hughes' judgement was that Warhol had been subversive in the 1960s but that his 'one piercing insight about the nature of media' had been quickly exhausted.

Next, Roy Lichtenstein's comic-based paintings were examined. Hughes paid attention to their formal qualities but, more unusually, he also discussed their mythic, American iconography. This was communicated via an extended sequence showing the hedonistic pleasures of California: incredible affluence, surfing, junk food, the beach life of sunbathing boys and girls. There was an excess of naked female flesh in the beach scenes; here *Shock of the New* was remote from the norms of serious art programmes. A female teenager wearing blue jeans was also shown descending a staircase - she was the typical heroine of Lichtenstein's romance comic images - while on the soundtrack the strains of classic pop song *Venus in Blue Jeans* was heard.

James Rosenquist's early days as a billboard painter were illustrated via an old film clip and, to make the point that some pop art was political, his enormous *F-111* (1965) Vietnam-bomber mural was illustrated. Another lengthy digression took place during which Hughes examined the real mass culture of America in order to argue that pop art could not compete with it at street level. In his opinion, pop art could only survive in museums. His key example of mass culture was the anonymous art of neon illumination typified in the spectacle of nightime Las Vegas, a town he described in a memorable phrase as 'the Disneyland of terminal greed'. In

a lyrical sequence, the camera explored the extraordinary moving patterns of the neon lights to the sounds of a Simon and Garfunkel hit. After this spectacle, the rest of the programme was something of an anti-climax.

Hughes' last example of a pop artist was Claes Oldenburg. The artist's early fireplug sculptures were shown via archive film and then he was seen watching the enormous balloons in the shape of animals and cartoon characters which float between New York's skyscrapers as part of Thanksgiving Day parades. Hughes rated Oldenburg highly, claiming he was the nearest equivalent to Picasso America had yet produced. His evaluation was somewhat undercut by the huge balloons which appeared so much more exciting and uncanny than anything Oldenburg has devised. (Despite the anti-museum rhetoric of Oldenburg's published statements, his career has depended heavily upon gallery and museum shows.) However, Hughes included film footage of several of Oldenburg's huge public monuments in order to demonstrate the artist's commitment to escape the confines of the museum.

Finally, Hughes addressed the question of the continued existence of high culture in a media-saturated environment. Via a film clip, Marshall McLuhan made a priceless appearance to observe that 'pattern recognition' was the only possible human response to a situation of 'electric information overload'. We were then introduced to the multi-media, 'Living History Centre' in Philadelphia where children listen to the Declaration of Independence on headphones. This attempt at popularising the past was cited as an example of the worst aspects of a mass media society and the so-called information revolution. Some TV viewers were not impressed by Hughes' evident contempt for this type of education because they felt his programme suffered from exactly the same faults.[3] The programme concluded with the judgement that art is a small thing compared to the mass media. Hughes also observed that art loses all claim to our attention once it renounces seriousness, taste and moral responsibility for imagery.

John Wyver, who was then a TV critic, characterised *Shock of the New* as 'a chronicle of disappointment', because it so often concluded that the political and social aims of the modernists had not been realised.[4] Furthermore, there was a certain irony in watching a TV series about modern art in which it was asserted that no one extracted the essential information for the conduct of their lives any longer from looking at paintings. People now referred to photographs and cinema/TV screens. According to Hughes, this was one of the negative consequences of mass communications. No doubt he was right, but in that case why bother to make a TV series about modern art?

Hughes' declamatory discourse was plausible while one watched and listened, but doubts about the examples chosen and the sweeping judgements made arose immediately the set was switched off. Although overlong, the programmes were sufficiently varied in their ingredients to hold the attention. In terms of their level and popular character, they most

closely resembled Sunday colour supplement journalism. Perhaps the most damning criticism one could make of the series was that it was yet another rehash of extremely familiar material. Despite his claims to the contrary, Hughes made little or no attempt to look beyond the story of modern art as told by the standard textbooks and major museums. For instance, in the mid-1970s a new generation of artists in London began to use mass media imagery in a critical way (John Stezaker, Jonathan Miles and others) but Hughes' 'Culture as nature' programme ignored them. Aside from pop art, Hughes' treatment of the art of the period 1950-75 was confused and perfunctory. In TV terms too, *Shock of the New* was conservative in that it relied on the single-voice, male-presenter formula.

For a TV series willing to tackle the complexities and issues of contemporary art, and to experiment with new methods of presentation, viewers had to wait another seven years until the appearance of Channel 4's *State of the Art*.

References

1. R. Hughes, *Shock of the New,* London: BBC, 1980, p. 7. (A second edition of Hughes' book was published by Thames & Hudson in 1991.)

2. The 'TV commercial' is described and illustrated in R. Hamilton's *Collected Words 1953-82,* London, Thames & Hudson, 1982, pp. 73-74.

3. The opinion of several conservative, mature students expressed in a class held at Middlesex Polytechnic in the early 1980s.

4. J. Wyver, 'Is there life after *Civilisation?*' *Time Out,* (544), September 19-25, 1980, pp. 18-9.

fig 19 | **David Hall**

two stills of 'Tap Piece', 1971:

1. The TV set fills with water;
2. The TV set drains off.

From 'Seven TV pieces' a selection from the original ten, unannounced interruptions (each approx. three-minutes long) made for and shown on Scottish TV in 1971.

PHOTOS COPYRIGHT AND COURTESY OF DAVID HALL.

Showcases for Artists' Work

As explained earlier, showcases are programmes in which artists - primarily those working in the fields of performance, film, video, animation and computer graphics - are permitted to present their work direct and unedited to TV audiences. Examples include *Dadarama* (Channel 4, 1985), *Eleventh Hour* (Channel 4, 1988), *Ghosts in the Machine* (Channel 4, 1988), *Alter Image* (Channel 4, 1988) and *White Noise* (BBC 2, 1990). It should be admitted that 'showcases' is not an entirely satisfactory name and some examples are better described as 'art interruptions, interventions or breaks'.[1] We should also distinguish between 'TV Art' - artists' videos or films made specifically for broadcast television - and videos/films made independently of television which happen, later on, to be shown on the Box.[2]

Showcases are the rarest of all arts programmes. For many years professional broadcasters were very protective of their empires and refused to allow outsiders direct access to the mass media of radio and television. (Michael Kustow once described the centralized organizations undertaking most of their own production as 'fortress television'.) Public broadcasting systems in the United States and in Germany were the first to grant access to artists: Nam June Paik became an artist-in-residence at Boston's Public Broadcasting Laboratory in 1969 and a programme of his was transmitted in the same year. In 1969 and 1970 two productions of the Fernsehgalerie (TV Gallery) Gerry Schum - 'Land art' and 'Identifications' - that is, compilations of short films by various artists made specifically to be shown on television were transmitted in Germany. Schum also produced, in 1969, the sardonic 'TV as a Fireplace' by the Dutch artist Jan Dibbets.

In Britain, David Hall made ten 'TV Pieces', with the assistance of Anna Ridley, for Scottish television as early as 1971; they were transmitted at the time of the Edinburgh Festival. They have also been called 'Interruptions' because they appeared in the normal schedule of programmes without introduction or explanation. ('Seven TV Pieces', a selection from the original ten, were re-screened in 1990 via Channel 4's *19: 4: 90,* a series of

'television interventions' by different artists, curated by Stephen Partridge, commissioned and produced by Fields & Frames Production Ltd. A touring exhibition was also mounted.)

Hall's 1971 'TV Pieces' were shot on film because no video-recording equipment was then available to him. To describe just one example: a household tap noisily streaming water is seen in profile - the water gradually 'fills up' the whole screen - as the water level engulfs the tap, the jet of water disappears as does the sound - and, once the TV set is full, the tap is removed and the water begins to drain, very noisily, at an angle from the top, left-hand corner of the screen. Clearly, the impact of such a piece depended upon

 a, its surprise value; and
 b, what contrast was established with the images which preceded and followed it.

With wit and a minimum of means, Hall challenged the normality and naturalism of a medium whose 'stream' of sounds and images are 'on tap' every day. He also drew attention to the shape of 'the Box' in the corner. On several occasions Hall was able to observe the reaction of the public: 'TV Pieces' succeeded in surprising viewers and in holding their attention. The artist has commented: 'The pieces were not intended as declarations of art in their own right ... They were gestures and foils *within* the context of the predictable form and endless inconsequentiality of TV'.[3]

After 'TV Pieces' progress was slow. It was not until 1976 that Ridley, then a designer employed by the BBC, managed to persuade *Arena,* the BBC 2 strand series, to devote a whole programme to a survey of British and American video art. The programme, transmitted in March 1976, was prefaced by a David Hall piece entitled 'This is a Television Receiver' featuring Richard Baker, the leading, British newsreader of the day. His participation was unusual because newsreaders were normally discouraged from engaging in any activity likely to undermine their credibility. After an initial take in which Baker appeared as normal - apart from the fact that instead of the news he read a statement about the real and imagined functions of the TV set - progressive distortion was instituted by repeatedly regenerating the image optically off the monitor's screen. The illusionism of the TV image was thus undermined. Simultaneously, Hall showed the medium could be used to provide a different kind of aesthetic experience.

Coverage of video art increased with the advent of Channel 4 in 1982 because it proved more flexible and innovative than ITV and the BBC in its attitude towards the visual arts and towards the medium of television itself.

Anna Ridley became an independent producer in 1982 when she founded Annalogue Ltd. She has a special interest in the contemporary visual arts. It was she who proposed a series to be called *Artists' Works for Television* to Channel 4's commissioning editor Paul Madden; the shorter title *Dadarama* was eventually adopted. Earlier, in 1984, Ridley had worked

with Ian Breakwell on a series of over twenty programmes varying in length from five to eleven minutes based on the quirky, and at times bleak, *Continuous Diary* the artist has been keeping since 1965. Breakwell's offbeat portrayal of London life as seen from a high window in Smithfield Market proved a hit with both viewers and critics.

For *Dadarama* the artists Rosemary Butcher, David Cunningham, Rose Garrard, John Latham, Stephen Partridge, Paul Richards and the musician Michael Nyman were approached and offered access to video production facilities. Latham and Richards both chose to take advantage of the Quantel Paintbox, the electronic graphics system. They were assisted by the noted graphic designer and director Dean Stockton. During the production phase, Ridley strove to ensure that the artists' ideas were realised as fully as possible. The works that resulted were transmitted at various times on Channel 4 in 1985. There was a deliberate attempt to widen the audience by not promoting *Dadarama* as an arts series.

Having worked for the BBC for eleven years, Ridley was well aware of the restrictions normally placed upon artists by broadcasters. When negotiating with Channel 4, therefore, she insisted on some unusual pre-conditions, namely, that the artists were to be free to determine the format, duration and style of the works (some elected to make single pieces, while others elected to make mini-series); that the works were to be shown as individual items not packaged in terms of a magazine-type compilation or an arts programme; that the artists were to be given access to the equipment and specialists needed to make the work, and paid a fee comparable to that given to professional directors.

The artists concerned represented a range of aesthetic positions and styles, consequently every programme had a different character. A memorable contribution was made by John Latham whose videotapes contained a mix of figurative and abstract elements. A target-like motif with violent electronic hues flashed on and off at high speed, providing a stunning optical experience totally different from television's normal fare. However, the meaning and significance of his images were probably beyond the comprehension of most viewers since an understanding depends upon a knowledge of his earlier spray paintings and book reliefs, and the cosmological ideas informing them.

More experiments of this kind should be encouraged in order to increase the variety of television, but many will feel that presenting works of avant-garde art 'raw', without any commentary or contextualisation whatsoever, is likely to confuse and alienate non-specialist viewers. (Though Ridley reports the programmes evoked much interest and positive responses in terms of letters and phone calls.) After all, explanatory introductions or follow-up discussions need not conflict with the principle of presenting artworks in their entirety.

The kinds of art most suited to television transmission, of course, are time-based ones. The relay mode of television is never more evident than when television transmits pre-recorded material such as films or videos.

fig 20 | Two Stills of 'Dave's Bike', 1984 by John Latham. Video shown on Channel 4's *Dadarama* programme, March 1985. Annalogue Ltd for Channel 4.

PHOTOS COURTESY OF JOHN LATHAM AND ANNA RIDLEY.

During the 1980s TSW (Television South West), S4C (the Welsh-speaking channel), BBC 2 and Channel 4 (particularly the latter) succeeded in increasing the public's appreciation for the previously undervalued art of animation - an art that flourished in Europe and the United States in that decade - by showing hundreds of examples, by commissioning animated films, by screening documentaries about leading animators, by mounting special 'Animation Weeks', and by helping to sponsor the biennial International Animation Festival (held in Cambridge and Bristol).

One reason animation proved so successful was its versatility: its various techniques - from hand-drawing and modelling to generating images via computers - were used to make artists' films, short cartoons, full-length movies, TV commercials, graphics and series (such as *SuperTed* [SC4, 1984] about a character created by Mike Young, and the American cartoon, family soap opera *The Simpsons* [Rupert Murdoch's Fox network and Sky TV, 1990] with characters devised by Matt Groening). Furthermore, the contents and styles of animated films were so diverse, they appealed to adults as well as to children. The spectrum of work produced also spanned the divide between high art and popular culture.

After Image producers Jane Thorburn, Mark Lucas and Alex Graham in their *Alter Images* series for Channel 4 (3rd series, 1988) collaborated with artists using temporal forms and media to generate new, unique pieces tailor-made for television. Each programme normally consisted of a series of unrelated items presented straight without benefit of commentators, links or contextualisation. For example, one programme featured the Indian singer Najma, moving sculptures based on Nigerian culture made by the black British artist Sokari Douglas Camp, a poetic monologue by Neil Bartlett about gay friendship, and David Nash's sculptures set in the Welsh countryside.

More video art appeared on Channel 4 due to the initiative of John Wyver, of the independent production company Illuminations. Wyver produced a series entitled *Ghosts in the Machine* (first series January-February 1986, second series January-February 1988). The programmes were magazine-style compilations. Series one involved acquisitions, and series two commissions. The first series took advantage of the growing archive of videotapes made by fine artists since the advent of portable video cameras and recorders in the late 1960s. Although the scope was international, a significant proportion of the tapes came from the United States. Among the American artists featured in the first series were Laurie Anderson, Dara Birnbaum, Peter Campus, Les Levine, Nam June Paik, John Sanborn and Robert Wilson.

Film, video, television equipment and editing facilities are currently available to large numbers of art students and independent artists in Europe, North America and Japan, consequently a considerable number of works are available for transmission on mainstream television. However, since many of these films and videotapes were created in aesthetic and ideological opposition to the dominant values of broadcast television,

there is a certain contradiction in showing them. Again, a proportion of such works were designed for specific physical settings - a video installation in a gallery for example. Some were concerned with the TV monitor as an object, or employed banks of monitors to generate a multi-screen display of moving imagery. Obviously, works such as these cannot be transferred to television in their original form.

In the past, mainstream television tended to reject video art on the grounds that it was technically inferior and that, in form and content, it was too difficult and esoteric. Both these objections have lost force in recent years. Video artists now have access to broadcast standard facilities and in any case viewers have become more tolerant of 'imperfect' images. There now exists informed, minority audiences who are receptive to experimental television. Furthermore, video artists - American ones in particular - have sought to make videos more accessible by using actors and by telling stories.

The video pieces appearing in *Ghosts in the Machine* were uneven in quality and some compilations made for indigestible programmes, nevertheless there were some memorable tapes; for instance, Zbigniew Rybczynski's 'Steps' (co-produced with the PBS station KTCA, Minneapolis, shown in Britain on January 22, 1988). Rybczynski is a Polish experimental film and video artist now based in the United States. He is fascinated by the art and culture of the past and by the fact that we can visit the past - in our imaginations - when we study an earlier work of art.[4] In 'Steps' he paid homage to Eisenstein's *Battleship Potemkin* (1925), while at the same time deconstructing it, by taking a party of American tourists on a guided tour of the famous Odessa Steps sequence. Special techniques involving travelling mattes and chromakey work enabled him to insert the tourists inside this masterpiece of the Soviet cinema. 'Steps' was an astonishing and amusing video; at once a tribute and an iconoclastic gesture. Rybczynski's humour was even-handed: it was directed towards both the Soviet Union and the United States. It has been reported that some American viewers felt insulted by it.

Another remarkable video - 'Calling the Shots' (1984) - was made by the British artist Mark Wilcox, who studied film and video at Middlesex Polytechnic. An extract from this thirteen-minute tape was shown on *Video Video* (February 2, 1986). It is a post-modernist satire and critique of a clip from Douglas Sirk's 1950s melodrama *Imitation of Life.* On a cheaply constructed set a housewife and a photographer perform a ludicrously stilted courting scene. After the man leaves the room, the woman watches television and is amazed to discover the conversation she has just experienced is identical to a scene in the Sirk movie. A rerun of the film scene starring Lana Turner and John Gavin is then violated by various scratch techniques. Wilcox simplifies and heightens the electronic colours in a way that pays homage to those found in Andy Warhol's silk-screen canvases. He also produces a shiver down the spine by intercutting his film with the Sirk movie in such a way that his actress appears to be talking to

fig 21 | Two stills from 'Steps' by Zbigniew Rybczynski featured in the Channel 4 series *Ghosts in the machine II,* 1988.

PHOTO COURTESY OF CHANNEL 4 & JOHN WYVER OF ILLUMINATIONS, LONDON.

John Gavin. The scene is then played again by the British actors but this time the woman, having become aware that she is acting out a 'script' dictated by the mass media, starts to subvert her role. Finally, the whole process of television recording is exposed and deconstructed as the heroine reveals herself to be an actress, refuses her allotted part, and walks off the set.

Clearly, Wilcox's video was made in response to feminist 'images of women' debates and film theory discussions about reality, representation, intertextuality and reflexivity. But what was remarkable about the tape was that, despite its weighty theoretical background, it was humorous, entertaining, aesthetically pleasurable and enlightening.

During the early 1990s the Film, Video and Broadcasting Department of the Arts Council joined forces with BBC 2's *The Late Show* in order to commission a number of artists to produce examples of 'One Minute Television'. (In painting the equivalent would be portrait miniatures.) The resulting pieces were shown as 'art breaks' during episodes of *The Late Show*. In 1992 eleven items were made by Martin Gardiner, Tony Hill, Sandra Lahire, Phil Mulloy, Jo Pearson, Devika Ponnambalam, William Raban, John Smith and others. The artists employed a variety of media - animation, colour/black-and-white 16 mm and 35 mm film, U-Matic video - and a variety of techniques - cartoon drawing, shadow lighting, rostrum camerawork, superimposition and other special effects - and they addressed a disparate array of subjects - police brutality, lesbian romance, the desire for freedom, the Canary Wharf skyscraper in London's Docklands. Given the somewhat arbitrary and very short, time span, the most effective pieces were probably those that explored a restricted theme in a self-reflexive manner. For example, Hill's 'A short history of the wheel' illustrated different wheels while the TV image spun around as if it too was a wheel in motion; Smith's 'Gargantuan' featured a man speaking to a newt - he praised amphibians of different sizes and ended with a pun that played on the film's time limit and the newt's small dimensions ('minute/newt').

It seems clear that art breaks were modelled on the breaks for advertising that punctuate programmes on commercial television. In the case of TV commercials, advertising agencies have had decades to perfect the art of making fast, witty and formally inventive adverts. It has to be admitted that fine artists lack experience in this respect; a minute is a very short time in which to develop an idea or a narrative, but directors of TV commercials demonstrate daily how much information and entertainment can be packed in as little as thirty seconds. Many ads are microscopic masterpieces.

If the intention behind the art breaks was to broaden the audience for experimental art, then their inclusion in an existing arts programme was not likely to prove as effective as their placement in gaps between programmes at other, peak times. Whenever they are shown, the danger associated with art breaks - those transmitted without any explanation -

fig 22 | Two stills from 'Calling the Shots', 1984, directed by Mark Wilcox, with Billly Hartman as Steve and Roxy Spencer as Laura. 13 mins Umatic video-recording. Production Company: Middlesex Polytechnic. Distribution: London Video Arts.

PHOTOS COURTESY OF MARK WILCOX.

is that viewers will find them either frivolous or incomprehensible. In the case of TV commercials, viewers know who is speaking and for what purpose, but this is not so in the case of art breaks. The aims of artists are generally different and more complex than those of advertisers, consequently they need much longer than a minute in which to involve viewers.

As was explained in my book *Art and Artists on Screen,* fine artists have been making experimental films since the 1920s. Those associated with the dadaists and surrealists - Man Ray, Buñuel/Dali, Duchamp, etc., and with abstraction - Fernand Léger, Hans Richter and Moholy-Nagy - are well known. A number of contemporary artists also make films, often with the help of grants from national or regional arts councils. Unless they call for multiple projectors and screens, such films can be shown on television without too much loss. However, films like the structural/materialist ones of the 1970s are unlikely to appear because they so conspicuously refuse the normal entertainment values of mainstream cinema and television.

To cite just one example of an artist's film which has been seen in part on television: *The World of Gilbert and George* (Arts Council of Great Britain, sixty-nine minutes, 1981); extracts appeared in a 1984 *South of Watford* profile of the duo. The colour film is a highly stylised summary of their obsessions. Shot by Philip Haas in three weeks, every scene was fully planned in advance. As with all their narcissistic work, the film includes many images of the two 'living sculptures'.[5] Via an episodic structure, ritualistic body movements to the tune of *Bend it,* and strange chant-like voice-overs, the viewer is introduced to their ideas and enthusiasms: their 'art for all' philosophy; drinking and eating in a local cafe; London, as seen from their house in Spitalfields; urban dereliction in the person of a tramp; food in the form of animated fruits and vegetables; beauty as personified by flowers; patriotism as signified by Union Jacks and *Land of Hope and Glory;* and so on.

Interspersed amongst the personal sections are more social realist items: documentary-style interviews with bare-chested, East End youths whom G & G question as to their aims in life. The awkwardness and inarticulacy of these young men embarrassed by the camera and by the questions put to them, was one of the most memorable passages of the film. G & G excite much hostile criticism - some of which is justified - but they ought to be given credit for devising a fascinating and bizarre film with the simplest of contents capable of holding the attention and challenging the preconceptions of the audience.

British artists may have wished to see their work on television, but none that I am aware of has wanted, or been able, to produce and star in their own TV show (unless one counts Rolf Harris). In contrast, Andy Warhol was an artist whose ambition was to make a mark in all the mass media of the twentieth century. A fan of television since the 1950s, he conceived the idea of having his own show - to be called *Nothing Special* - during the late 1960s. However, it was not until 1980 that *Andy Warhol's TV* appeared on

<table>
<tr><td style="background:black;color:white">fig **23** | Four Stills</td><td>from a video recording of the film *The World of Gilbert & George,*
Arts Council of Great Britain, 1981.</td></tr>
</table>

PHOTOS REPRODUCED COURTESY OF GILBERT & GEORGE AND THE ARTS COUNCIL.

cable TV in the United States. Warhol was executive producer of the weekly, half-hour show. It resembled his magazine *Interview* in that it foregrounded people and gossip. Warhol was disappointed the show was not bought by the big American networks.

Later on, in 1986, he had more success with a similar venture entitled *Andy Warhol Fifteen Minutes* which appeared on MTV (Music Television) cable stations. Amongst those Warhol interviewed for television were: his friend, the curator Henry Geldzahler, the fashion expert Diana Vreeland and the British painter David Hockney. Fashion shows were reported and voyeuristic visits paid to the homes of rock singers like Debbie Harry. Apparently, the MTV show was a hit with twelve-to-fifteen year olds, so in the year before his death Warhol managed to attract and charm a whole new generation.

Warhol's work for television also included brief items for *Saturday Night Live* (in one special effects sequence his head fell off and rolled across the floor!); a 'guest star' appearance in the popular comedy series *The Love Boat* (recorded in Hollywood in March 1985, broadcast on October 12, 1985). He also made promo videos for bands like The Cars and Save the Robots. No European artist has equalled Warhol's 'entryism' in regard to the medium of television.

References

1. The term 'art breaks' has been used to describe video or film sequences created by artists from different disciplines appearing on, and commissioned by, MTV in the United States and Europe. According to Philip Hayward, they are 'eye-catching animations or visual effects designed to function as discrete textual units *without* the specifically *promotional* function of either music videos themselves or the channel's own indents or veejay sequences'. See Hayward's essay: 'Industrial light and magic: style, technology and special effects in the music video and music television', *Culture, Technology and Creativity in the Late Twentieth Century,* ed. P. Hayward, London, Paris & Rome, John Libbey, 1990, pp. 125-147.

2. This distinction has been made by the British video artist David Hall.

3. D. Hall, '7 TV Pieces', *19: 4: 90: Television Interventions,* by Stephen Partridge & others, Corshellach, Brigend, Dunning, Fields & Frames Production Ltd, 1990, p. 40.

4. Rybczynski was profiled by Channel 4 on December 11, 1991 in a programme entitled 'Four-mations' as a prelude to screenings of several of his films and videos including 'Steps'.

5. The 'living sculpture' mode of performance adopted by Gilbert & George was prefigured by the mass media, specifically, by the 1953 American crime movie *City that Never Sleeps* starring Gig Young. This film included a character who earned money by playing the part of a mechanical man or robot. With a painted face he appeared in a shop window standing perfectly still or executing jerky movements. Pedestrians stopped and wondered: 'Is he real or is he a machine?'.

fig 24 | **Clement Greenberg** the American art critic, as he appeared in the interview
with Tim Clark, 1983.

PHOTO COURTESY OF NICK LEVINSON, THE BBC AND THE OPEN UNIVERSITY, MILTON KEYNES.

Arts Television
and Education

The Open University

All arts television is in a sense educational, but there are certain pro-
grammes and series that have been specifically created as educational aids.
For instance, those produced for the academic courses of the Open
University (OU) of Great Britain based at Milton Keynes, Buckinghamshire.
A proposal for a 'university of the air' was made by the Labour Party as
early as 1963 but it was not until 1971 that the first students were
enrolled. The OU's aim was to provide opportunities for people who had
not already been to university to study for degrees. It differed from the
new universities established in the 1960s, by being based on the distance-
learning method. Students receive tutorials and attend summer schools
but most of their work is done at home and, as part of their learning,
they watch television programmes transmitted on BBC 1 and 2 at off-
peak times.

Strictly speaking, educational programmes of this kind should not be
evaluated independently of the courses which they serve as visual aids.
They are parts of a multi-media package which also includes specially
written texts, recommended reading, reproductions of works of art, and
radio broadcasts. Even so, the programmes can be watched and enjoyed in
their own right by people who are not OU students.

One of the first arts courses devised by the OU - *History of Architecture
and Design 1890-1939* - appeared in 1975. Twenty-four unpretentious and
inexpensive programmes were produced by Nick Levinson and presented
by such scholars as Geoffrey Baker, Stephen Bayley, Tim Benton, Dennis
Sharp and Sandra Millikin. These scholars appreciated modern architecture
and were enthusiastic about the newly-constituted discipline of design
history. Amongst the topics covered were: international exhibitions, the
Bauhaus, the London Underground, English furniture, plus various houses
and flats. From the student's point of view, the chief value of such
programmes was the chance to view key modern structures in Europe and
the United States which otherwise would have remained inaccessible. An

outstanding programme was Tim Benton's 'Le Corbusier's Villa Savoye'. It supplied a particularly precise and thorough account of the origins and character of the villa which was filmed in colour, inside and out, from every vantage point.

Another arts course - *Modern Art & Modernism: Manet to Pollock* - dates from 1983. Levinson was again in overall charge of the course's TV programmes. OU academics worked in close collaboration with BBC production staff and technicians. Emphasis was placed on scriptwriting because the intention was to generate 'television essays' rather than 'illustrated lectures'. It was also decided to avoid artiness and pretension in the style of filming. The programmes, thirty-two in all (for the full list, see the appendix), Levinson later explained, were *about* art not pieces of art. Incidental music was outlawed for the same reason. In any case, the limited budgets of educational programming precluded lavish production values.

Members of the OU course team, such as Francis Frascina and Briony Fer, scripted and presented some programmes but the majority were written and presented by outside experts from both Europe and the United States; for example, Benjamin Buchloh, T. J. Clark, Thomas Crow, Clement Greenberg, Serge Guilbaut, Donald Judd, Fred Orton, Griselda Pollock and Peter Wollen. As this list of names indicates, the experts included artists and critics as well as art historians. The involvement of several members, or ex-members, of Art & Language - Terry Atkinson, Michael Baldwin and Charles Harrison - meant that this radical British 'conceptual art' group had a considerable influence on the intellectual content of certain parts of the course.

No single, format or presentation mode was adopted, but many programmes showed presenters standing in front of paintings speaking direct to camera. Not all scholars were at ease in this role - some lacked the smooth professionalism of regular TV presenters and actors, but Levinson later claimed this 'roughness' was a strength rather than a weakness. Other programmes consisted of filmed material with a commentary. In one, about the paintings of Piet Mondrian, an extract from a humorous, animated film about his work was also featured. In another, formalist and social history conceptions of art clashed as the famous American critic Clement Greenberg was questioned by the noted British art historian Tim Clark.

OU programmes differ from the general run of arts programmes in several ways: the intellectual level of their commentaries is higher; the camera is allowed more time to scan works of art; there is no attempt to achieve a balance of political opinion. Regarding the latter point: a programme about the Pompidou Centre in Paris, scripted by Michael Baldwin, provided a critique of the building from a Jean Baudrillard/neo-Marxist perspective. It was considered so partial by the BBC that they prefaced it with a disclaimer.

Freed from the requirement to entertain an unknown, unseen public or to attract large audiences, the OU programmes could risk being boring (though most in fact were not). They could transpose in a more systematic way the insights of the discipline of art history to the medium of television and acknowledge that art is a site of controversy and ideological struggle as well as pleasurable aesthetic and emotional experiences. In the case of the *Modern Art & Modernism* course, the aim was not art appreciation but a critical/social history of art (and that history included concepts, theories and issues as well as art objects). Not all programmes fulfilled this aim, but a fair number did. Besides Baldwin's programme, noteworthy ones were: Griselda Pollock and Fred Orton on Van Gogh's *Potato Eaters;* Tim Clark on Manet's *Olympia* and *Bar at the Folies-Bergère;* and Serge Guilbaut on a Jackson Pollock drip painting.

Once VHS video-recorders became widely available in the 1980s, they were acquired by individuals, schools, colleges and universities. Broadcast arts programmes could then be recorded for later use as visual aids during classroom teaching. Some libraries in higher educational institutions now possess extensive collections of such video-recordings classified in the same manner as their books. Students can select which programmes they wish to view and screen them in specially-equipped viewing areas. Via the use of headsets, several students can watch different programmes simultaneously. So, video-recordings can serve the ends of group teaching or independent study.

Hyper or Multimedia

At the time of writing, new forms of multimedia, hypermedia or hybrid media, such as CD-I (Compact Disc-Interactive), are being applied in the realms of entertainment, education, art and museums. These forms could transform learning about the arts in the near future. In terms of recorded music, millions are already familiar with compact discs and the machines that play them, but their potential in relation to visual media is less well known. During the early 1990s major companies such as Philips/Polygram and Sony began to market CD-I players with built-in computers (which connect directly to TV sets) and sound and vision discs featuring children's games, sports and other 'edutainment' material at prices equivalent to those of comparable material in record, tape or book form.

CD-I discs can store large amounts of information in digital form: equivalent to 250,000 pages of typed text, or 7,000 full-colour still images, or nineteen hours of speech, or seventy-two minutes of animated pictures or moving video. Their use as electronic encyclopedias is obvious. CD-I databases are now multimedia, that is, they combine text, sounds, graphics, still images, animation, video and film clips. (Obviously, when a mix of media occurs, the total storage capacity for each medium is reduced.) Data is stored in discrete bits, so discs can be searched at great speed and randomly accessed. Their contents can be made visible on high

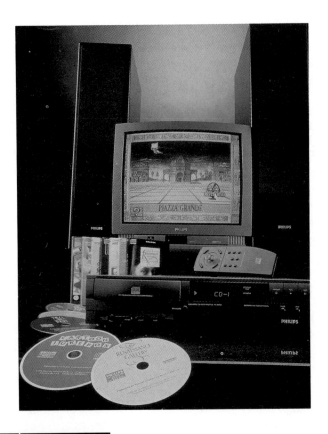

fig **25** | CD-I

Phillips Interactive Media Systems, 1993.

REPRODUCED COURTESY OF PHILLIPS IMS.

resolution colour monitors. For maximum use all this material is thoroughly indexed and cross-referenced by means of hypermedia software such as Hypercard.

Like printed paper, compact or laser discs are a write-once, read-only medium so information cannot be lost or erased; the discs are read by laser beams (via 'intelligent' laser disc players) and so they give high quality reproduction and are virtually indestructible. They can be replicated as easily and cheaply as books and records. An international standard has been agreed, so it is anticipated that all CD-I discs and players will be compatible even when manufactured by different companies.

The interactive facility provided by the CD-I player - which does not need a separate computer - by such means as a remote control or screen touching is the most innovatory feature because it enables viewers not simply to watch and listen, but to decide what they will look at and listen to, and for how long. Working at their own pace, users select images, move around within them, switch to other images, call up related texts; in short, they explore the database in a multiplicity of ways. The content of databases can be arranged in layers of increasing complexity, so that users can can pursue a subject until their interest wanes. The experience can be compared to browsing in a multimedia library. The user is thus far more active and involved than when watching broadcast television or listening to a lecture. Furthermore, information in lectures and programmes is normally presented in a single, linear sequence, whereas the CD-I user can search in many directions and there are alternative choices at every stage. According to Douglas Adams, 'linear television is closing down'.[1]

From the point of view of structured learning, multimedia databases have the disadvantage that students browsing through them may easily miss something of importance. But while the special quality of CD-I is the undirected nature of learning, it is also possible to provide more conventional, structured bodies of information. Some CD-Is even have an 'essay-writing' or 'authoring' facility which enables users to add to the database; for instance, to compose their own 'essay' by writing and by 'quoting' from the database. Both lecturers and students could thus add 'essays' to a particular database.

An arts CD-I - *Sculpture Interactive* - with all these facilities has been developed by Roy Stringer of Liverpool Polytechnic in association with Richard Francis of the Tate Gallery North in Liverpool. The project was commissioned by the Henry Moore Sculpture Trust and the material in the database is about British sculpture, in particular Moore's work, and draws upon archive material about the artist. Two hundred sculptures were documented and photographed from various points of view and under different lighting conditions. Viewers can 'navigate' around them at their own pace. A particularly impressive feature of CD-I is the ability to interrogate the database by means of concept or themes; for instance, if the viewer requests material on 'the family' for the year 1936 then

everything that has been indexed under this heading for that year will be displayed. Roy Stringer is a technological visionary who foresees a time when open-learning systems will be available to all, when multimedia libraries held by educational institutions will be available 'on line' to other colleges and home users via fibre-optic, cable networks.

CD-Is are becoming available for home use and they are already installed in some public museums. In 1991 the new Sainsbury Wing of the National Gallery in London, designed by the American, post-modernist architects Robert Venturi and Denise Scott-Brown, was opened to the public. It includes an information room with fifteen terminals giving access to a computerised information system known as *The Micro Gallery*. This system cost £500,000 to establish. It allows visitors to call up on screens all 2,000 pictures in the National Gallery's collection. Users are provided with high-quality coloured images plus details, images of related works, catalogue information and scholarly commentaries. A painting with a later addition can be shown with and without the addition. 'Guided tours' through the collection and 'visual essays' on different topics are provided. Hard copy in the form of printouts of particular 'pages' and maps of the gallery marked with paintings the viewer has asked to see are also available.

Incidentally, the National Gallery has already permitted guided tours of its collection to be issued on videotape, that is, the six tours written and presented by Edwin Mullins entitled *The National Gallery: a Private View* (Pacesetter/Mersham Productions, 1990). The video-cassettes are distributed by Odyssey Video, London, via record/video stores and are slightly more expensive to buy than movies on video.

Major museums and galleries are keen to enhance the experience of visitors by supplying additional information resources such as interactive catalogues. Another reason for making databases of this kind available to the public is to overcome the problem that a large proportion of the museum's collection is generally in store at any one time. Clearly, the database can also be searched much more quickly than the museum itself.

In the case of a museum whose whole collection was recorded on a CD-I, the disc could be duplicated and published and sold to other museums, libraries and individuals. An art-history student or scholar who had the whole collection/catalogue information of, say, the Tate Gallery on a CD-I would obviously find such a record immensely useful; there is a danger that possession of such discs might discourage people from visiting museums. Such videodiscs already exist: Interactive Learning Productions of Newcastle upon Tyne, in association with Anglia Television, for example, have produced a disc of the whole collection of the State Russian Museum in Leningrad. Ken Morse's rostrum camera studio in London was hired in order to record the visual artifacts and details from colour transparencies supplied by the Russians. Another museum whose treasures have been put on CD-I (by Philips) is the Smithsonian in Washington, USA. Interactive technology can also be applied to a single art object and its related

fig 26 Martin Ellis, computer consultant since 1988 to the Micro Gallery, computer information room (which opened in 1991 and was sponsored by American Express Foundation), Sainsbury Wing of the National Gallery London.

PHOTO: FERGUS GREER, REPRODUCED COURTESY OF THE NATIONAL GALLERY PRESS OFFICE.

historical material: Robert Abel's *Guernica* project has already been mentioned. In Britain, the Arts Council is currently funding John Wyver of Illuminations to explore the potential of CD-I as a new medium for the arts.

As with conventional publishing, a thorny problem facing publishers of CD-Is is copyright clearance of the words, sounds and images they wish to employ. (Even museums do not necessarily hold the copyright of all the material in their collections.)

At the moment, the novelty value of multimedia is high, but familiarity made breed contempt rather quickly. One critic, John Dvorak, has called CD-Is 'glorified teaching machines'. The information they contain, he argues, has been 'predistilled by the producers', consequently he doubts the claim that they 'empower' users.[2] Dvorak also points out that such machines lack the human dimension of teacher-student interactions and distance students from contact with actual art objects. To be fair, the same complaints could be made about an illustrated, reference book.

In spite of their new characteristics, what CD-Is have done so far is to synthesise and enhance the kind of art-historical information already found in illustrated books and catalogues, slide lectures and TV arts programmes. There is a certain irony in the fact while some curators and art historians are applying new technology to the heritage of art, others are discussing the end of art and the end of art history as a discipline.[3] CD-Is will certainly be of value as educational and reference tools but if living artists were given access to the new multimedia then some genuinely unexpected results might ensue.[4]

References

1. Adams, quoted in, Phillips Interactive Media Systems, *Introducing CD-I: the official guide to Compact Disc-Interactive,* Wokingham, Addison-Wesley, 1992, p. 2.

2. J. Dvorak, 'Why the M-word is baloney', *The Guardian,* December 7, 1989, p. 29. See also *The Interactive Learning Revolution: Multimedia in Education and Training,* eds J. Barker & R. Tucker, New York, Nichols Publishing/London, Kogan Page, 1990.

3. Discussions along these lines occurred during the annual conference of the Association of Art Historians, held in London in 1991.

4. A few interactive, videodisc artworks have already been made. For a description of one called *The Erl King* (1987), by Grahame Weinbren and Roberta Friedman, see David Reisman's article 'Telescreen as text: interactive videodisc now', *Artscribe International,* (69), May, 1988, pp. 66-70.

British Arts television
in the third age of Broadcasting

Significant changes took place in British arts television during the 1980s as a result of several factors: first, the introduction of a fourth terrestrial channel; second, the Conservative Government's policy of de-regulation - which stimulated the free-market, private sector while undermining public-sector broadcasting; and third, the impact of technological innovations such as cable and satellite transmission systems, video-recorders/cassettes/discs, computers and new electronic graphics machines such as the Quantel Paintbox. The advent of satellite television caused the established broadcasting systems to be called 'terrestrial', and the term 'narrowcasting' was introduced to distinguish the new, specialist channels from the older, general broadcasting channels. As a consequences of these developments, the amount of television time devoted to the arts increased and new kinds of arts programme were devised.

Channel 4

Channel 4, the second commercial channel, was launched in November 1982. The British public now had more television to choose from and a wider range of programmes because each of the main channels had a partner presenting programmes appealing to minority tastes. Channel 4 was also significant for the arts because its founding charter committed it to encourage experimentation in both form and content. Its brief was to operate like a publishing house and so it commissioned arts programmes from independent production companies such as After Image, Annalogue, Holmes Associates, Illuminations, InCA and Landseer. This resulted in greater variety and novelty. The new Channel also boosted British film-production by funding new projects and directors: two of these films - *The Draughtsman's Contract* and *Caravaggio* - were discussed in my earlier book *Art and Artists on Screen*.

Michael Kustow served as Channel 4's first commissioning editor for the arts from 1981 to 1989. Having been director of the Institute of

Contemporary Arts, London (1968-71), he was familiar with, and supportive of, avant-garde art. For its first six years Channel 4 had no regular, general arts strand like *Omnibus* or *The South Bank Show* because Kustow wanted it to be different from the BBC and ITV. Arts programmes and series were treated, therefore, as one offs.

Initially, Kustow expressed a commitment to aesthetic pleasure and artistic quality rather than to social need, that is, he was unwilling to commission community arts programmes unless the art concerned matched the high standards set by professional artists and performers. Nevertheless, his intention was to encourage alternatives to the arts series and documentaries found on the other three channels. He declared: 'What I'm seeking is art television, not simply the arts on television: television that is shaped and altered by the insights and practice of art and artists'[1]. This aim was to be achieved by encouraging artists and programme makers to collaborate.

According to John Ellis, Kustow's regime 'strongly favoured relay of performance over any information or analysis'.[2] Kustow was certainly keen on the performing art of dance: he commissioned and purchased many programmes and films about classical ballet and modern dance and, in 1983, he instituted the influential series *Dance on 4*. [3] However, it was also during Kustow's time that the discussion series *Voices* and the major, contemporary art series *State of the Art* were commissioned.

Coverage of the fine arts began, inauspiciously in my view, with a populist series - *Tom Keating on Painters* - starring a well known, white-bearded artist, restorer and forger. Many people regarded Keating (1917-84) not as a criminal but as a loveable rogue and folk hero. His aim was to reveal the secrets of the techniques of the great masters of painting - Rembrandt, Titian, Constable, Turner, Van Gogh, etc. - by re-creating one their masterpieces in thirty minutes. But Keating's pictures were such crude pastiches one wondered how his Samuel Palmer fakes had ever fooled anyone. Keating may have been an endearing entertainer, but in terms of genuine knowledge about art his programmes were of little value.

Kustow's ambition to link artists' ways of seeing and making to the medium of television was exemplified by his commission for the pilot version of Canto five of Dante's *Inferno: A TV Dante* (1985). (Later, in 1990, eight Cantos were presented on Channel 4.) This programme was the result of Kustow's desire to bring together two British artists he greatly admired: the painter Tom Phillips and the film-director Peter Greenaway. The latter's 1982 art-cinema cult movie *The Draughtsman's Contract* had been made with Channel 4 funding, while the former's illustrated version of Dante's *Inferno* had been published in 1983.[4] The result of their collaboration was a complex, demanding arts programme with several layers of imagery and commentary that was virtually designed for repeated viewing. The programme fulfilled a second objective of Kustow's, that of bringing the classics of world literature to the television audience. Dante's famous poem about the journey of the human soul was re-interpreted by

two contemporary artists who made full use of the video editing possibilities of television. (Video post-production was the work of Bill Saint at 'The Palace'.)

Discussion programmes

The appearance of a fourth channel and the advent, at the end of the decade, of BBC 2's *The Late Show* enabled British television to allow more time for late evening discussions of the arts. During the 1970s and 1980s academic fields such as literary criticism, cultural studies and art history underwent a succession of theoretical revolutions as a result of the impact of linguistics, semiotics, structuralism, Russian formalism, Marxism, feminism, black studies, reception theory, psycho-analysis and deconstruction.

If television had ignored these developments altogether, then it would have run the risk of becoming an intellectual backwater. At the same time, the adaptation of such complex theories to the medium of television was clearly problematic given the obligation producers feel to devise accessible, intelligible programmes capable of attracting substantial audiences. These theories had their impact on such series as *State of the Art* and upon certain arts programmes produced by the Open University, however, in general the producers of British arts programmes seemed more cautious than their counterparts dealing with science. Scientific investigation of nature gives rise to many difficult subjects - chaos theory, fractal geometry, genetic engineering, etc. - but TV science/technology series such as *Equinox* (Channel 4, 1988-) appeared to have no inhibitions about tackling them and using models, diagrams and animated sequences to aid understanding. Where science, technology and art intersect, science programmes were sometimes more adventurous than arts programmes - witness *Equinox's* 'Computer graphics special' transmitted in 1990.

One way in which British television has introduced difficult ideas and theories to the general public has been through discussion programmes. Philosophical ideas, for instance, have been presented by Bryan Magee in dialogues with other thinkers. Sometimes an edition of *Voices* (Channel 4, 1982-88) was devoted to the visual arts, but it could be argued such programmes were fundamentally inappropriate to the subject because of the lack of illustrations of visual examples. Of course, examples can be shown by means of slide-projection, if the speakers decide in advance which works of art they wish to cite in support of their arguments.

Some of the discussions broadcast were absurdly short, allowing no time for speakers to develop their ideas. Often the problem was simply too many speakers for the time allotted. (Four or five seems to be the optimum number for an hour-long programme.) When there are several speakers in a studio, astute positioning of chairs and cameras and agile switching from one camera to another is essential if the screen is to show the person talking and to register the reactions of the others. There were times when

this basic problem of studio layout proved too taxing for television's directors and technicians.

The choice and mix of participants is obviously crucial to the success of any discussion but clearly what will prove to be 'the right combination of personalities' on the night is hard to determine in advance. If a live, improvised discussion is wanted, then too much planning and rehearsal may prove counter-productive. Programme makers frequently invite speakers they know hold diametrically opposed views. This tactic is designed to serve a double purpose: on the one hand, it ensures 'balance', while on other hand, it ensures a clash of ideas and wills which, the programme makers hope, will make for dynamic television (there was a famous occasion when the film director Ken Russell and the film critic Alexander Walker came to blows). In fact, the most illuminating exchanges tend to come, not from angry confrontations, but from relaxed conversations amongst speakers who share some common ground.

Although Channel 4's staff reached the conclusion that the 'balance' requirement need not mean that two sides had to be represented in every discussion programme, that 'balance' could be achieved by allowing different opinions to be aired over a period of time, elsewhere the requirement sometimes prevented the open discussion of current issues in the arts. For instance, in 1991 the Scottish mural painter Ian McCulloch reported that two television debates concerning the rejection and destruction of some of his work in Glasgow were cancelled because officials from the Scottish Arts Council declined to participate.[5]

In the case of recorded discussions, editors can enliven or complexify the result by inserting short film clips of other speakers whose comments extend or contradict the arguments of the original participants. This technique was used effectively in a 'Fin de Siècle' debate (*Without Walls, Channel 4,* January 28, 1992). Three, mature, male authors (led by Saul Bellow) discussed the future of American society and culture in a striking, but somewhat distracting, setting: a bare room high up in a Chicago skyscraper. Critical comments by the American novelist Toni Morrison and the performance artist Laurie Anderson were then added to ensure that the views of blacks and women were represented.

Some viewers find television debates irritating because so often speakers talk at cross purposes or become side-tracked. Viewers can also become frustrated by their inability to join in. British television has devised some viewer feedback programmes but the kind of phone-in programmes now so typical of radio have not, on the whole, been imitated.

Discussions involving more than three people generally require a chairperson to keep speakers to the point and to make sure everyone around the table has the opportunity to contribute. A firm chairperson is essential because otherwise domineering individuals (like the late Peter Fuller) tend to hijack the whole programme. Michael Ignatieff and Sarah Dunant have proved effective in this role: during the period 1989-93 they led several stimulating discussions about topical issues and controversies in the arts for BBC 2's *The Late Show.*

In view of the multiple problems of discussion programmes, one might be tempted to conclude that radio is a more appropriate medium as far as intellectual debate is concerned. (No television review programme has matched the longevity of *The Critics,* later called *Critics' Forum* [1947-90], a respected arts programme on BBC Radio 3.) However, the long-running, French TV series *Apostrophes* (1975-90) demonstrated that, given a society which esteems artists and intellectuals, this type of programme can be a success. *Apostrophes* was a prestigious, weekly, ninety-minute literary discussion series hosted by Bernard Pivot. He interviewed leading writers and invited small groups of them to the studio to discuss texts selected according to a common theme. Between three and six million viewers watched the programmes, and afterwards the sales of the books analysed increased dramatically.

Co-productions

In some instances Channel 4's arts programmes were co-productions with foreign television companies. Often several sources of finance were needed before a series became viable. During the 1980s business sponsorship became increasingly important as another means of funding the arts and arts television. For instance, *Art of the Western World,* a breathless, eighteen-part survey of the history of Western art presented largely by Michael Wood, received sponsorship in the United States from the Annenkerg/CPB Project and the Movado Watch Corporation, and in Britain from the Norwich Union Insurance Company. This series was premiered on PBS television in the United States and screened on Channel 4 in Britain in 1990.

Co-productions also occurred between Channel 4 and public organisations such as the Arts Council of Great Britain. The latter organisation expanded its remit in parallel with television in the decades since it was founded in 1945. Artists' films and videos, and documentary films about the arts, have been financed by the Arts Council since the late 1960s. In 1981 the Arts Council established a film and video library so that items could be purchased or hired. Its third catalogue, published in 1988, contained details of 348 examples. Many of these films and videos (or extracts from them) found their way on to television, although at first documentaries tended to be featured more than artists' films because they were more accessible. The Arts Council has also collaborated with BBC 2's *The Late Show* in order to fund experimental 'art breaks', that is, the 'One Minute Television' series of 1991 and 1992. This development indicated a shift of policy away from didactic, arts documentaries towards more experimental pieces commissioned from artists and made specifically for television transmission.

Globalisation

As television increasingly became, during the 1980s, a global form of culture through the agency of multi-national entertainment and communication enterprises, cable and satellite systems, it produced on the one hand homogeneity (the same soap operas and commercials were shown around the world) and, on the other hand, heterogeneity (more specialist interest channels, more alternative stations, more independent production companies). In this paradoxical situation it seemed that arts programming would survive and perhaps even flourish because of its specialist character and because of its appeal to affluent viewers (this fact should have attracted subscriptions, sponsors and advertisers).

Prestigious series like *State of the Art* (Channel 4, 1987) were expensive to make, consequently they had to be co-produced with foreign companies (in spite of the dangers and problems - such as blandness, sub-titling or translation - associated with co-productions.) However, these series could be sold to many other countries, and so they had a long shelf life. It followed that, although arts programmes were directed at a minority of viewers within particular nations, the increasingly international nature of the medium meant that they could reach substantial audiences worldwide. In order to make their major arts series more attractive to overseas buyers, and in recognition of the ever increasing international character of art itself, British television producers increasingly sent their camera crews overseas.

It was also paradoxical that the globalising tendencies of communications, media and business were accompanied by various countervailing tendencies that emphasised national, racial, regional, ethnic and religious identities. Perhaps the latter were a negative response to the former. As we shall see shortly, part four of *State of the Art* bravely tackled the issue of the local identity of artists in relation to a global context, and review/discussion programmes debated the relationship between the resurgent religion of Islam and the arts.

References

1. M. Kustow, *One in Four,* London, Chatto & Windus, 1987.
2. J. Ellis, 'Television and the Arts: another fine mess', *Modern Painters,* 4 (1), Spring, 1991, pp. 60-1.
3. Two interviews with Kustow regarding Channel 4's support of dance are to be found in *Parallel Lines: Media Representations of Dance,* ed. S. Jordan and D. Allen, London, Paris, Rome, John Libbey/Arts Council, 1993, pp. 83-98.
4. See the booklet written by T. Phillips, *A TV Dante directed by Tom Phillips and Peter Greenaway,* London, Channel 4, 1990. Phillips' translation of Dante's *Inferno* was published by Talfourd Press in 1983 and then reprinted by Thames & Hudson in 1985.
5. See the letters from McCulloch in *Art Monthly,* (146), May 1991, p. 29; and *Art Monthly,* (149), September, 1991, p. 29. But see also the rebuttal letter from the director of the Scottish Arts Council in *Art Monthly,* (150), October, 1991, p. 30.

fig 27 | Barbara Kruger 'We don't need another hero'. Billboard and publicity image for
State of the Art.

PHOTO COURTESY KRUGER, ILLUMINATIONS AND CHANNEL 4 TELEVISION, LONDON.

Beyond the Pundit Series: *State of the Art* (1987)

State of the Art: Ideas and Images in the 1980s was an ambitious documentary series of six, one-hour programmes about contemporary art transmitted in Britain on Channel 4 in January and February 1987. The series, which took two years to make, was produced by Illuminations (Television) Ltd for Channel 4 and WDR (Cologne) in Germany. Filming took place in six countries - Australia, Britain, France, Germany, Italy, and the United States - but this did not mean the series was conceived in terms of national schools of art. Sandy Nairne wrote the script, Geoff Dunlop directed and John Wyver produced. A tie-in book written by Nairne with photographs by Dunlop was published simultaneously by Chatto & Windus, and an exhibition of works featured in the programmes, curated by Nairne and James Lingwood, was shown in London, Newcastle upon Tyne, Preston and Bradford. Also, Barbara Kruger's poster *We don't need another Hero,* specially commissioned as part of the series, appeared on billboards throughout the country.

Nairne (b. 1953) had previously organised exhibitions at the Institute of Contemporary Arts, London, so he was well informed about the artworld of the 1980s. He thought it odd that no major TV series had addressed itself to current art and the issues that were being fiercely debated by living artists and theorists. *State of the Art* was conceived, therefore, as a synchronic slice through contemporary art. Although the series was international in scope - featuring twenty-six British, American, German and Australian artists - no attempt was made to supply a comprehensive survey. Artists and works were selected in relation to six themes:

1. history, the modern and post-modern;
2. value, commodity and criticism;
3. imagination, creativity and work;
4. sexuality, image and identity;
5. politics, intervention and representation;
6. identity, culture and power.

These categories can be criticised - a feminist artist presumably belongs in both 'sexuality' and 'politics' - but clearly some division of the material had to be imposed to achieve a modicum of order and coherence.

The makers of *State of the Art* were keenly aware of the limitations of previous arts programmes and were determined to find an alternative. The biographical, psychologising study of an individual artist favoured by so many programme makers was rejected as a model, as was the 'personal view' pundit series, as was the overview of modern art in terms of a spectrum of styles or a chronological sequence of 'isms'. Two precedents were respected: the Open University's *Modern Art & Modernism* series and Berger's *Ways of Seeing*. However, the OU programmes were addressed to a narrow constituency and ended with the art of Jackson Pollock, while Berger's series excluded contemporary art practice. Furthermore, significant changes had taken place since 1972 - the date *Ways of Seeing* was transmitted - most notably, the advent of 'the post-modern condition'.

State of the Art was itself the consequence of developments in the discourses of criticism, film theory and art history during the period 1968-85. Sustained critical and theoretical analyses within these discourses had produced, by mid-1980s, a much greater understanding of the part played by artworld institutions - artschools, the art market, arts agencies, councils, museums and galleries, the art press, and so on - in determining what counts as art and how it acquires value. This meant that *State of the Art* could not confine itself simply to artists and artworks; it had also to consider economic aspects and the discourses and institutions of the artworld.

Another change which had occurred since the conceptual art movement of the late 1960s, was that artists had become more articulate: many now engaged in theoretical as well as practical work. The activities of these artists tended to follow from a critical engagement with ideas and political issues, and to foreground problems of representation. Filming and recording such artists necessarily involved attempting to present the intellectual and social issues informing their art. For this reason there were extended interviews with a small number of artists in each programme. A mirror device was used during the shooting of interviews so that the artists appeared to be talking direct to the viewer rather than to Nairne, the questioner.

A new documentary series not only had to take account of changes within the realm of art but also within the realm of television itself. Rock videos, computer graphics title sequences, new complexly structured drama and crime series, all indicated that the medium had become visually much more sophisticated. Any arts programme which failed to respond to these changes was in danger of being perceived as old fashioned. The film-makers employed 16mm for its flexibility. Still camera and tracking shots were preferred to pans and zooms.

Given the above, Nairne decided to focus upon those issues, forces and contexts which influence the art and artists of most of the advanced Western nations. While he was the chief instigator of the series, the planning stages involved close collaboration with Dunlop, Wyver and others. Ideas were debated at length and the form and style of the filming were discussed simultaneously with the contents. To avoid 'the presenter as hero' syndrome, Nairne did not appear in front of camera nor did a lone male voice dominate the soundtrack. In fact, the script and the book feature a higher than usual proportion of quotations and interviews. Among the critics and theorists quoted were: Walter Benjamin, Rosetta Brooks, Stuart Hall, Frederic Jameson, Donald Kuspit, Jean-François Lyotard, Edward Said and Judith Williamson.

The Brechtian quotational tactic was invoked in order to avoid the single, authoritative, omniscient author and to present a challenge to viewers. Instead of passively consuming predigested art appreciation, viewers were expected to engage intellectually with a montage of words and images. Contrasting aesthetic theories and political positions were juxtaposed in order to show that contemporary art is both heterogeneous and a site of contestation.

When asked about his aims, Nairne replied:

> I wasn't interested in saying this is what I, Sandy Nairne, want to say about contemporary art. We are asking: 'What are other people saying? What are the arguments?' We wanted to bring out the fact that most things in contemporary art are very much in contest. People *don't* agree... We are trying to say art is not a reflection of society, but *part* of society, part of the contest of images that happens everywhere, whether it's in advertising, the media or television.[1]

Clearly, Nairne's intention was to put his personal preferences and views aside and to approach art in a quasi-anthropological way by investigating and reporting it as objectively as possible. What he wanted to avoid was a readymade evaluation which absolved the audience from the genuine problems of coming to terms with the multifarious work produced by living artists. As we shall see later, this approach provoked some adverse criticism. Sympathetic critics saw Nairne's decision to stand back in order to let others speak as an admirably modest, self-effacing act, whilst antagonistic ones saw it as an abdication of authorial responsibility.

Although *State of the Art* had no single author or point of view in the traditional sense, it is true of course that the material it contained had been *selected, arranged and edited,* consequently it cannot be claimed the series was ideologically neutral or undetermined. The very willingness of the makers to address issues of commerce, politics, feminism, race and colonialism as they relate to visual art signified certain obvious political sympathies. It was indeed refreshing to find a major art series which considered it essential to feature a number of black and women artists.

Nevertheless, the deliberate plurality and eclecticism of the contents indicated a degree of objectivity absent from programmes in which connoisseurs celebrate only what they personally admire.

Any truthful description of even a small part of the international artworld was bound to reveal examples of bad and mediocre art as well as good art. It was bound to include reactionaries as well as progressives, those motivated by private gain as well as those inspired by social ideals. If the negative aspects had been ignored or edited out, as some critics of the series seemed to want, then a bland and dishonest picture would have resulted. Of course, there is a danger that the inclusion of aesthetically poor and morally suspect art will be seen as a sign of approval or endorsement, an unwillingness to discriminate and make value judgements. But if questionable imagery is always censored in advance, or accompanied on television by moral condemnation, then the viewers' thinking is being done for them.

Montage in the cinema and on television involves the juxtaposition of two or more images or scenes (or images and words/music) so that a 'third effect' meaning results from the *relation* between the distinct elements made by the viewing subject. This basic technique was often employed in *State of the Art.* For example, in programme four on 'sexuality' film of the work of artists critically examining issues of sexuality and gender was intercut with scenes showing the uncritical reproduction of sexual stereotypes in the fashion and advertising industries. Also, there was a recurring shot of a printing press in operation. At the end of the programme, we discover it has been printing Kruger's poster which we see being pasted up and then obliterated by another poster for Mary Quant make-up. These juxtapositions established the context of representation within which feminist artists labour, and indicated the difficulty they face in communicating with the public when their message is so often drowned by the more powerful voice of the mass media.

Normally, the soundtrack of a film or TV programme simply echoes the contents of the images being shown but this need not be so. Words and music can be used as a counterpoint to the imagery in order to generate additional layers of meaning, contradictions or ironies. Repeatedly, in *State of the Art,* the disjunction between the verbal and visual dis-courses was exploited thereby producing a more complex than usual televisual experience.

Appropriately, for an up-to-the-minute series, the first programme looked at the relation between artists and the past. After posing the question in general terms and explaining the crisis in culture signified by the expression 'post-modernism', the works of four artists who employ historical styles, or who make history part of their content, were singled out for closer scrutiny: the Italian Carlo Maria Mariani, the Germans Anselm Kiefer and Jörg Immendorff, and the American Jonathan Borofsky. (Kiefer, incidentally, refuses to give interviews and this applied even to *State of the Art.*) The general-to-particular, abstract idea-to-concrete

examples movement was followed in most of the programmes. Sometimes, the programme's introduction was highly effective and aroused a sense of expectancy and intellectual excitement which was never quite fulfilled by what followed. This was because at times the artists selected as instances of the working out of the problem proved to be an anti-climax. Or, possibly, the issue being addressed was lost sight of by the film-makers once particular examples began to be considered.

Programme two, about 'value', promised to be one of the most helpful and illuminating given the mysterious relationship between aesthetic value and monetary value. Examined were some, but not all, of the different locations in which validation and valuation occur once an artwork leaves an artist's studio, that is, the private collection, the commercial gallery, the public museum, the art magazine, the public site. The specific examples featured were: the Deutsche Bank collection; the Michael Werner and Mary Boone galleries in Cologne and New York respectively (it seems Boone, the American dealer, was upset by the film-maker's activities and threatened legal action to stop the documentary being shown); the new Museum of Contemporary Art in Los Angeles; Battery Park, and the Federal Plaza, New York (with its controversial steel sculpture by Richard Serra); and the private collector Douglas S. Cramer. The latter is a Hollywood producer associated with the TV soap opera *The Colbys*. Extracts from this popular series were shown to illustrate the use of art in American soaps. Arguably, too much time was devoted to this item.

Although the programme was in certain respects highly informative, overall it was a disappointment. Basic theoretical clarifications, such as the distinction between use-value and exchange-value in art commodities, were not stressed enough and the question 'Is aesthetic quality/value absolute or relative?' was never tackled head on.

'Imagination, creativity and work', the themes of programme three, were no doubt considered by many viewers to be the most central to art. The opening scenes contrasted the different kinds of labour found in society in order to establish the special status accorded that of the artist's. Then examples of Joseph Beuys' installations and sculptures were shown and the artist himself expounded his utopian idea 'everyone can become an artist'. Beuys died in 1986, so his appearance was moving to his admirers. The second artist featured was the British, figurative sculptor Antony Gormley. Film of the artist at work in his studio made clear the casting process involving live models he uses to make his lead statues. Miriam Cahn, a Swiss artist little-known in Britain, was the third one shown. She was filmed hand-smearing her large drawings made with black chalk dust and talking about her imagery and creative methods. Cahn was one of the finds of the series. Since she opposes the idea of preserving art forever, her view was contrasted with that of the conservation department of the Tate Gallery in London.

Finally, the work of two leading British artists - Howard Hodgkin and Susan Hiller - was explored. By including both men and women artists, the programme succeeded in identifying some differences between male and female conceptions of creativity. In terms of form and content, the work of these five artists had little in common. What the artists seemed to share was a humanistic outlook and a faith in the social value of artistic creation in a world of strife and destruction.

Programme four - 'Sexuality, image and identity' - reflected developments in feminist theory and art since the late 1960s. Via film of fashion modelling and the photographic role-playing of Cindy Sherman, the theme of how women are represented and how their identities are constructed was broached. Alexis Hunter, a British painter whose expressionistic style and imagery embodies female emotions and sexuality, served as an example of an artist attempting a critical self-exploration. The only man to appear - the fashionable American painter Eric Fischl - was cited in order to pursue the question of eroticism in art and the appropriation of feminist ideas by male artists. As the commentary made clear, some people find Fischl's voyeuristic scenes quasi-pornographic. Their very ambiguity enabled him to defend them. The role of psychoanalytic theory in contemporary feminist art was then explored via the work and teaching of Mary Kelly. In conclusion, the programme looked at Barbara Kruger's pithy slogans and bold graphics whose contents are generally inspired by feminist and political ideas. This programme probably attempted too much. A whole series would be needed to do justice to the complexities of the issues addressed by feminist art.

Kruger could equally well have appeared in programme five because it examined the contentious issue of art's relationship with politics. A prologue showing the flickering screens of a TV news control room reminded us of the mass media's immense production of images and its editorial power to decide what counts as news. This is the context within which fine art now functions. Art, the programme argued, is nowhere near as powerful as the media, but it can influence how we interpret images and supply alternative representations.

Six artists were chosen to exemplify different kinds of political art: the American painter Leon Golub, whose work often deals with the subject of torture in South America; the German-American Hans Haacke, whose mixed-media installations present critiques of the political roles of big business and nations such as South Africa, plus the institutions of the artworld; Peter Dunn and Loraine Leeson, two 'community artists', whose billboard projects in London's Docklands during the 1980s were interventions within a specific, local struggle; Victor Burgin, a British photographer and theorist, whose work is primarily concerned with the politics of representation and is informed by feminism and psychoanalysis; and, finally, Terry Atkinson, another British artist whose sardonic paintings and drawings are about nuclear weapons and the problems of Northern Ireland.

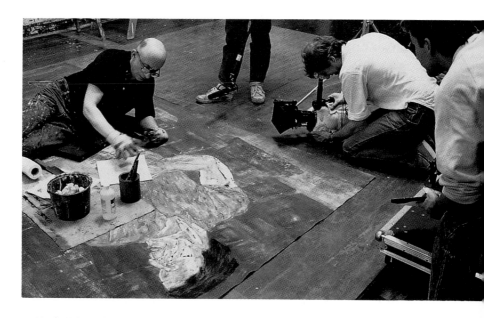

fig **28** | Leon Golub at work in his New York studio in 1985 being filmed by *State of the Art* cameraman Jeremy Stavenhagen.

PHOTO REPRODUCED COURTESY OF GEOFF DUNLOP AND ILLUMINATIONS, LONDON.

All these artists can be described as being on the left of the political spectrum. This was a weakness of the programme because it neglected to show that art can be right-wing too. One strength of the programme was its willingness to pose awkward questions. For instance, Golub was asked how he coped with the purchase of his paintings by wealthy collectors such as Charles and Doris Saatchi.

'Identity, culture and power', the final programme, was probably the most original in conception because it tackled a complex subject rarely addressed by arts television. The subject was cultural identity in a global context - how artists from different countries, races and cultures relate to the 'international' culture represented by major exhibitions such as the Sydney Biennale of 1986; how a 'provincial' country like Australia relates to the more powerful cultural centres of Europe and the United States, but also how black, aboriginal artists relate to the white-dominated artworld of Sydney.

The first half of the programme was set in Australia. This was instructive for European and American viewers and it signified television's belated recognition that, in the 1980s, Australia produced artists and theorists comparable to those anywhere in the world. Art and culture in Australian cities is now part of an international system. Imants Tillers, an Australian painter whose multi-panel pieces are based on images derived from other artists was interviewed concerning his strategy of appropriation. Next, Michael Tjakamarra, a traditional aboriginal artist, was shown at work and questioned about the future of his people's culture.

The scene then shifted back to London and New York in order to examine the situation of black artists from ex-colonial/slave populations who now live in predominantly white cities. In London, the artists featured were Lubaina Himid, Sonia Boyce and Sutapa Biswas, while in New York the collaboration of Andy Warhol and the post-graffiti artist Jean-Michel Basquiat was illustrated.

Programme six proved confusing - it probably tried to address too many topics. Its conclusions also seemed unsatisfactory, but this may well have been due to the fact that there are no easy answers to the problems discussed.

In terms of audience figures and sales, *State of the Art* was a considerable success: the programmes were watched by between four and nine million viewers; the series was bought by thirteen countries; and the tie-in book sold 10,000 copies. *State of the Art* was widely reviewed and evoked a range of responses, some favourable and some vituperative. Amanda Sebestyen, writing in the left-wing magazine *New Socialist*, equated the post-modernism of the series with mannerism. She claimed the accompanying exhibition was 'rudimentary' and the book 'bitty'. The 'sexuality' programme she criticised for excluding consideration of homosexuality and she also complained it half-buried its subject under 'a snowstorm of sociologism'.[2]

Peter Fuller (1947-90), the pugnacious English art critic, reacted with wholesale condemnation in an article apocalyptically entitled 'The great British art disaster'. The series, he wrote, 'in so far as it is not just mindless cacophony ... presents an alliance between two philistinisms: that of the old New Left, and that of the yuppie, or managerial, end of the (relatively) New Right. They are united in their "progressive" contempt for duty, taste, skill and position.' Fuller described Nairne as one of 'a new breed of art bureaucrat' and claimed he 'offers no vision, and affirms no value. He wishes only to assert the relativity of all aesthetics, and the validity of *any* idea, however venal, or contradictory, it may be'.[3]

It has already been argued that certain values and convictions do underpin the series, even if they are ones Fuller did not share. But also that the objective reporting of the series was bound to expose material of dubious merit. The trap into which Fuller fell was that of blaming the messengers for the bad news they brought. As far as Fuller was concerned, only one artist of real stature appeared in the series: Howard Hodgkin whose 'sumptuous picture glows among all this anti-art like a phosphorescent jewel dropped on a rubbish tip'. If Fuller could make such discriminations, then perhaps other viewers could too. What Fuller wanted was to restrict arts programmes to those artists lucky enough to receive his stamp of approval. He was unwilling to admit that no consensus as to aesthetic value exists in relation to contemporary art. His desire to impose a single canon of taste - his own - was simply an authoritarian fantasy. He also refused to recognise that there are a host of issues of importance concerning the visual arts besides that of aesthetic quality.

Another weakness of Fuller's diatribe was his failure to discuss the *televisual character* of *State of the Art.* During the latter part of his life, Fuller appeared in a number of TV discussion programmes and he wrote/presented some films of his own, nevertheless he showed no awareness that film and television are audio-visual media in their own right.

A review of the programmes which did consider them as instances of film/television, was written by the theorist and Middlesex University lecturer Jon Bird. His assessment was generally favourable - 'intelligent and provocative' - but in conclusion he wrote: 'it is hard to know what a viewer partially or totally uninformed about contemporary international visual art might make of this series. The ambitious nature of the project implies an active and critical public'.[4] Undoubtedly, the series did assume a certain level of sophistication and specialist knowledge on the part of viewers not just of art but of the language of film and television. Such an audience exists and it is surely legitimate for programme makers to address it from time to time (must arts television always be for the novice?). 'Difficult' programmes are surely more acceptable now - in the age of video-recorders - because viewers can watch them again and again until understanding is reached. Tie-in books can also help beginners.

fig 29 | A Biff cartoon satirizing academics who use TV arts programmes for teaching purposes. It appeared in *The Guardian* on 21 February 1987 at the time the series *State of the Art* was transmitted. Copyright Biff Products.

REPRODUCED BY PERMISSION OF BIFF AND *THE GUARDIAN*.

Another serious and complex analysis of the series was provided in 1988 by the British art critic John Roberts. Like Bird, he valued the series highly and welcomed its intertexuality, its willingness to foreground contradiction and to acknowledge that art is the result of competing value systems. He especially praised its 'attempt to *secularise* art's production and consumption. By showing that art participates *in* the world, is made out of extant cultural and cognitive materials, it also shows art to be at work *on* the world'.[5] However, he also identified some weaknesses: the series failed to make clear the different degrees of success (economic and critical) enjoyed by the featured artists; by avoiding the word 'socialism', it failed to connect the artists who are critics of the present socio-economic system to any political programme for reform. Reflecting on the televisual character of the series, Roberts observed:

> The use of a systematic intertextual aesthetic... has advantages and disadvantages. On the one hand, it clearly offers an advance in the complexity and texture of argument over the profile and lecture, but given the tendency of anti-narrative strategies to weaken causality, it can also reduce ideas to a heterogeneous soup. The liberation from the 'pretence of relaying a Real'... can just as easily fall into a politics of representation which is as much assimilative and relativist as 'dialectical'.

The issue of relativism was to remain on the agenda of British arts television: witness BBC 2's 1991 series *Relative Values* (of which more later).

State of the Art may have promised more than it finally delivered, nevertheless it set a new standard in the discussion of contemporary art on television which future programme makers will find difficult to transcend.

References

1. M. Currah, 'Images for the eighties?' *City Limits,* January 15-22, 1987, pp. 16-8.

2. A. Sebestyen, 'The mannerist marketplace', *New Socialist,* March, 1987.

3. P. Fuller, 'The great British art disaster', *New Society,* January 23, 1987, pp. 14-7.

4. J. Bird, 'Notes: *State of the Art'*, *Artscribe,* March/April, 1987, pp. 11-2.

5. J. Roberts, 'Postmodernism, television and the visual arts: a critical consideration of *State of the Art'*, *Picture This,* ed. P. Hayward, London & Paris, John Libbey, 1988, pp. 47-62.

fig **30** | Michael Berkeley composer and presenter of *Front of House,* 1990.

PHOTO REPRODUCED COURTESY OF BRITISH SATELLITE BROADCASTING.

fig **31** | Publicity flyer for a programme about the state of British art education,
Signals, Channel 4, March 8, 1989.

PHOTO REPRODUCED COURTESY OF CHANNEL 4.

Television in the third age of Broadcasting continued

Cable and satellite

In Britain the situation in regard to cable and satellite television proved much more problematical than in Europe and the United States. Cable TV - transmitting programme signals via coaxial or fibre-optic cables buried in the ground - does exist here but to nothing like the same extent as in the United States and Canada. So far it has not proved nearly as popular with the British public or City investors as its promoters hoped.

Cable TV is especially useful in areas where aerial reception is poor. The cables - particularly the new fibre-optic ones - have the capacity to carry up to fifty channels simultaneously. Cable also has the advantage that it is two-way, hence viewers have the ability to 'talk back' to the medium: electronic banking, shopping, voting and home security links to emergency services are all possible. As a means of delivery, cable can be used for low cost, local, community or educational broadcasting (for instance, several university campuses have their own systems relaying educational material), or for commercial, entertainment channels (for example, viewers can subscribe to a movie channel).

During the 1970s, community artists, particularly community video groups with portapaks, were keen to exploit the social and creative potential of cable TV but how to fund such a service remained a problem. Britain's first local, cable station - Greenwich Cablevision - was established in 1972. It was one of five experimental licences granted by the Government under strictly controlled conditions (no advertising or business sponsorship, no public money, local programmes only). The other four stations were at Bristol, Sheffield, Swindon and Wellingborough. The first wave of cable in the 1970s was followed by a second, more commercially-orientated wave in the mid- 1980s. All new cable franchises

involved some commitment to access and local programming but, it has been argued, only Aberdeen managed to preserve the community access ideal.

According to figures supplied by the Independent Television Commission (ITC), by the summer of 1991 there were 128 cable operators holding the new broadband franchise, but only thirty-seven of these were in operation. The number of broadband homes connected was 191,610, while the total number of homes connected by cable in Britain was 429,577. When an area was wired up 20% of homes, on average, agreed to take the service. Fifteen programme channels are currently being provided. (It should also be remembered that many BBC and ITV viewers and subscribers to satellite TV actually receive their programmes via cable.) Judging by the extracts from Manhattan Cable, shown on Channel 4 in 1991, the contents of British cable TV programmes are nothing like so heterogeneous, salacious and outré as those of some American stations.

The Soviet Union launched the World's first satellite - the Sputnik - in 1957. Five years later the United States launched the first communications satellite - Telstar 1 - capable of relaying television pictures across the globe. (Joe Meek had a hit record named after this satellite in Britain during the 1960s.) However, it was not until much later - the second half of the 1980s - that privately owned satellite channels began to make an impact in Britain. The take-up was slow because many viewers were reluctant to pay for yet more television (when they already had four national channels plus rental video shops stocked with popular movies) and to invest in the additional hardware needed, in particular the ugly, round or square outside aerials. As in the 1950s, environmentalists complained about the disfiguring effect of these aerials on the appearance of houses. The mass market character of satellite programming also prompted the snobbish observation that the dishes indicated where the most stupid people lived.

Initially, 'The Arts Channel' was an early morning European cultural programme transmitted via the satellite Intelsat VA F11. It was directed towards cable heads for recording and later transmission to individual homes. John Griffiths, a former Liberal Party president, founded it in 1986. The Welsh Development Agency gave him a grant to move his offices from London to Ebbw Vale, Wales and the major financial backer was the bookshop chain W. H. Smith. The Arts Channel cost £3.5 million to establish and attracted between one and two million viewers, but its revenue from subscriptions only reached £250,000. The content appears to have been safe and conservative: programmes included recordings of the performing arts and John Julius Norwich escorting viewers around country houses.

For a while The Arts Channel was transmitted for three hours per day (after midnight) via the 'Sky' satellite system, but it folded in 1989 because of low audiences. (Sky was a foreign system - owned by Rupert Murdoch - beamed at Europe; it used a medium-powered, sixteen-channel satellite called Astra and came on air in Britain in February 1989. By 1990, Sky programmes were being watched by 1.6 million British viewers.) The

failure of The Arts Channel suggested that the specialisation, or niche marketing, associated with cable and satellite is not suited to minority/highbrow subjects, that the result is an arts ghetto. Some observers are sceptical of the promise that more TV channels means more choice. They fear multiplication will not equal diversity, and they also suspect that the decline in the public service ideal, plus the internationalisation and commercialisation of the medium, will mean the end of so-called 'quality' programmes. [1]

Certain broadcasters have concluded that if arts programmes are to appear on cable or satellite in the future, then they must be incorporated into general channels, that is, those covering a wider spectrum of topics. This appears to have been the thinking behind British Satellite Broadcasting (BSB) which came on air in April 1990. (BSB was backed by a consortium of British companies and was designed specifically for the British public. When it was awarded its franchise, it was under the false impression that it would have a monopoly of satellite broadcasting over Britain. BSB used a satellite called Marco Polo and employed technology of a newer, higher-powered kind than Sky. Unfortunately, it had teething troubles and was launched after Sky had cornered the market.) It had five different channels two of which were devoted to the popular arts of the cinema and music (the movie channel and the so-called 'Power' station that relayed rock and pop music). The other arts were featured at the weekends on the 'Now' channel whose overall content was described as 'lifestyle'.

Like Channel 4, BSB bought in programmes from a number of independent production companies, for example, Unitel (a German company), National Video Corporation, Landseer Productions and RM (Reiner Moritz) Arts of Munich and London. In the Autumn of 1990, BSB scheduled twenty hours of arts programming each weekend for the 'Now' channel. Emphasis was placed on the performing arts - opera, dance and classical music concerts - but there were also interviews, profiles and documentaries about visual artists, plus a regular preview programme called *Front of House.* The latter, produced by Landseer, was hosted by such luminaries as Humphrey Burton, Mel Cooper, Valerie Solti and Michael Berkeley.

By the early 1990s, investment in satellite TV had reached £1.25 billion, but both BSB and Sky were sustaining losses of millions of pounds every month as they competed and struggled to persuade people to subscribe. In November 1990 the slow public response to BSB precipitated a financial crisis and the company was taken over by Murdoch's Sky Television. The merged company was renamed BSkyB and offered viewers a choice of five channels. In terms of content, sports and movies predominated. The founders of BSB had been committed to quality as well as popular television but commercial imperatives made the former unsustainable. At the time of writing, it appears that coverage of the fine arts has disappeared from satellite TV in Britain.

Telematics and Interactive art

'Telematics' is a term devised by Simon Nora to describe the new electronic technology derived from the convergence of computers and telecommunication systems. His 1978 report to the French Government - *L'Informatisation de la Société* - led to the establishment of the 'Programme Télématique'. The term was subsequently adopted by Roy Ascott, the British artist and art educator, who with others around the globe has employed international computer-telecommunication systems to generate interactive artworks. (The first, live two-way satellite video transmission by artists took place between the East and West Coasts of the USA in 1977.) Since several people contribute to the making of a work, such networking undermines the traditional conceptions of authorship and individualism associated with the fine arts. Besides Ascott, artists involved in this kind of activity have included Eric Gidney (Australian), Tom Sherman (Canadian) and Robert Adrian X (Austrian).

Without participating in these networks it is difficult to judge the nature and quality of the art produced, however, it is clear that the technologies of satellites and computer systems permits the generation of a new kind of art that is collaborative, international and interactive. In his articles on the subject, Ascott stresses 'connectivity', 'transformability' and the challenge to the hierarchical character of high culture. He is critical of broadcast TV on the grounds that it has anchored itself to the conventions of the cinema, theatre and music hall. Unfortunately, arts programmes on British television have so far ignored the new realms Ascott and his colleagues are exploring.

Video-recorders/cassettes

Videotape recording machines were successfully demonstrated by the Ampex Corporation in the United States as early as 1956, but VCRs and pre-recorded videotapes in cassette form for home use only became widely available in Britain in the 1970s. Phillips were the first company to market a VCR in 1972. Initially, buyers had to choose between several incompatible formats: Sony U Matic, V2000, VHS and Betamax. The VHS system, made by JVC (trademark of the Victor Company of Japan) triumphed because it came with a wider range of software. VCRs proved very popular with the British people: by 1983 Britain had the highest saturation of machines in the World.

VCRs offered viewers five, new possibilities: first, the ability to record existing broadcast programmes; second, the time-shift capability; third, the chance to watch the same recording many times; fourth, an alternative - via rented or purchased tapes - to broadcast TV; and fifth, the ability to show amateur, home videos made with camcorders.

Although arts videos are never likely to rival rock music and movie videos in terms of popularity, they could become more commonplace in the future. There might well be a small market for video art cassettes, for

instance. *Videola* (Videolabel, 1989-), a British magazine published in video-cassette form, sold via record stores, can be regarded as a prototype. *Videola* features original works by experimental video artists and musicians such as Kevin Godley, Lol Creme and Zbig Rybczynski. In the United States a market for such tapes already appears to exist: Electronic Arts Intermix of New York distribute over a 1,000 tapes by 120 artists and Facets of Chicago publishes a mail-order catalogue in which videotapes by artists like Bill Viola and Juan Downey are listed alongside Hollywood movies.[2]

Museums are another source of arts videos: the existence of videotape guides to the National Gallery's collection, on sale in shops, has already been mentioned. During the early 1990s, the Arts Council explored the possibility of increasing its involvement in the production of arts films and videos for television transmission and distribution via videotapes. Rodney Wilson, director of the Council's Film, Video and Broadcasting department, proposed to 'build new audiences' by founding a new company called 'Arts Council Television' with a funding of £1.5 million (the plan was later abandoned). Another proposal involved 'a home video catalogue of Arts Council films for release through public libraries'.

Wilson's initiatives were prompted by fears that a new Broadcasting Bill (1989-90) introduced by the Conservative Government, which no longer requires ITV companies to inform and educate, threatens the existence of quality television and puts arts programming at risk. In the regions, relatively expensive documentaries about the arts have already been displaced by cheaper, journalistic programmes of the 'what's on' variety. The intention of the Bill was to increase competition and to pave the way for a fifth commercial channel. (Due to an unfavourable economic climate and other problems, a fifth channel in 1993 now seems unlikely.) It also applied the publishing model associated with Channel 4 to the BBC and ITV: it stipulated that in future 25% of newly- commissioned programmes must be supplied by independent production companies. A significant number of BBC and ITV staff were made redundant as a result. Concern was expressed that the BBC will not be able to train staff as it did in the past and that this could have serious consequences in the long term, even for the independent sector. Naturally, the 25% rule was regarded more positively by the 'indies' and it may help to maintain the diversity of arts television.

Terrestrial channels

In contrast to the teething troubles of cable and satellite outlined above, existing terrestrial channels in Britain witnessed a boom in arts programming in the late 1980s. Respected, long-established programmes like *The South Bank Show* and *Omnibus* continued to appear, as did the pundit series of Edward Mullins, but they were joined by several newcomers: *Signals, The Late Show* and *Club X*. Television also began to present special events such as 'The Week of British Art' (BBC, May 1988)

and 'retrospectives' such as 'Ten Green bottles' (BBC 2, November 24, 1988), a compilation celebrating a decade of *Arena.* The latter demonstrated that British television had become old enough to reflect on its own history and to repeat past programmes for the benefit of new generations of viewers.

Signals

In the Autumn of 1988 Michael Kustow, Channel 4's commissioning editor for the arts, announced a new mid-week, prime-time arts series of twenty-two, hour-long programmes to be called *Signals.* Roger Graef was appointed chief editor. His previous experience had not been with arts programmes but with fly-on-the-wall documentaries about subjects like the police force. Despite tight budgets, short production and post-production times, Graef was convinced he could bring a fresh approach to arts subjects and broaden the audience by means of a popular address defined as 'friendliness, openness, directness, accessibility'. He wanted, he said, to avoid preaching to the already converted.

Signals' proposed populism was demonstrated in an early programme about contemporary dance which challenged the distinction between professional and amateur by bringing both together for a special festival of dance set in the streets of Leeds. Despite heavy rain, a Betacam video-recording was made which conveyed the tremendous enthusiasm, energy and stylistic diversity of the British dance scene. The Northern location was important: Graef was determined to show that exciting cultural events occurred outside the capital. The inclusion of many black performers was also significant: the culture of Britain's ethnic minorities has lacked media representation (it tends to be confined to specialist, ethnic minority programmes such as *Network East* [BBC 1, 1988]).

Other topics tackled by *Signals* included the neglected art of typography, the work of the American composer Steve Reich and the British sculptor Antony Gormley, prison art, modern architecture, Steinbeck's *Grapes of Wrath,* the state of British art education, originality and plagiarism in new art. The latter programme - 'The shock of the neo' (February 1, 1989) - was written and directed by Geoff Dunlop and produced by Holmes Associates for Channel 4; it was notable for the appearances of the fashionable, post-modern theorist Jean Baudrillard and the New York conceptual painter Mike Bidlo, and for its exploitation of post-production video techniques.

Sometimes a whole programme was devoted to a single subject. For instance, 'Art on Trial' concerned the court case against the artist Rick Gibson and the gallery director Peter Sylveire (Gibson was judged to have outraged public decency by making an earring out of a dried human foetus). At other times a magazine-format was adopted but no regular presenter was used. The variety of subjects tackled was matched by the diversity of ways in which topics were treated, but since no single format or style predominated, the series lacked coherence.

Graef's populism risked alienating the existing sophisticated audience for arts programmes. Press reaction to the first few episodes of *Signals* was certainly hostile. Reviewers judged the series hurried, unimaginative and lamentably executed. Andrew Brighton, writing in *Art Monthly,* accused it of setting out to show that art, like television, is a form of entertainment. This, of course, is not how he conceives of art or 'imaginative culture' as he prefers to describe it.

Graef's response to the chorus of complaint was to condemn the snobbishness and intolerance of highbrow critics whose horizons, he claimed, were limited to the capital city. It was surely unfair of the critics to condemn the series before it had had a chance to establish a track record. After only two seasons *Signals* was axed by the new commissioning editor for the arts at Channel 4 - Waldemar Januszczak (an art critic who writes for *The Guardian*) - on the grounds that it was 'too apologetic', and because he thought it wrong that one independent production company - Holmes Associates - should dominate the Channel's arts coverage.[3]

References

1. See Graham Murdock's contribution to *Art and Television: transcript of a one-day conference held at the Victoria & Albert Museum May 19 1990,* London, National Art Library, V & A/Wimbledon School of Art, 1991.
2. C. Hagen, 'The fabulous chameleon: video art', *Art News,* 88 (6), Summer, 1989, pp. 118-23.
3. A. Bati, 'Arts flagships up periscope', *The Guardian,* July 26, 1990, p. 26.

fig 32 | **Title image** for *The Late Show.*

PHOTO COURTESY OF BBC TELEVISION.

Review Programmes

The late 1980s witnessed a proliferation of review or 'magazine' programmes. This type of programme generally consists of a number of fairly brief items - five, ten or twenty minutes each - about different aspects of the arts. Like the review sections of newspapers and 'what's on?' or listings publications, the programmes are concerned with topical events such as current exhibitions, new books, films, plays, buildings, etc. Examples include: *Review* (BBC 2, 1988), *01 For London* (ITV, 1988-) and *The Late Show* (BBC 2 1989-). Budgets for review programmes are normally much less than for 'flagship' series like *The South Bank Show,* or for pundit series like *Civilisation,* so production values are more modest. Several 'magazine' programmes dependent upon pre-recorded material have failed, so it's a problem for producers to get the formula right.

The fact that coverage extends across a range of media and artforms is valuable but the overall quality of each show is clearly dependent upon the particular concatenation of items. Various kinds of presentation are routinely employed: the guided tour of an exhibition or a building; the interview with an artist or performer; the filmed report; the studio discussion; the live musical performance; and so on. Some producers use presenters and link persons while others prefer a rapid-fire succession of items without any introduction, links or contextualisation.

Review programmes have the qualities of immediacy and novelty, but they can prove frustrating in their inability to explore any topic at length and in depth. The work of young and lesser-known artists is more likely to be publicised than in major arts series but even here there is a herd-like tendency: the same tiny number of new exhibitions (or novels or films or plays) will monopolise the media's attention at any one time. Big shows at major galleries will tend to attract all the attention while offbeat material in minor venues is ignored. Many artists produce significant work in their studios but if they are unable to obtain public exposure in galleries, then they are generally condemned to media oblivion. There is so much art activity in the public domain to report, that arts programme makers have little incentive to undertake journeys of discovery.

In the case of programmes like *01 For London* (sponsored by the London evening newspaper *The Evening Standard*) - rapid-fire guides to what's on - the arts are presented as part of the spectrum of

entertainments the capital city has to offer. Reviewing is always also advertising but the brevity of description and evaluation subjects received in *01 For London* meant that their publicity character was particularly blatant.

The Late Show

This series began in January 1989. It signified a major commitment to reviewing the arts by BBC 2 under its new controller Alan Yentob and its head of Arts and Music Leslie Megahey. The forty-five minute programme was transmitted in the late evenings, four nights per week, for forty weeks in the year. Its first editor was Michael Jackson (a graduate of a London Polytechnic's media course) and his budget was £4 million (out of a total arts budget of £20 million). In 1992 a new editor - Janice Hadlow - was appointed.

For older viewers the show's title and time slot recalled *Late Night Lineup,* a fondly remembered arts and news programme of the 1960s. Over 60% of *The Late Show's* content consisted of live/studio-based items. This meant it had a freshness pre-recorded programmes lacked (live television also had the advantage of cheapness). Its frequency meant that it could cover a lot of ground and respond quickly to topical events and issues. It could also afford to be flexible in terms of format: sometimes the programme consisted of a mix of live interviews, performances and videoed reports, sometimes it consisted of a studio debate, and sometimes a filmed report from abroad. *The Late Show* proved more internationally-minded than earlier review programmes: it carried reports from Berlin, Paris, New York, Russia and Eastern Europe. In December 1991 it instituted a monthly American edition. Critics living in the North of England, however, complained that the programme was too metro-politan, that it failed to do justice to arts activities in the provinces. In 1993, a regular Scottish edition was introduced to broaden the series' geographical coverage.

In order to make art more accessible, to break out of the highbrow ghetto and to avoid the stilted formality of much arts programming, *The Late Show* adopted a direct and, at times, irreverent approach. The style of some items resembled investigative journalism. In terms of content, the programme encompassed the mass media, style and rock music in addition to the traditional fine arts. It was also willing to discuss the economic and political dimensions of the arts.

Jackson felt there was no single, authorised view of what culture was any more - contemporary culture was too heterogeneous and complex - consequently no one expert could host the programme. Various presenters, therefore, were used in rotation: Stuart Cosgrove, Sarah Dunant, Tracy McLeod, Paul Morley and Kirsty Wark. Major discussions were usually chaired by Dunant or Michael Ignatieff (the presenter of a TV series about 'three-minute culture') or Waldemar Januszczak (the art critic)

and special reports about the visual arts were supplied by Mathew Collings (the ex-editor of *Artscribe*), Andrew Brighton and Simon Watney (two college lecturers and writers). These tactics certainly resulted in a diversity of voices and opinions.

Among the topics featured during *The Late Show's* first year were the implications for the arts of new laws banning 'the promotion of homosexuality', images of the Falklands War, a Paris exhibition about the Situationists, the 'neo-geo' art of Jeff Koons and Peter Halley, the Salman Rushdie affair, work by black and Asian immigrant artists exhibiting at the Hayward Gallery, an interview with Stuart Hall, and the response of New York artists to the disease Aids.

Given the spate of new programmes and the fact that *The Late Show* appeared several evenings per week, the time devoted to the arts increased markedly (after some months of viewing, one critic complained that quantity had replaced quality). The new programmes took it for granted that there was a continuum between the fine arts and mass culture even though this led to an overlap with pop music and media programmes such as *Def II* and *The Media Show*.

Inevitably, the new programmes were patchy and at times the journalistic approach resulted in items reflecting the most vulgar and trivial news values. (For instance, in May 1990 Collings reported from America for *The Late Show* on some paintings executed by chickens belonging to Andy Warhol's brother.) By emphasising the present moment and the various contexts of artistic production, it seemed to some viewers that the BBC had abandoned in-depth studies of the careers of major artists and key works of art. Arguably, other arts series should have performed these tasks, leaving *The Late Show* free to concentrate on reviewing and debating topical issues. In spite of the criticisms it attracted from various quarters, *The Late Show* quickly established itself as essential viewing for those involved with the arts. Viewing figures were reported, in 1992, to be between 300,000 and 400,000. More, therefore, than even a well-attended exhibition at the Royal Academy (the Pop Art Show of 1991 attracted 260,000 visitors).

By adopting a pluralistic and non-élitist conception of culture and by focusing on the arts of the present, the new programmes managed to shelve the old issue of class, that is, expecting audiences at the bottom of the social scale to learn to appreciate works of art made for the aristocratic and bourgeois patrons of the past. As far as the makers of the notoriously dire *Club X* (Channel 4, 1989) were concerned, the problem was not one of class but one of age, that is, how to interest young people in the arts. *Club X* was the brainchild of artist-film-maker Nichola Bruce and Michael Coulson, her partner in Muscle Films, and it was commissioned by Stephen Garrett, Channel 4's 'editor for youth'. Various independent production companies were asked to find young, talented artists, musicians and performers and to film them for ten-minute slots. Each programme, therefore, was a cocktail of items. Four oddball presenters - Martina Attille,

Murray Boland, Joel Coleman and Fou Foy - were employed, and the programme's setting was a noisy, crowded nightclub.

The new arts programmes accepted the fact that we now live in a multi-channel environment, a multi-cultural not a mono-cultural society, that the public has splintered into fragments, that they would be speaking to minority audiences, and indeed making programmes about the art of minorities (blacks, gays, feminists, etc.). These changes were not endorsed by everyone. Joan Bakewell, for instance, a BBC arts correspondent whose career dates back to the 1960s, complained about the increasing specialisation and fragmentation revealed by programmes like *The Late Show.* She regretted the loss of 'shared values, the highest standards: tolerance, a search for the true judgement...'[1] Arguably, 'the shared values' of earlier radio and TV programmes were an illusion, a reflection of the smaller number of channels and the hegemony exercised by white, Oxbridge-educated broadcasters, not a reflection of real cultural unity amongst the British people.

Culture versus politics

Why did British television give new prominence to the arts in the late 1980s? One explanation was provided by Roger Graef, editor of Channel 4's *Signals:*

> Where left-of-centre opposition is blocked, there's a diversion
> of energy into other areas. And for some time politicians have
> been discredited as sources of insight about the world. Nobody
> recognises their own experiences in politics any more, so
> people turn to art for descriptions which are more complex
> and contradictory.[2]

When Michael Jackson of BBC 2 was questioned by newspaper journalists, he responded in similar vein.[3]

Graef was probably right in suggesting that a diversion from party politics into culture had occurred amongst people on the Left. But it should not be forgotten that British governments of all complexions frame laws in relation to freedom of speech and fund arts institutions, art education, museums, and so forth; consequently, they actively intervene in the realm of culture in order to fulfil their political objectives. This means that art cannot exist 'beyond' party politics or serve as a refuge from them. In Britain, during the 1980s there was in a struggle over culture and the future of cultural industries which gave a new pertinence to the idea of cultural struggle. And since television was itself a form of culture, it was not exempt from governmental and commercial pressures either. It was in the common interest of people working in television and the arts to seek an alliance in order to protect their freedom to innovate, investigate, question and comment.

The rise of the Artelegentsia

Arguably, an informal alliance did emerge amongst intellectuals working in the arts and media. This 'artelegentsia', as it may be called, was predominantly Left-liberal in its political complexion. It felt embattled by the success of right-wing thought and the Conservative Government under Mrs Thatcher in the decade 1979-89. It was suspicious of the increasing commercialisation of art and culture, that is, the boom in the art market, business sponsorship, the relative decline in public funding for the arts, the shift of emphasis from public to private sources of funding associated with Thatcherism. It was also deeply concerned about the increased censorship of both the media and the arts which occurred in the 1980s and so it gave artists and theorists the opportunity to protest.[4]

Arts television's commitment to pluralism (the representation of all legitimate viewpoints) meant that even conservative positions had to be accommodated. Right-wing thinkers, therefore, were invited to appear on panel discussions. The philosopher/novelist Roger Scruton and the 'red Tory' art critic Peter Fuller were two defenders of traditional artists and aesthetic values who were given airtime.

Architecture and Prince Charles

Architecture is not as popular a subject with television's commissioning editors as painting and so blockbuster series about it have not been made very often. One did appear in 1986: BBC 2 transmitted a major series entitled *Architecture at the Crossroads*. It was devised and scripted by Peter Adam (a TV producer with many years experience) and it provided a wide-ranging, international survey of new architecture. It was also screened in Germany, France and Austria - expensive series such as this increasingly depended on co-production deals and international distribution. Although various cities were visited and many new structures were illustrated and many architects were interviewed, the camera tended to dwell on exteriors and the voice-over commentary on stylistic issues. TV's visual dimension means that it excels at showing the appearance of things, but in the case of successful architecture looks are not everything. Of course, the soundtrack can also supply additional information and critical assessments, but evaluations of buildings require knowledge of their interiors and how well or badly they function, and this in turn implies interviews with people who have actually lived or worked in them, not merely interviews with their designers.

Adam's series welcomed the advent of post-modernism: it was deemed to be 'accessible' and 'humane', while modern architecture was considered 'sterile' and 'rigid'. The press critic Martin Pawley condemned the series for its failure to examine the real determinants of architecture, for its over-dependence on the opinions of architects, for its lack of drawings, progress shots, and historical depth. His negative review began with the sweeping assertion: 'No-one knows how to deal with architecture on television'.

fig 33 | Prince Charles views the skyline of London from the River Thames. Publicity still from *Omnibus: A vision of Britain,* BBC1, 1989.

PHOTO COURTESY OF PRINCE CHARLES AND BBC TELEVISION.

New architecture and issues concerning the built environment received unprecedented TV exposure during the late 1980s as a consequence of the intervention of a famous public figure and watercolour painter: Prince Charles of the British Royal family. On October 28, 1988 *Omnibus* (BBC 1) broadcast 'A vision of Britain', a seventy-five minute film written and narrated by Prince Charles in which he identified what had gone wrong with modern British architecture and town planning, and what should be done to put it right. Prince Charles proved to be an urbane, competent presenter and his programme was watched by millions. There is no doubt that the vast majority of viewers agreed with his conservative, commensensical views and sided with him against modern architects and planners. This was popular arts programming with a vengeance. Prince Charles' critics complained in vain that his arguments were 'simplistic', that his aesthetic analysis ignored the deeper political and economic reasons for Britain's environmental problems.

Critiques of modern architecture had appeared on television several times before. For example, in 1979 Christopher Booker (author of of *The Neophiliacs* [1969]) scripted a five-part series called *Where we live now* and, a year later, a two-hour distillation entitled 'City of towers' (BBC 2). These programmes were a polemic against the post-war alliance of planners, architects and property developers that had resulted in the high-rise housing and office blocks of the 1960s and 1970s (by now hated and considered unsafe). Booker's analysis went far beyond stylistic evaluation; it exposed the political and economic reasons for the character of the towers that had been erected. Another example - Robert Hughes' 1980 attack on modern architecture in programme four of *Shock of the New* - has already been discussed.

The fame of the Prince Charles ensured that his somewhat belated attack received maximum attention. His purpose was to stimulate a public debate that would eventually result in changes in the training of architects and improvements in what was built. In other words, the medium of television was being used to bring about social change. Alan Yentob, Controller of BBC 2, had a similar conception of the role of television. He initiated some programmes about design - *Design 1990* (BBC 2, June-July 1990) - that awarded prizes after television evaluations of competition entries by panels of experts and after votes had been cast by members of the public.[5] Yentob's aim was to employ television to 'draw people into an argument', to set up a dialogue between professionals and the public, in the hope of improving the design of buildings and products by raising the level of awareness of consumers.

Islam and the arts

Towards the end of the decade a British religious minority, the Muslims (most of whom had come to Britain from Pakistan and India), posed the artelegentsia a serious moral dilemma. The death threat originating from

Iran against the novelist Salmon Rushdie because of his allegedly blasphemous book *The Satanic Verses,* prompted debates on arts programmes about the conflict of rights and values between Islam, on the one hand, and the freedom of expression of artists, on the other. Leading Muslims were invited to appear to put their case but when they did so they seemed like intruders. The studio context and the chairing of the discussions (by the white man Michael Ignatieff) favoured the Left-liberal consensus. A non-arts programme adopted a more cunning tactic: it presented the views of a dissident group within the Muslim community in order to subvert it, that is, a group of young, radical Asian women critical of Islamic fundamentalism on feminist grounds. This programme showed that there was a minority within the minority, that even the Muslim community was divided.

What the Rushdie case revealed was not just the ideological framework of the religious zealots, but also the ideological framework of the artelegentsia. The latter's beliefs and values were suddenly exposed to the light of day and they were called upon to defend them. Few black people were employed in British television in the late 1980s and few appeared on arts programmes or presented them. (Stuart Hall of West Indian origin, professor of sociology at the Open University, was a guest speaker time and time again because he was virtually the only articulate, black, British, Left-wing intellectual television producers knew.) Evidently, the multi-racial, multi-cultural nature of British society was not yet reflected in the composition of the artelegentsia.

Furthermore, it became obvious that arts television had paid little attention to the art and culture of Asians and Arabs. The Rushdie affair upset the long-standing assumption that the function of arts programmes was to celebrate the world's cultural diversity. The values of modernism and avant-garde art, it emerged, were at odds with those of an ancient religions such as Islam and Christianity. Different cultures, it turned out, involved living human beings with strong emotions as well as exquisite artifacts, and gave rise to extreme clashes of ideologies and even to physical violence (book burning, death threats, the murder of translators of Rushdie's novel). Art or culture was revealed as a divisive force as much as a harmonising one. In this new situation, arts programmes found it extremely hard to maintain their normal stance of art appreciation, balance and critical distance.

Post-imperial Britain, as Graham Murdock has noted, is experiencing a profound crisis in its national culture, indeed over the question: 'Whose culture is the national culture?' Arts programmes alone cannot solve this crisis, but what they could do is to ensure that the various cultures and sub-cultures within Britain are fairly represented, to examine rationally the clash of different cultures and value systems occurring in countries throughout the world, and to commission historical programmes to learn how human beings have resolved similar problems in the past without resorting to violence.

References

1. Joan Bakewell responding to questions put by Robert Carver -in- *Ariel at Bay: Reflections on Broadcasting and the Arts, a Festschrift for Philip French,* ed. R. Carver, Manchester, Carcanet Press, 1990, p. 33.

2. J. Dugdale, 'Culture clash', *The Listener,* July 28, 1988, pp. 33-4.

3. N. de Jongh, 'Screen of consciousness', *The Guardian,* July 29, 1988, p. 27.

4. Martin McLoone went so far as to describe *Signals* and *The Late Show* as 'responses to the rampant excesses of the radical right. They are more than pre-emptive strikes. They represent the arts' very fight for survival'; see 'Reviews: TV special', *Circa,* (45), May-June, 1989, pp. 35-7.

5. N. Fraser, 'The good, the bad and the extremely ugly', *The Observer,* June 17, 1990, p. 71.

'Bureau de change', 1988, mixed-media installation Matt's Gallery, London.

PHOTO COURTESY OF THE ARTIST.

British Arts
Television in the 1990s

Relative Values (1991)

BBC 2's major contribution to arts programming at the beginning of the last decade of the twentieth century was *Relative Values,* a series of six, fifty-minute programmes transmitted on Sunday evenings. The series was three years in the making and involved the research and labour of many people. Perhaps the gestation period was too long: some of the programmes had an air of staleness. Keith Alexander was the series' executive producer and some individual programmes were directed by Nicholas Rossiter and by Hannah Rothschild. Leslie Megahey seems to have played an increasingly important role as the series progressed: his name did not appear on the credits to the first programme, but by the last he was named as the writer and narrator. Acting as a consultant to the series was Philip Dodd, a writer, film magazine editor and TV presenter. A paperback written by Dodd and Louisa Buck, a freelance journalist specialising in twentieth century art, was published by the BBC to accompany the series. The text of this book explores the same topics as the programmes, but it does not duplicate the scripts.

Relative Values dealt with the issue of value - mainly monetary - in relation to art. It set out to show how values change over time and how they are influenced by various economic and institutional factors. The contents of the six programmes can be summarised as follows:

1. 'The colour of money': the role of auction houses and patrons was illustrated via the sale of a Picasso painting that eventually fetched $37 million;
2. 'Keeping up with the Medici': the power of wealthy collectors and corporate patrons;
3. 'Sweet smell of success': the part played by dealers;
4. 'Altered States': the role of nations in the movement of art; cultural imperialism and tourism. Japan and Haiti were two countries cited as examples;

5. 'The last picture show': the role of the museum in conveying value;
6. 'The agony and the ecstasy': an account of the myths, legends and media images of the artist as genius, celebrity, bohemian, saint and tortured soul.

In the main, the programmes consisted of filmed reports and interviews. Camera crews were dispatched to Europe, Japan, the United States and Haiti. They went behind the scenes into the inner sanctums of galleries and museums, the offices of auction houses and the homes of artists, film-stars and the superrich. Evidence and opinions were gathered from a wide range of art historians, dealers, critics, movie stars, collectors, museum directors and businessmen.

For the most part, the questions posed by researchers were not audible. American locations and experts dominated, presumably for two reasons: the large size and power of the American art market and the need to ensure sales of the series there. The presence of a pundit on screen was avoided but a linking commentary was supplied by the male voice of Megahey.

There was nothing exceptional about the visual style of the series and much of the content was tedious: there were too many businessmen in suits mouthing platitudes. Rapid transitions from continent to continent and from topic to topic made it hard to follow the arguments. Indeed, far too many issues were raised in quick succession, so one was left with the sense of a superficial treatment. The most successful programme was the final one dealing with the cult of the artist begun by the Italian Renaissance artist-historian Giorgio Vasari. It was enlivened by clips from Clark's *Civilisation* and from bio-pics about Van Gogh, Rembrandt and Michelangelo. It also included interviews with Irving Stone, author of several novelized biographies of famous artists, and Charlton Heston, the movie star who played the part of Michelangelo in Twentieth Century Fox's 1965 epic *The Agony and the Ecstasy.* Perceptive comments were elicited from three noted, American, female art historians: Linda Nochlin, Rosalind Krauss and Svetlana Alpers.

Relative Values attempted to demystify the cult of art. It was probably the most sophisticated and in-depth analysis of art's infrastructure that television has provided since Julia Cave's 'For love or money' (two films for BBC 1's *Omnibus,* 1977), and yet for those already familiar with the machinations of the artworld there were few new insights. The series was also dispiriting because, although there was some critical value in the detailed description of the artworld's swarm of speculators and bureaucrats, the system came across as all powerful. Few alternatives were described and the series' opening philosophical gambit - 'What would an alien from outer space make of the modern cult of art?' - indicated a desire on the part of the programme makers to stand outside human society, to avoid admitting that they too might be complicit in the system, that they might have some responsibility not merely to document the situation, but

to challenge it and to encourage alternatives.

One of few critical works by a contemporary artist featured in the final programme was a reproduction of one of Van Gogh's sunflower paintings (recently sold at Christie's for £22.5 million) made from coins worth £1,000. The work, a pithy illustration of the way Van Gogh's art has been transformed into money, was part of a mixed-media installation - *Bureau de Change* (1988) - that also included a video monitor, camera, false wooden floor, viewing platform, four spotlights and a security guard. The installation was filmed at Matt's Gallery in London. Rose Finn-Kelcey, the British artist responsible, was prompted to make it by the contrast between her own hard struggle to survive and the huge sums lavished on the work of certain dead artists. The coins used in the piece were borrowed from a bank and, when the show closed, they were returned to the lender.[1] Television programmes that repeatedly dwell upon the wealth of the artworld mislead the public as to the parlous financial situation of the vast majority of contemporary artists.

The BBC series was an extended discussion of values but the one that matters most as far as art lovers are concerned - aesthetic value - was conspicuous by its absence. Admittedly, the issue of aesthetic value raises philosophical questions that are difficult to address even in the seminar rooms of universities, so it is not surprising the majority of arts programmes avoid it. Early proposals for the series included a programme on taste but this idea was dropped.[2] The relativism underpinning the BBC series was also open to criticism. It is one thing to argue that history shows certain artists go in and out of fashion, that prices rise and fall, that monetary value changes when a so-called Rembrandt is re-attributed, and quite another to say that the aesthetic value of a picture changes over time (only the physical deterioration of a work resulting in changes in colour schemes, might be said to alter the aesthetic character of the work).

There are no aesthetic experiences without human subjects, but does the artistic quality of an artwork really vary according to whoever is looking at it? (Does a red rose cease to be red just because a colour-blind person cannot perceive it?) If one person values the paintings of Cézanne while another prefers those of Burne-Jones, is the difference between the works/responses merely a matter of individual taste? Is there really no objective difference in artistic quality between a painting by Cézanne and one by Burne-Jones? There are some critics who believe that aesthetic value is an objective property of the finest art, just as strength is an objective property of steel. One day, perhaps, arts television will be bold enough to tackle the issue of aesthetic value head on.

The debate about cultural standards

During 1990-91 issues concerning 'posh' and 'popular' culture, the quality of art, and the cultural standards evident in British arts television were hotly debated by such people as John Ellis, David Hare, Michael Ignatieff,

Michael Kustow, Angela McRobbie, Patrick Wright and Peter York.[3] York, a style and marketing expert, claimed that the 1980s had been the era of 'posh pop', that is, posh talk about popular culture, and he predicted that the 1990s would be the era of 'pop posh', that is, popular accounts of high art. (Clark's acclaimed series *Civilisation* was clearly a 1960s example of the latter.)

Other commentators argued there had been a decline in 'posh posh' - serious criticism of serious art - that the influence of the academic discipline of cultural studies upon arts television had gone too far, that the interest shown in popular culture, design and youth subcultures had demolished the boundary between art and pop culture and thereby obscured the distinction between good and bad. They felt it was time to return to a situation in which art was sharply distinguished from advertising, in which it was made clear that Keat's poems were better than Bob Dylan's lyrics, that Mozart's music was superior to Madonna's.

On December 7, 1990 BBC 1's *Omnibus* devoted a whole programme to the life and work of the American rock singer and film star Madonna. Andrew Snell, the editor, and Nadia Hagger, the producer, obviously considered her an important artist who merited a full-length profile. The subject matter of the programme increased the series' audience by over four million (7.7 million watched as against the average audience of 3.1 million). One outraged viewer was the cultural critic and *Late Show* interviewer Michael Ignatieff: he claimed that Madonna's conception of art was false, that she was not a serious artist, and that the programme was 'an amazing abdication of editorial integrity'[4]

One point needs to be made immediately: the *Omnibus* programme was not that unprecedented. The British pop stars Tommy Steele and David Bowie had been profiled in earlier editions of *Omnibus* and other strand series - *Arena, The South Bank Show* - had also featured popular culture subjects. Letters and articles subsequently appeared in the press both for and against Madonna. The fact that her work could provoke such a lively debate was surely a sign of its cultural significance, if not of its high aesthetic value.

Another criticism levelled against arts television, this time by John Ellis (of the independent, film production company Large Door), was that in treating popular culture as art, too many arts programmes were becoming 'marketing adjuncts of the cultural industries'; they were being 'led by the market'[5] But was this any worse than being led by the art market? He also claimed that the priority given to the artist as creator/genius in traditional arts programming persisted in the treatment of popular culture, that is, it was centred upon individual producers and stars, with the result that other issues were ignored along with popular culture's 'glorious anonymity'. (He could also have added that these programmes reproduced another weaknesses of profiles of fine artists, that is, the tendency to ignore negative critical assessments of the artists concerned.) Ellis feared that serious arts documentaries were being supplanted by arts journalism.

Review programmes on television are necessary and valuable but one can agree with Ellis that the journalistic emphasis of the 1980s and the attention paid to contextual issues, did result in a reduction in the number of documentaries presenting detailed profiles of leading fine artists and analyses of major works of art. It was also true that there were some reports about trivial subjects and some superficial treatments of important subjects. However, coverage of current arts events and popular culture topics ought not to be abandoned; after all, aside from the ever-present problem of resources, there is no reason why arts television should not concern itself with both mass culture and the traditional arts, and with the manifold interactions between them.

Much of the debate between élitists and populists about cultural standards was misconceived because it mixed up the issue of high/low quality with the issue of high/low culture. The fact is qualitative distinctions and judgements can be made *within categories* as well as *between categories,* that is, there are good oil paintings and bad oil paintings; exceptional rock bands and dreadful rock bands. Is a third-rate oil painting really superior to a first-rate rock 'n' roll record simply because it is a painting rather than a disc?[7] More fundamentally, is it reasonable to compare two such different forms of expression? Does it even make sense to compare Mozart and Madonna when their kinds of music, audiences and socio-historical contexts were so different? There are many types of music performing a variety of functions. The same person can enjoy different kinds of music at different times. Even Ignatieff admitted that while he considered Beethoven a greater musician than Chuck Berry, he would take records by both men to a desert island.

Academics who lecture on the fine arts and popular culture do not wish to deny that qualitative differences exist, or that value judgements are constantly made, but they see a need to ask: 'who is making them, according to what criteria? How can we account for the fact that judgements of quality in art can vary from person to person, from culture to culture, and from period to period? Does this mean there are no absolute aesthetic values, that everything is relative? How do canons of great works and masters come into being and how are they maintained? How, historically, did the hierarchical distinctions between high and low culture come about and what social function do they perform? What is the fate of the traditional fine arts in an age dominated by the mass media?'

Those who 'know instinctively' what is great or good art tend to avoid thinking about such difficult, theoretical questions. Arts television could help here by commissioning programmes that attempted to explore these vexed questions. (After this was written, a programme that went some way to fulfilling this demand did appear, that is, a film made by Martin Davidson for *The Late Show* [BBC 2, February 25, 1992] which brought the minds of a range of thinkers to bear on the problems of quality in art, the canon, and the categories of high, middlebrow and low culture.)

Arguably, behind the debate was a fear or distrust of the mass media, particularly television. As Ignatieff expressed it: 'Everything cultural is fed into the great maw of our visual media and comes out as entertainment.'[6] This huge generalisation ignores the ability of television to inform and educate as well as to entertain: witness the arts programmes of the Open University. A theorist might also wish to unpack the notion of 'entertainment' and consider the role pleasure plays in the appreciation of both art and advertising.

The positive aspect of the mass media is their ability to disseminate and democratise culture (both high and low), but as far as the fine arts are concerned there are prices to be paid: the diminishing of the aura of art (identified by Walter Benjamin), and the changes in the appearance of art objects caused by the recording media of film and television. Furthermore, as the subject matter of this book and the debate summarised above testifies, television's mediation of the fine arts is itself such a fascinating process that it can draw attention away from the arts themselves.

Another complication arises from the fact that when the medium of television is situated in terms of 'posh/pop' divide, then it is pop rather than posh. It would seem, therefore, that there is an inherent contradiction between the subject of high art and its medium of dissemination. Yet hierarchical distinctions appear even within the discourse about television, witness the distinction between 'quality' programmes and the rest. Television also has aspirations to become an art in its own right. In the case of arts programmes with such ambitions, television as art replaces art on television.

References

1. *Bureau de Change* is described and illustrated in the catalogue *Signs of the Times: a Decade of Video, Film and Slide-tape Installation in Britain, 1980-90,* Oxford, Museum of Modern Art, 1990. pp. 32-3.
2. Internal BBC memorandum dated January 1988 in possession of the author.
3. see P. Wright, 'Putting culture in the picture', *The Guardian,* November 28, 1991, p. 25, plus letters and articles written in response in *The Guardian* on December 2 and 5, and in *The Observer* on December 1 and 8.
4. M. Ignatieff, 'Madonna's false conception of art', *The Observer,* December 16, 1990 p. 15.
5. J. Ellis, 'Television and the arts: another fine mess', *Modern Painters,* 4 (1), Spring, 1991, pp. 60-1.
6. M. Ignatieff, 'Let élitists stand up and be counted', *The Observer,* December 1, 1991, p. 25.
7. A further complexity arises from the fact that not all oil paintings fall within the high culture category. For example, Vladimir Tretchikoff's 1952 *Chinese Girl* (the one with a green complexion) is an oil that has been displayed in numerous art exhibitions (held in department stores as well as galleries), but it was also created for the purpose of reproduction. Prints of the painting were bought by millions and so it became an extremely popular image, consequently most critics would place it in the categories popular culture/kitsch rather than high culture/fine art. See the artist's autobiography: V. Tretchikoff & A. Hocking, *Pigeon's Luck,* London, Collins, 1973.

Impact and audiences

This chapter considers the impact of arts television upon viewers and upon British society since the 1950s. It also discusses a programme in which the class character of the audience addressed was an issue as far as the producers were concerned. Given the theoretical difficulties associated with studies of reception and the patchiness of the evidence, the conclusions drawn are bound to be somewhat tentative.

The encounter between a viewer and a programme (or a work of art), involves the interaction of an internal, subjective consciousness with an external, objective artifact that has been structured in order to stimulate certain responses. Every human being has direct knowledge of their own reactions, but knowledge about the experiences of others is harder to obtain. Reading press reviews is one common way of learning how others have responded. Like most reviewers, TV critics write about programmes in the third person, thereby giving the impression that their individual responses and judgements are universal. Studying a number of reviews of the same programme will generally reveal differences of opinion which it may be impossible to reconcile. One can always discuss a programme with relatives and friends but, unless one undertakes detailed market research, the range of opinion sampled is going to small.

Responses to programmes vary because of the different personalities, interests, levels of education, ages, classes, races, genders, etc., of the viewers concerned. (However, the differential nature of perception should not be taken to mean that common or communal experiences are impossible.) Two examples will bring this out. In a sociological study entitled *Wellington Road* (1962), Margaret Lassell described the lifestyle of a poor, working-class family - the Johnsons - who lived on a new modern housing estate in Northern England. (The research appears to have been undertaken in the late 1950s.) The Johnsons wanted a TV set but until they could afford it, they travelled across town to view one belonging to relatives. They were not always pleased with what they were offered: a concert was broadcast for a whole hour; they couldn't stand it and switched the set off. A male visitor to the house told Lassell: 'It's not our class ... we wouldn't go to that sort of thing, and I don't see why we should have to look at it on TV'[1] Classical music and talks programmes on TV or radio bored and irritated the Johnsons. Clearly, persuading such people to appreciate high culture was going to be an uphill struggle.

The second example concerns myself. I came from a similar home to the Johnsons', but I was educated at a grammar school and I made full use of the public library system, so that by the late 1950s I was studying fine art at a Northern, red brick university. (My interest in art stemmed from childhood pleasure in drawing and painting.) As a student I did not own a TV set, but on Sunday evenings I often watched *Monitor* in the company of my landlady (a lover of ballet). I recall disliking Wheldon's headmasterly manner, but I was keen to view anything about the arts. Upwardly mobile, working-class teenagers such as myself, benefiting from access to higher education in the 1950s, were interested therefore in TV arts programmes and learnt from them. Having won a painting competition sponsored by Tyne Tees Television, I also had the then rare experience of appearing on TV (a live interview on a local, early evening news programme).

Aside from such individual testimonies, there are various kinds of objective evidence indicating that arts television can make a significant impact: high viewing figures for certain programmes; sales of arts series to foreign countries; letters of comment and protest to the BBC, ITV, the press and magazines like *The Listener;* instances of censorship such as the legal action taken against David Bailey's Warhol documentary; the dramatic surge in the demand for Elgar records after Ken Russell's 1962 drama documentary (and for Pavarotti recordings after the operatic theme music accompanying TV coverage of the 1990 World Football Cup competition held in Italy); the tremendous emotional response evoked in the United States by Clark's *Civilisation;* the long-running intellectual debates stimulated by Berger's *Ways of Seeing;* instances of people altering their holiday plans in order to see places featured in arts programmes; the proliferation of spraycanned 'tags' on London's railways after screenings of arts programmes about New York's subway, graffiti writers.

In view of the large number of arts programmes that have been produced in Britain since the 1950s and the number of viewers they have attracted, it is reasonable to assume that a much higher proportion of the British populace is knowledgeable about and interested in the visual arts than was the case in 1950. London is still Britain's main centre for the arts but television's programmes about major exhibitions means that people in the provinces can keep in touch with events in the capital in a way inconceivable before the advent of the medium. Furthermore, foreign reports and series which are international in scope inform British viewers about the arts of other countries.

Television, in all probability, has encouraged many people to visit museums and exhibitions who otherwise would not have done so. Assuming this is the case, then it has increased the first-hand experience of works of art, but the mediating factor should not be forgotten. TV images of paintings, sculpture and architecture are second-hand representations. How continual exposure to this kind of imagery conditions our response to works of art when we see them in reality is hard for us to judge. There are some writers who maintain that a constant daily diet of television ruins the

capacity to appreciate paintings and sculptures because the fast consumption of moving images and the resulting short attention spans - 'three-minute culture' - militates against the silent, slow contemplation demanded by the traditional fine arts. Whether this is true or not, the clock cannot be turned back; for good or ill, television and its arts programmes are a powerful presence. Even if the art lover avoids television in order to preserve an uncontaminated perception, its existence could not be escaped altogether because a number of contemporary artists employ the medium of video and rework images quoted from mainstream television.

Surveys of visitors to museums indicate that the public interested in the arts comes mainly from the middle-classes. It can be safely assumed that viewers who watch serious arts programmes are also drawn from the same social strata. Most arts programmes and series are designed, consciously or unconsciously, with the cultured fraction of the middle-classes in mind. However, sporadic attempts have been made to broaden the class composition of the audience by making programmes about popular songs and musicians, by employing characters such as Tom Keating and Sister Wendy Beckett to present arts series, and by asking the popular animal painter David Shepherd to present a wildlife series in which he painted pictures of animals under threat of extinction (*In Search of Wildlife* ITV, 1988).

Few programmes have addressed the issue of the relationship of working-class people to avant-garde art directly. One that did was Kate Rivers' film *Another Country* (BBC 2, May 1980). It followed the progress of the art critic William Packer selecting contemporary works for a travelling exhibition entitled 'The British Art Show', and then filmed the responses of two male, Sheffield steel workers to the objects displayed. The result was a fascinating clash of cultures and values. Packer and some of the artists he had selected were discomforted by the intelligent, sceptical comments of the two workers. Their presence in an arts programme was itself exceptional and must have provided any working-class viewers with a rare opportunity for identification.

Some theorists maintain that the very concept 'Art' is a bourgeois category and that, consequently, the task of a mass medium such as television should be to problematise and demystify the category rather than relay it uncritically. It was because *Ways of Seeing* achieved this to some degree that it became such a landmark in television's arts coverage and why the 'let us now worship the great masters of European art' approach favoured by the late Sir Lawrence Gowing (1918-91) in his 1980s arts programmes for BBC 2 seemed, to some observers, a throwback to a pre-Berger age.

Earlier, market research was mentioned as a method of discovering viewers' attitudes and habits. A survey of this kind was undertaken during the planning for the Channel 4 arts strand *Signals*. According to Roger Graef, *Signal's* editor, a fresh initiative in arts programming was needed because research revealed the following surprising facts:

1. audiences for a series changed by as much as 50% from week to week;
2. shared knowledge amongst viewers could not be presumed;
3. 70% of the public said they would watch more arts programmes if the latter abandoned 'their off-putting tone';
4. people often catch only parts of programmes hence a linear, narrative exposition may be inappropriate;
5. viewers said they wanted more explanation, but not from critics;
6. an interest in the arts extended across the whole country; many people thought existing programmes were too London-based.

It should be remembered that arts programmes are also used in educational contexts where, contrary to the audience behaviour described in the survey cited above, groups of students pay close attention to the TV screen, learn from it, and discuss what they have seen.

Viewing figures for TV programmes are regularly published and they provide some indication of the extent of the public's interest in particular subjects. Arts programmes do not normally appear in the 'top thirty' lists of programmes with the highest figures. In Britain, soap operas such as *EastEnders* and *Neighbours* regularly attract audiences of seventeen or eighteen million (out of a national population of fifty-five million), while figures for arts programmes normally fall between a few hundred thousand and two or three million. Aside from *The Antiques Roadshow* - which attracts thirteen or fourteen million - arts programmes are reported to be less popular than religious programmes. Nevertheless, an audience of 500,000 for a BBC 2 review programme is not negligible; it exceeds by several times the numbers who would attend even a successful major exhibition at the Tate Gallery in London. Furthermore, arts series sold abroad may be seen, eventually, by millions of people worldwide.

Broadcasters have a special interest in ratings. Ultimately their jobs depend on them because the high costs of producing TV programmes cannot be justified if only a few people watch. Regarding ratings, Melvyn Bragg once observed: 'Numbers matter of course. But what matters more is the optimum number for the type of programme'.[2]

The limitation of viewing figures is that they are a purely quantitative measure of impact. They do not measure the intrinsic, aesthetic quality of the programme, nor the quality of the experience for individual viewers. Reference the latter, BBC audience researchers have devised a qualitative measure - the so-called 'reaction or appreciation index' - which rates programmes according to a scale of one to a hundred. The reaction index figure for Ken Russell's 1962 film 'Elgar' was eighty-six, the highest number achieved by any of the *Monitor* series (sixty was the average figure for television drama).

Since 1945 the cultural organisations of the British state, such as the Arts Council, local authorities and public museums, have striven to enlarge and broaden the constituency for the arts. Intellectuals working for television - particularly those employed by the BBC when the Reithian public broadcasting ethos was paramount - set themselves a comparable task and scored some notable successes. However, there is surely a limit to the popularisation process. Consider, for instance, Marcel Duchamp's glass construction *The Bride Stripped Bare by her Bachelors, Even* (1915-23). It is one of the most complex and arcane works in the history of modern art; it was designed to be difficult. Duchamp's aim was to prolong 'reading' and interpretation by creating a work with multiple meanings. Therefore, any attempt to simplify it for rapid consumption would negate its very nature.

Presumably, one of the motives behind Channel 4's sponsorship of the Turner Prize competition was to help explain and popularize contemporary British art. Channel 4 arts programmes profile the four, short-listed artists who compete against one another every year and they also cover the public ceremony held at the Tate Gallery at which the winner is awarded the £20,000 prize. There is something demeaning about the spectacle of artists racing against one another like horses or dogs. (Genuinely radical artists with a critical agenda would not take part in such a competition unless it was to sabotage it.) The selection and ranking exercises are also fraught with difficulties (according to what aesthetic criteria is the winner chosen?) The Turner Prize competition is a pseudo-event (Daniel Boorstin's term for events designed purely for media and publicity purposes). It seems probable that the audiences for programmes about it consist of those already interested in the visual arts. Furthermore, it seems unlikely that a broader public will develop an interest in contemporary art unless the art itself has some popular appeal. Unfortunately, most of the paintings and sculptures featured in the Turner Prize events conspicuously lack the popular values one finds in the work of such modern artists as Käthe Kollwitz and Vincent Van Gogh.

Popularization would be better achieved via serious documentaries and by encouraging more fine artists to make work especially for television. If the search for ever-larger viewing figures means taking arts programming downmarket, if it means a loss of quality and intellectual rigour, then this may well prove counter-productive because it could alienate the existing audience for arts programmes.

Furthermore, the idea that people in C1, C2, D and E marketing categories should be force-fed high culture or avant-garde art whether they want it or not is surely a patronising one. (At present arts programmes are primarily watched by those in the A and B categories.) The underlying assumption seems to be that such people lack culture, though it may well be they have all they can cope with, even if it is not Culture with a capital 'C'. A healthy television schedule should surely contain a range of programmes - some popular, some specialist, some accessible, some demanding - what Bragg calls 'a rich and varied

portfolio', to cater for the needs, interests and tastes of various types of audience including intellectuals. The latter, minority group also pays the BBC's annual fee and endures advertising on the commercial channels, so there is no reason why a multi-channel environment should not, in the future, provide a proportion of arts programmes that are more demanding than hitherto, that are as complex as scholarly books and articles.

Of course, television is not the only factor contributing to social change. For instance, rising educational standards in schools and the provision of more opportunities for higher education for working-class children, have been vitally important in widening the audience for the arts during the second half of the twentieth century. If further progress can be made along these lines, then programmes about works of art which at present only appeal to a few could, over time, become more popular. In other words, a democratisation of high culture via the medium of television is unlikely to succeed unless it is also accompanied by a wider distribution of wealth, more leisure-time and educational opportunities, and by more financial support for artists, community and public arts projects, public libraries, museums and art centres.

Politicians and other prominent people with access to television often try to use it to achieve social change. Prince Charles' attempt to use television (amongst other media) to change the prevailing styles of architecture and to transform the built environment has already been cited. Television's actual social effects are hard to judge - it is not clear, for example, what impact programmes about architecture have had on people's understanding and appreciation of the artform, but more people seem to be conscious of the urban environment and willing to protest about it than ever before. There are some instances of direct effects: the negative comments of Prince Charles about several new architectural schemes, circulated and magnified by the mass media, have resulted in them being abandoned or changed.

In regard to architecture, perhaps the greatest public impact is achieved not by TV arts programmes but by news programmes reporting disasters like the partial collapse, in 1968, of the Ronan Point tower block following a gas explosion, by socially-concerned documentaries exposing the desperate living conditions typical of so many of Britain's council housing estates, and by financial programmes reporting the bankruptcy of property developers associated with such massive architectural schemes as Canary Wharf, the office complex in London's Docklands.

References

1. M. Lassell, *Wellington Road,* London, Routledge & Kegan Paul, 1962, p. 72.

2. M. Bragg, 'Chorus of booze for the BBC's bar', *The Guardian,* November 11, 1992, supplement p. 7.

fig **35** | Martin Lambie-Nairn (designer), 'Round and back', Channel 4 corporate logo.

ANIMATION PHOTO COURTESY OF CHANNEL 4 TELEVISION.

Simulations on screen:

chp.**21**

Computer Art/Graphics

One of the most remarkable technological achievements of the second half of the twentieth century was the invention and subsequent development of computers. In the 1940s and 1950s computers were large, expensive machines owned by a few national and commercial organisations, but by the 1980s they were plentiful, small, cheap, much more powerful machines, owned by thousands of businesses and institutions, and by millions of ordinary citizens. Miniaturisation was made possible by the inventions of the transistor and the microchip. Such was the pace of innovation that machines and software rapidly became out of date. So, despite the computer's short history, museums devoted to it already exist in Europe and the United States.

Today, the computer is the only machine whose social impact is comparable to that of television and the motor car. In 1950 there were no such fields as computer art and graphics, they emerged when scientists, artists, architects, engineers, industrial and graphic designers realised that the computer was a visualising and design tool of unprecedented potential.

Computer imagery

Computers are electronic calculating machines (the hardware) that store and process data in numerical form according to programs of instructions (the software). Using various input devices and programs, mathematical models of real or invented objects can be created and stored in the computer's memory. Visual representations of aspects of these models can be seen by the operator via the use of output devices such as plotters capable of drawing lines or via screens capable of displaying images.

Line drawing plotters and cathode ray tubes were linked to computers in the mid-1950s. The term 'computer graphics' was introduced by William Fetter in 1960 to describe plotter drawings. Working with images became much easier once visual display units (VDUs) had been invented. This graphic capability was pioneered at the Massachusetts Institute of

Technology in the early 1960s. By the following decade 'vectorgraphics' - glowing, wire-frame drawings - capable of movement in three dimensions had been developed by staff of the University of Utah. Now many computers are equipped with a screen and a graphics facility. (Today, the workstation of a computer graphics designer normally has several monitors linked together.) Furthermore, these images can be recorded photographically, and on to videotape/disc, and film. By the 1980s, the latter technical development enabled computer imagery to appear in entertainment movies such as Steven Lisberger's *Tron* (1982) and Nick Castle's *The Last Starfighter* (1983), and on television.

Computer art

Computer art is more accurately described as 'computer-aided or computer-generated art'. (If machines with independent artificial intelligences can be invented, then a really unique and authentic computer art may emerge.) It has been produced internationally since about 1956 by people belonging to a variety of professions - anyone, in fact, with access to computer time. Although computers had been used for a number of years to produce concrete poetry and electronic music, their relevance to the visual arts was not evident to the British public until the 'Cybernetic Serendipity' exhibition, organised by Jasia Reichardt, held at the Institute of Contemporary Art, London, in 1968. This was not quite the first such show because a display of computer graphics had previously taken place in 1965 at the Howard Wise Gallery, New York. As a result of the ICA exhibition, a Computer Arts Society (CAS) was founded in Britain which, from 1969 onwards, published a bulletin entitled *PAGE*.

In the United States the pioneers of computer graphics during the 1960s were Charles Csuri, John Whitney (plus his three sons and his brother James), John Stehura, Stan VanDerBeek and Peter Kammnizer.

Their work was documented by Gene Youngblood in his seminal text *Expanded Cinema* (1970). Often the work consisted of films of computer-generated, abstract or floral-like and mandala-type patterns that permutated over time. The artists' motivation seems to have been to produce a visual 'language' equivalent to poetry or music.

Since many computer images were generated by scientists and commercial designers, the line between computer graphics and computer art was often blurred. If the latter served no immediate utilitarian purpose, was aesthetically pleasing, and was displayed in an art gallery, then it counted as art rather than design. Artists contributing to computer art shows have included: Stephen Bell, Harold Cohen, Scott Daly, Herbert Franke, Jonathan Inglis, Alyce Kaprow, Hiroshi Kawano, Ben Laposky, William Latham, Manfred Mohr, Frieder Nake, Brian Reffin, Brian Smith, Peter Struycken, Barbara Sykes, Frederic Voisin and John Whitney. Most professional fine artists were not specialists in the medium; in 1988 the American David Em (b. 1949) claimed to be the first, full-time computer artist. (This claim has been disputed by others.)

An alternative term for computer art is 'pixel art'. This is because the screen of a computer's monitor consists of thousands of phosphor cells which in groups form pixels (short for 'picture elements'). Like the dabs of paint in a canvas by Seurat, the pixels are the building blocks of computer imagery. The resolution of computer monitors is higher than of TV sets, so there is some loss of definition when images are transferred. Fuzzy outlines also occur because of 'pixel bleed', that is, the colours from one pixel shine into those nearby. The result is that computer images on television have a slightly blurred quality.

Initially, the 'art' produced via computers was mostly in the hard copy form of drawings and graphics. Computers linked to printers and plotters were programmed to print out geometric shapes in random combinations, or to transform images by a series of discrete steps; for example, changing the image of a man into a bottle and then into a map of Africa. This transformatory or metamorphic ability became one of the key characteristics of computer art/graphics: today computer-generated objects can mutate into objects that are completely different in their size, shape and colour in the blink of an eye. Objects move and change shape as if by their own accord. The world generated by the computer is one of total malleability. From the viewer's point of view, it is as if the invisible force causing the changes on screen had the infinite creative power of God.

Modern computers can fabricate totally fictional worlds, but the parts from which these worlds are constructed are often derived from existing reality. An artist makes a series of outline drawings of a real object seen from the front and the side, then the drawings are traced into the computer's memory via a mouse. The computer then 'models' the object by extruding it into the third dimension. The wire-frame model of the object is then 'rendered' by being made solid, coloured, shaded and lit. The technique called 'ray tracing' dates from the late 1970s; it is a technique for calculating how light from a single source falls across a scene. Another technique - 'radiosity' - introduced a decade later, calculates light reflecting off objects.

Representing movement, especially that of the human face and body, is more difficult than modelling. During the making of the commercial *The Sexy Robot* (for The Canned Food Information Council), Robert Abel adapted an old Walt Disney animation technique: a human model painted with black spots here and there as references points was filmed while moving. The movements of the spots were then entered into the computer. Information about the complex ways in which humans move was thus acquired by the machine.

Once computers have mastered the appearance, sounds and movements of humans they will be able to generate synthetic, humanoid actors with ideal features. 'User Friendly' (circa 1983), the first computer-

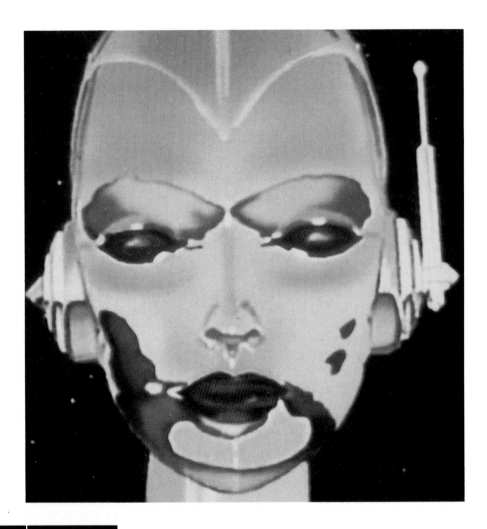

fig **36** Robert Abel 'The Sexy Robot', IBM, 1986.

PHOTO COURTESY OF ROBERT ABEL AND IBM.

generated TV presenter, modelled by Carter Burwell and designed by Bill Maher of the Computer Graphics Laboratory, New York Institute of Technology, was a step in this direction. Such creatures could become stars because film studios might well prefer to deal with actors who always obey orders, require no wages and never age. After all, Walt Disney made a fortune by inventing fantasy animals such as Mickey Mouse and Donald Duck.

Computer art was similar to photography in the sense that a single program could generate an a large number of identical images (hence the potential for a significant democratisation of art). But if the program included a random factor, then a series of unique images could be produced. Artists created both figurative and abstract images, but since most artists lacked programming skills, they had to collaborate with computer experts. The artists' interaction with computers was greatly facilitated by the appearance, in the 1950s and 1960s, of cathode ray tubes as output devices and light pens for touching screens or drawing tablets.

During the 1980s highly expensive and sophisticated machines such as the Quantel Paintbox, the Antics Paintbox system and the Ampex AVA became available which enabled artists to 'paint' directly with light on a screen via an electronic stylus, a drawing tablet and a range of menus concerned with colour, lighting, airbrushing, etc. (A series of encounters between fine artists and the Quantel Paintbox recorded for television were described earlier.) Arguably, these interactive machines incorporated and automated pictorial tools and techniques that had been evolved over the previous two thousand years. Colour photography and printing enabled the imagery generated to be fixed permanently. Alternatively, video recordings of computer patterns could be replayed on TV monitors. For the illusion of movement, a two-minute video requires 3000 video stills displayed at rate of twenty-five per second.

Another important technological breakthrough that took place in the same decade was the advent of low-cost home or personal microcomputers, with graphics tablets and dot-matrix printers. These machines made it possible for millions of ordinary people to create computer images, albeit of a crude and lumpy kind, if they so wished. One journalist described computer graphics of this type as 'the folk art of the 1980s' because they were 'cheap, pervasive and popular'.

Computer sculpture

In 1968 the American artist Robert Mallary (b. 1917) developed TRAN2, the first program for the computer-aided design of sculptures. He used milling machines controlled by punched tape to make laminated, abstract sculptures from marble and veneer slabs. At the same time Edward Ihnatowicz (1926-88) presented 'SAM', a Sound Activated Mobile, at the 'Cybernetic Serendipity' exhibition. Subsequently he was commissioned by

the Phillips company of Eindhoven to design a computer-controlled mechanical monster called 'Senster' (1971) that also responded to sounds.

Two decades later the British artist William Latham programmed computers to generate weird, organic forms resembling coloured intestines or fossils. These forms have been called 'computer sculptures' and 'proto-sculptures', even though they exist (so far) only as images. Since they inhabit virtual space, they are not restricted by the nature of physical materials or by gravity. They can be endlessly varied in terms of their forms, colours, textures and surface patterns; they can be made to look smooth or shiny, or like velvet or silk.

Latham studied at the Royal College of Art, London and then, in 1987, he became a research fellow with the Graphics Applications Group of IBM at their Scientific Centre in Winchester. One of the programs Latham used - 'Mutator', devised by Stephen Todd - mimicked the evolutionary processes of nature. In other words, Latham does not know in advance exactly what will emerge: there is as much discovery as design. Although his work seems to parallel nature, his declared aim is to generate forms which could not exist in nature.

An exhibition of Latham's work was held at the Arnolfini Gallery, Bristol, in 1988. An installation was created with computer screens and visitors were encouraged to participate by selecting parameters for the generation of new forms. Cibachrome prints provided still images of Latham's 'impossible objects', while their transformations over time were made visible on film. Latham's film, called *Conquest of Form,* showed the sculptures rotating, mutating, being sliced and entered. Extracts from it appeared on *Tomorrow's World* (November 24, 1988), the popular BBC 1 series about the technology of the present and future.

Computer-aided design

During the 1970s and 1980s computers were increasingly employed in the fields of architecture, engineering, medicine, industry, business and advertising. Designs for future artifacts - complex, three-dimensional ones such as buildings, oil-rigs, cars and aircraft - could be represented by mathematical models stored in the computer's memory. Images of these models could then be studied on VDUs from all angles, changed at will and tested. Obviously, it was cheaper, quicker and less damaging to the environment to experiment with computer simulations than with real models or prototypes.

Simulation

'Simulation' became a buzz word in the 1980s. A tremendous effort was made by computer graphics companies to produce images that could simulate reality more and more accurately. Since we already have colour film capable of recording visual appearances, such a quest might seem

fig 37 | William Latham — two computer sculptures: 'Coiled form number 1', 1987; 'Slugani', 1988. Cibachrome.

PHOTOS COURTESY THE ARTIST AND IBM, WINCHESTER.

redundant, but the difference between images captured on film and those generated by computers is that the former are limited to what already exists. Worlds constructed within the memory bank of a computer, however, can be completely fictional. (For centuries fine artists have used drawing and painting for this purpose. The traditional skill of drawing remains of value to the new media: computer artists use it in the preliminary stages of their work, movie makers use it for storyboards.)

Computer graphics designers aimed to make these synthetic worlds look as real as possible. As in the development of the art of painting since the Italian Renaissance, there was a step-by-step increase in verisimilitude, but the surfaces of objects in computer images are still unconvincing and rather repulsive: objects look as if they are made from translucent plastic, they seem to be illuminated from within rather than from without, and their edges are fuzzy. So far, computer imagery has been better at simulating the surfaces and textures of artificial materials and geometric forms than natural forms such as clouds, water, trees, human flesh, etc. However, the advent of fractal geometry has enabled designers to imitate such complex, 'self-similar' forms as mountain ranges.

A paradoxical aspect of the cult of illusionism is that computer animators - particularly those with experience of a hand-drawn cartoon animation - often use the computer's resources for non-realistic, indeed surrealistic ends. For example, inorganic objects such as teapots, trains and telephones are brought to life and are made to imitate the movements, behaviour and expressions of animals or humans. (Animism persists in this realm.) These hybrid characters are often grotesque and cute. In computer animation - especially that created for TV commercials - what might be called 'digital kitsch' abounds.

Real-time simulations are those in which the operator controls and interacts with the images on the screen. The most familiar examples are video games. Much more sophisticated are those used to train pilots to fly and land aircraft. They require immense amounts of computing power and are therefore very expensive (a flight simulator can cost between six and ten million pounds). The CT5 simulator produced by Rediffusion and the American computer graphics company Evans & Sutherland enables pilots to fly combat missions. For greater realism, overlapping images are projected on the inside of a dome instead of a flat screen. Computer simulations obviously have many military applications, consequently much of the development in computer graphics has been funded by the armed forces.

Space research is another field where computer simulations have proved useful as a way of picturing future missions and as promotional/educational tools: NASA has financed simulations of the building of space stations and of the journeys of their space vehicles as they travel across the solar system.

Increasingly, contemporary fine artists are gaining access to sophisticated computers. Matt Mullican (b. 1951) is an American artist

obsessed with the signs of mass culture. In the late 1980s he used a computer to design a synthetic city viewers could visit via a laser videodisc. Mullican lacked programming skills and so he worked with Karl Sims and Jerry Weil of Optomystic, a Los Angeles computer animation centre run by John Whitney Jnr. The work was sponsored by New York Telephone and exploited the tremendous processing capacity of a Connection Machine 2 (CM2) supercomputer. Mullican provided sketches and specifications. Sims wrote or adapted programs in order to generate outline drawings; later, Weil added colour, lighting, shadows, reflections, mists and trees. Mullican's eerie city is clean, sterile and empty (there are no people or animals). The 'buildings' are constructed from simple forms and primary colours. Realism was not Mullican's goal: he was not attempting to simulate a city in the way an architect might for preview purposes; his interest was in the cityscape as a system of signs. Mullican's computer city was presented at the Museum of Modern Art in New York in laser disc form and also in the form of photographs printed from digital data tape presented in light boxes.[1]

fig **38** | Matt Mullican, 'Untitled', 1989. Colour duratrans in light box.

PHOTO COURTESY OF GALERIJ BRUGES LA MORTE, BRUGES AND THE SERPENTINE GALLERY, LONDON.

Media convergence and synthesis

A significant characteristic of communications technologies in the twentieth century has been their capacity to combine or interact. For example, a remarkable technical development has been the ability to combine cinematography, animation, video and computer graphics. One consequence is that filmed or videotaped live action can be combined with computer-generated imagery. Completely imaginary, moving objects can be inserted into scenes of real places or, alternatively, filmed human beings can be inserted into synthetic, computer-generated environments.

For example, in the American movie *The Young Sherlock Holmes,* directed by Barry Levinson in 1985, there is a sequence in which a stained-glass knight comes alive, descends from a church window and attacks a priest. This special effect was the work of PIXAR and took several designers six months to achieve. Robert Zemeckis's *Who Framed Roger Rabbit?* (1988) was another film exploiting the combination of live action with computer-generated imagery, in this case a cartoon character. This popular movie was made at Elstree and the animation was by Richard Williams (Canadian-born but resident in London).

Digitilization of imagery has meant that in the science-fiction/action movie *Terminator 2* (1991), it proved possible to insert a computer-generated chrome man into live-action, film sequences without any joins showing. The chrome figure was also capable of infinite transformations of shape.[2] This special effect, called 'morphing' (or 'morfing', derived from 'metamorphosis'), was quickly adopted by the makers of TV commercials.

Not only can frames be 'grabbed' from films and videos, still pictures of all kinds can also be scanned and entered into the computer's memory. The pictures in question might well be derived from a Logica Gallery 2000, a digital library system that stores images on optical discs. The designer can then call them up and retouch them. Photographs can now be doctored in ways that are undetectable to the viewer. The potential for producing fantasy scenes or telling lies is obvious. Awareness of such techniques should make viewers sceptical about the truth claims of the imagery illustrating TV news programmes.[3]

Computer graphics on television

As far as the general public is concerned, it is the work of the designers in the field of computer graphics that matter more than the work of computer artists, because the public has been exposed to thousands of examples via the medium of television. Computer graphics sequences regularly appear in channel logos, programme titles, weather reports, commercials and pop music videos. The public does not know the names of the designers and companies responsible for them because no credits are given. (They are known in the industry, of course, and they are identified in such books as Douglas Merritt's *Television Graphics* [1987].)

London became noted as a centre for excellence in the production of computer graphics during the mid-1980s. Leading companies included: Amazing Array Productions, CAL Video Graphics Ltd., Cucumber Studios, Digital Pictures, Eidographics Ltd., Electric Image, Electronic Arts, Moving Picture Company Ltd., Robinson Lambie-Nairn, Rushes Computer Animation and Vanishing Point.

Computer graphics are now capable of showing movements in all directions. Often designers seek to astonish viewers by the complex ways in which objects such as spheres or cubes are shown moving relative to one another. Some software packages also enable the designer to distort objects by squashing and stretching them. Furthermore, not only do the objects move, so does the viewpoint of the spectator. It is a visual effect designers indulge in over and over again. The viewpoint is usually that of a bird's eye, that is, an aerial vista. This viewpoint is not static because 'the bird' is in motion: it flies into and out of the scene, swoops and circles. The experience resembles a flying dream or travelling at low level over a landscape in a high-speed jet; the viewer is weightless, movement is rapid, smooth and effortless. The sense of penetrating three-dimensional space is very strong. At the same time the novelty of this effect quickly wears off and the repetitiveness becomes tiresome. In the case of breakthroughs in computer graphics, awe is all too quickly replaced by ennui. Critics of computer graphics have argued that they have yet to achieve an authentic visual style.[4]

Corporate identity in the worlds of business and television relies heavily upon the effective design of company and channel names, logos, symbols or identifications. In a multi-channel environment the 'branding' value of a distinctive logo is obvious. The symbol of a TV channel is a challenge to any graphic designer: it has to be expressive of that channel, vivid and simple in design, yet capable of being seen repeatedly without causing irritation. One way of maintaining viewer interest, is to play a series of variations on a basic design. This was the strategy adopted by the American cable TV service MTV (Music Television) launched in 1981, and by the designers of the BBC 2 logo in the early 1990s.[5]

Lettering on television is often dull when presented flat, so designers animate it by making it three-dimensional, by adding dramatic lighting, and by making it spin in space. The viewer can also be taken on a 'flight' around a moving logo.

Channel 4's highly praised, multi-coloured logo dating from 1982 is very familiar to British viewers. There have been two versions: in the first the number '4' was formed from nine, differently-coloured blocks tumbling through space to the sound of four chords. In the second, the number '4' magically coalesced from coloured fragments travelling like a flight of arrows: at first the 'arrows' flew towards the viewer, then they reversed direction and headed towards a central point in space. The designs visually expressed the particular personality of Channel 4, that is, a channel made up of distinct programmes and series commissioned from

various sources. Both were designed by Martin Lambie-Nairn of the London company Robinson Lambie-Nairn. This company, formed in 1976, was one of the first independent, TV graphics companies serving both ITV and BBC to be established. (Previously, most designers had been in-house.) Lambie-Nairn commissioned System Simulation Ltd of London to choreograph the 4 and then the program was taken to Bo Gehring Aviation of Los Angeles because no British company was capable, at that time, of executing it in full colour. The second version was produced by the American company Digital Effects Inc.

The way in which Channel 4 contributed to the public appreciation of the art of animation during the 1980s - by screening examples and 'how they were made' programmes - was described earlier. During the early 1990s the Channel did the same for computer animation. The BBC responded by establishing a computer animation unit in Bristol. It is producing compilations of existing examples and commissioning new works from leading practitioners.

In one chapter it has not been possible to do justice to all aspects of computer art/graphics, especially since it is such a rapidly developing field. Yet it is clear, even from the account provided, that computers have revolutionised image-based media such as TV graphics and commercials, cartoon animation, sci-fi feature films, video games and rock music videos.[6] In the future, ever greater illusionism and more amazing special effects will no doubt be achieved, but high quality art and design does not result from such techniques alone: it employs them with discrimination and it also requires original ideas and significant themes/content. So far, most computer graphics seen on television have been limited by the functional roles they have been called upon to play, but this situation may change as more creative artists gain access to computers.

References

1. M. Pye, 'Polygons and pixels: the city as techno-art', *The Independent on Sunday,* February 11, 1990, p. 31; L. Ponti, 'Matt Mullican: an installation of computer-generated art', *Domus,* (714), March, 1990, pp 8-9.

2. For a detailed description of the special effects in this film see G. Turner, *'Terminator 2: for FX, the future is now', American Cinematographer,* 72 (12), December, 1991, pp. 62-9.

3. For more on this subject see *Photovideo: Photography in the Age of the Computer,* ed. P. Wombell, London, Rivers Oram Press, 1991; and Derek Bishton and others (eds), 'Digital dialogues: photography in the age of cyberspace', *Ten 8,* 2 (2), Autumn, 1991.

4. Commentary written by Geoffrey de Valois and Donna Cohen for the television programme 'Computer graphics special' in the *Equinox* series. The programme, produced by One Pass Productions, was originally American. Post-production work was undertaken by Uden Associates of London and the revised programme was first shown in Britain on Channel 4 on January 7, 1990. It surveyed the work of a wide range of computer graphics companies, mostly American. For instance, Robert Abel Productions, Apollo Computer, Artronics, Cranston-Csuri Productions, Digital Effects, Pacific Data Images, PIXAR, Prism Arts Group, Videofonics, Vmax, and Wavefront Technologies.

5. For a history of the MTV logo see J. Canemaker, 'Over the edge with *MTV', Print*, 46 (5), September-October, 1992, pp. 21-31.

6. They have also made an impact on British art and design education. At Middlesex University in London a National Centre for Computer-Aided Art & Design was established in 1986. In the same year a new professional body was founded - ACADE: The Association for Computing in Art & Design Education - to act as a national forum. In the United States a National Computer Graphics Association (NCGA) has existed since the late 1970s; it has an art section and holds annual conferences (proceedings are published).

fig **39** | Bob Peck as Dante in *A TV Dante,* Channel 4, 1990. Directors: Tom Phillips and
Peter Greenaway.

PHOTO COURTESY OF CHANNEL 4 TELEVISION.

chp.**22** | # Conclusion: The fate

of art in the age of television

As this text has documented, it was the mass medium of television which from the 1950s onwards brought information about art and artists into millions of British homes. TV producers imbued with a public service ethos shouldered the responsibility to inform and educate as well as to entertain, and so they created factual programmes of various kinds and commissioned documentary films with the aim of communicating knowledge about the visual arts to the public at large. It is reasonable to assume that these popularising efforts contributed to the significant increase in the size of the audience for the visual arts evidenced by steadily rising gallery and museum attendance figures.

From time to time Left-wing critics voiced their dissatisfaction with arts programmes on the grounds that they tended to reproduce dominant ideology and exhibit exactly the same faults as traditional art history: the cult of the individual artist; treating artworks as illustrations of the artist's personality; a non-critical, over-reverential attitude to art and artists; a connoisseurial approach to works of art which undervalued social, historical, economic, political and institutional determinants; neglect of radical, experimental art especially in the fields of film and video; racial and sexual discrimination - neglect of black and women artists; élitism - neglect of popular and anonymous art; the presenter-as-hero syndrome; and so on. For many years these accusations were justified: programmes did exhibit these faults. However, the criticisms have lost force because more and more programmes have adopted alternative approaches, often in response to the complaints of the Left-wingers. Indeed, some erstwhile critics were given the opportunity to make programmes.

And what of art itself? The heritage of past ages is a vast treasure trove TV producers can plunder at will. Marshall McLuhan, Melvyn Bragg and others have pointed out that new media tend to cannibalise earlier art-forms. Modern and contemporary art are more problematical topics for television. Many modern artists set out make work that would disturb, shock and be difficult to understand, consequently there is a limit to its

popularisation. Every year a huge quantity of new art is produced in the world's advanced countries, most of which is mediocre or bad, some of which aims to subvert existing standards of taste, so it is often hard to identify artworks of lasting value. Dead artists cannot object to what film and television producers do with their lives and works, but living artists can and do. Most artists are willing to co-operate with the mass media in order to publicise their art, but many feel they would like more editorial control over what is said about them and how their work is presented. Artists who are isolated producers often feel intimidated by the size and power of the television bureaucracies with which they have to negotiate.

In the case of the minority of fine artists who employ film, video and computers, what they would like is more access to broadcast television in order to present their work direct to the public. Performance and multi-media artists would also like more opportunities to collaborate with sympathetic producers in order to create works of art specially for television.

A few artists despise the mass media and see them as the enemies of art - witness the 1988 bronze *A Mighty Blow for Freedom: Fuck the Media* by the British sculptor Michael Sandle - but gestures of defiance of this kind do not alter the fundamental imbalance of power between fine art and the mass media. What politically astute artists realise is that the mass media are to some degree the rivals of art, indeed much more powerful rivals, that threaten to marginalise, absorb or transform the fine arts. Responses to this situation vary: some artists undertake a critique of the media in their work; some follow the precedent of Salvador Dali by collaborating with the mass media (see my earlier book *Art and Artists on Screen*); others adopt mass media forms of communication in an attempt to beat them at their own game; and some foreground the particular characteristics of their chosen medium - say oil painting - in order to maintain a sharp art/mass media distinction[1] Producers are capable of making pro-grammes about all these kinds of art, so resisting the embrace of television is quite difficult.

Ostensibly, the aim of arts programming is to foster an interest in the arts and thereby sustain them, but is this what actually happens? Not according to the theatre critic John Elsom: 'far from helping the arts, the system (public service broadcasting) is designed to neutralise them, to marginalise them and reduce their scale and appeal'[2] Michael Holroyd, the biographer, has also bemoaned the fate of the arts in the age of television:

> Whatever moments of excellence it achieves, television is a natural enemy of the other arts and has almost overwhelmed them. It has taught us to be impatient. We almost want the pictures in our galleries to *move* ... The 'mystical, hypnotic powers' of television are such as to create inappropriate and unreasonable expectations from the other arts... Pulled by the force field of television, literature and the theatre rotate like dying worlds without the energy to establish

independent life. They have come to rely on television for money: and money... has imprisoned them.[3]

Fay Weldon, the writer, speaking at 'The Odd Couple' Brighton conference in 1992, went so far as to declare: 'Television's preoccupation with art and culture comes from its guilt in having destroyed art and culture'.

In defence of television, it can be argued that when the medium deals with contemporary paintings and sculptures its special ability is to animate a set of inert, mute art objects by adding images of people, the sounds of speech and music, and the dynamism of camera movement. What television shows is that such artifacts are not simply things to be preserved in a museum, but part of the lived experience of human beings. TV interviews, discussions and debates also reveal that art objects are capable of arousing powerful emotions and generating conflicting interpretations. Showing, in fact, that they are frequently the sites of aesthetic, cultural and political struggles.

The new mass media that emerged during the nineteenth and twentieth centuries have not eliminated the fine arts - there are probably more artists alive now, and more art being produced, than at any stage of human history, and the artworld retains a measure of autonomy - but what the mass media have done is first, to reduce the social significance of the arts (one critic has called them 'cultural irrelevances'); and second, mediatised them, that is, made them part of the content of the media and made them dependent upon the media's publicity power. Paradoxically then, the mass media have helped to create a huge audience for the arts while simultaneously reducing their social importance.

Arguably, the fate of the arts in the age of television and the computer is analogous to the fate of the horse in the age of the motor car and the aeroplane. (Horses have not vanished but they no longer play the vital roles they once did in war, transportation and agriculture.) Architecture is probably the one traditional art that is an exception to this rule: architecture is still an important art as far as the state and big business are concerned; it continues to perform practical functions and its construction requires large capital sums and workforces. Certain modern architects - Richard Rogers and Sir Norman Foster, for instance - have been highly successful while maintaining their artistic integrity. Rogers and Foster are not avant-garde bohemians alienated from society, on the contrary, they are fully integrated into society; they are also minor media celebrities.

During the 1980s the increasing commercialism and commodification of fine art made it harder to argue that it was a form of communication different from, and morally superior to, mass culture. Aside from their smaller editions and higher price tags, artworks began to resemble the other consumer goods churned out by the culture industries. Art became simply one of the leisure and entertainment activities available to urban populations and TV review programmes treated it as such.

While the waning of art's aura was regretted by critics nostalgic for a bygone age of authenticity, others considered the new situation called for a change of tactics. For instance, acknowledging that the really significant and innovative artists of the contemporary period were not fine artists but stage performers like David Bowie, Michael Jackson, Prince, Madonna and David Byrne, designers like Jean-Paul Goude, film and television directors like Francis Ford Coppola and David Lynch. In other words, an acceptance that the stars and makers of popular culture were in fact serious artists and deserved, therefore, to be treated seriously. The frenetic efforts the American artist Jeff Koons made during the 1980s to promote himself like a rock or film star, and to direct/play the lead role in a film - *Made in Heaven* - with the ex-porn queen/Italian politician La Cicciolina (Ilona Staller, b. Budapest 1952), only served to confirm the point.

British TV has been described as 'the best in the world' (or 'the least worst'), but it has also been condemned as 'unredeemably mediocre ... suburban, predictable, ... irretrievably dull ... a huge quiescent middlebrow empire of the second-rate, the second-hand, the second, third and fourth best'[4] The truth, no doubt, lies somewhere in between. Our survey of British arts television since 1936 has certainly identified many admirable programmes. Generalisations that are valid across several decades of TV transmissions are none the less hard to make because the output has been so heterogeneous and variable in terms of quality, and because the technologies and organisations have changed so rapidly.

Arts programming expands and contracts according to the state of the economy: it is especially vulnerable to any decline in television's revenues. For example, the British economic recession of 1989-93 has meant that commercial channels have received less income from advertising, which in turn has meant cuts in the budgets of arts series. Television's impact on society is also a matter of periodic concern. The medium is currently being blamed for a decline in literacy amongst children but educators do not test them to see if there has been an increase in their visual literacy as a result of years of viewing. In our culture, words on paper still seem to be privileged over images and sounds.[5]

Assuming the public service ideal of broadcasting can be maintained, in spite of the increasingly commercial, free market environment, then British television will continue to 'serve' the fine arts by transmitting, reporting and reviewing them. Future technological innovations in audio-visual media will also continue to provide new tools for fine artists and new educational/reference materials about the arts as alternatives to broadcast television.

As the negative comments about television cited above indicate, considerable distrust and antagonism remains between those in the arts and those who work for television. Naturally, the former's priority is see their work presented in the best possible light, while the latter's priority is 'good television'. A gap certainly exists between art and television, yet there are various ways in which it can be bridged.

One arises from the propensity of modern media to converge with one another, and to incorporate, mechanise and enhance traditional techniques - as explained earlier in relation to the Quantel Paintbox and computer graphics. The popular comedy series *Spitting Image* is another example of this tendency[6] Beginning in 1984, three series were transmitted on ITV on Sunday evenings in Britain. It was also featured on cable, CBS and NBC in the United States. John Lloyd was the producer of the series for Central Television in Birmingham. The content of the programmes was savagely critical and anti-establishment. There was no shortage of targets: it was the era of monetarism, Reaganism, Thatcherism and a bitterly-fought miners' strike. Amongst the people satirised were politicians, bureaucrats, the British Royal Family, actors, film and pop music stars, TV and sports personalities. They were represented by grotesque, animated puppets made from foam or latex rubber. These were drawn, modelled and fabricated by a team of designers headed by Peter Fluck and Roger Law, two Left-wing caricaturists who had previously studied commercial art together at Cambridge School of Art in the late 1950s. Puppets were manufactured in London's Docklands in a workshop that resembled those of Renaissance Italy.

Spitting Image was a remarkable development of the ancient arts of caricature and puppetry which, when combined with the contemporary mass medium of television, was able to communicate a humorous critique of society to audiences of six to ten million. From time to time, *Spitting Image* ran into censorship problems, but on the whole television supported the artists' freedom of expression more than the art establishment: during the 1980s exhibitions of the puppets were held in various art centres but a major one planned for the National Portrait Gallery in London was cancelled at the last minute because the Gallery's trustees thought they would cause too much offence.

The career of Peter Greenaway can also be cited as an example of the way in which the art/television gap can be narrowed. Greenaway was trained at artschool in London and then became a film-maker. However, he continued to draw and paint and the iconography of his films was usually influenced by the heritage of Western European art. Furthermore, Greenaway was willing to collaborate with other artists to make experimental TV series - witness *A TV Dante* (Channel 4, July-August 1990) - made in association with the British painter Tom Phillips[7] The future of film, Greenaway feels, is not necessarily dependent on cinema exhibition. Circulation via broadcasting and videotape may become more important, hence his increasing interest in the potential of television. His 1991 film *Prospero's Books* (based on Shakespeare's play *The Tempest*) was edited in London and Paris but also exploited the special effects made possible by the latest video post-production technology and software developed in Japan[8] This multi-layered film was a remarkable synthesis of literature, acting, painting, set design, cinematography and HDTV (High Definition Television).

A desire to bring art and television together has also been evident in the efforts Arts Council officers committed to the time-based arts have made, in association with TV producers, to commission artists to devise new works for television transmission. The 'One Minute Television' commissions described earlier were one instance of this collaborative endeavour.

A final possibility involves a change of consciousness - the re-evaluation of television itself: as *Ways of Seeing* and the finest programmes of the *Arena* series have demonstrated, arts television at its best can be a creative medium in its own right. Perhaps it is time we stopped thinking television is inferior to the traditional art-forms and allowed it to take its place amongst the Pantheon of the arts[9] This book has treated the subject of television and art seriously in the hope of contributing to such a re-evaluation.

References

1. For a more extended discussion of this topic see my book *Art in the Age of Mass Media,* London, Pluto Press, 1983.

2. J. Elsom, 'The call of the tamed' -in- *Ariel at Bay: Reflections on Broadcasting and the Arts, a Festschrift for Philip French,* ed. R. Carver, Manchester, Carcanet Press, 1990, pp. 96-101.

3. M. Holroyd, 'Seeing in the dark', *The Observer,* (Review section) January 10, 1982, p. 25.

4. Robert Carver, 'The Eunuch & the virile phallus...', -in- *Ariel at Bay,* pp. 55-62.

5. Film and television normally consist of combinations of images and words, hence the opposition between them is a spurious one.

6. There are three books about *Spitting Image:* J. Lloyd & others, *The Spitting Image Book (The Appallingly Disrespectful Spitting Image Book),* London, Faber & Faber, 1985; L. Chester, *Tooth & Claw: the Inside Story of Spitting Image,* London, Faber & Faber, 1986; and R. Law, *A Nasty Piece of Work: the Art and Graft of Spitting Image,* London, Booth Clibborn, 1992. A TV programme about the series - 'Luck & Flaw's illustrated guide to caricature' - was broadcast by BBC 1 on July 27, 1985. Highlights of *Spitting Image* are also available in video-cassette form.

7. See *A TV Dante directed by Tom Phillips & Peter Greenaway,* London, Channel 4, 1990 (a booklet with notes and commentaries by T. Phillips), and also *Dante's Inferno,* London, Thames & Hudson, 1985 (a book with translation and illustrations by T. Phillips).

8. See P. Greenaway's *Prospero's Books: a Film of Shakespeare's 'The Tempest',* London, Chatto & Windus, 1991. This book contains a chapter on the image-manipulating potential of the digital, electronic Graphic Paintbox.

9. Some professional broadcasters do think television is an art. In 1984 M. Bragg observed: 'In so far as we have a common culture it is transmitted through television and to some extent created by it. Television, some would say, is itself the Arts of our time'. See 'How broadcasters serve the arts', *Independent Broadcaster,* June, 1984, p. xvi. Later, in 1992, W. Januszczak, commissioning editor for the arts at Channel 4, boldly asserted: 'Television is an art-form'. He added: 'but try telling that to the other art-forms'. See his article 'The media slave breaks its chains', *The Guardian,* October 27, 1992, supplement pp. 4-5.

Arts television programmes

History of Architecture and Design 1890 -1939

What is architecture? An architect at work, Geoffrey Baker.

The Universal International Exhibition, Paris, 1900, Tim Benton.

Charles Rennie Mackintosh: Hill House, Sandra Millikin.

Industrial Architecture: AEG and Fagus factories, Tim Benton.

Frank Lloyd Wright: the Robie House, Sandra Millikin.

R. M. Schindler: the Lovell Beach House, Sandra Millikin.

Eric Mendelsohn: the Einstein Tower, Denis Sharp.

The Bauhaus at Weimar 1919-23, Tim Benton.

Berlin Siedlungen, Tim Benton.

The Weissenhof Siedlung, 1927, Stuttgart, Tim Benton

The International Exhibition of decorative arts, Paris 1925, Tim Benton.

Adolf Loos, Tim Benton.

Le Corbusier: Le Villa Savoye, Tim Benton.

English flats of the thirties.

English houses of the thirties, Geoffrey Baker.

Hans Scharoun, Tim Benton.

English Furniture.

Edwin Lutyens: Deanery Gardens, Geoffrey Baker.

The London Underground, Geoffrey Baker.

Moderne and modernistic, Geoffrey Baker.

The other tradition, Geoffrey Baker.

Mechanical services in the cinema.

The semi-detached house, Stephen Bayley.

The housing question, Stephen Bayley.

Art in fifteenth century Italy

Panel painting.

Florence part 1.

Florence part 2.

The Sassetti Chapel, Santa Trinita.

San Marco: a Dominican Priory.

Santo Spirito: a Renaissance church.

Pienza: a Renaissance city.

Ferrera: planning the ideal city.

San Francesco, Rimini: Il Tempio Malatestiano.

Mantegna: *The Triumph of Ceasar.*

Santa Maria dei Mircoli, Venice.

Palazzo Venezia, Rome: a Cardinal's palace.

Arts Foundation course

The Albert Memorial.

Cragside.

Constable: *The Leaping Horse.*

Victorian ways of death.

The Great Exhibition 1: an exercise in industry.

The Great Exhibition 2: a lesson in taste?

The Victorian high church.

Victorian dissenting chapels.

Religion and society in Victorian Bristol.

Victorian views of the art of the past.

The Leathart collection.

A new museum at South Kensington.

King Cotton's palace.

Rural life 1: image and reality.

Rural life 2: Victorian farming.

The Melbury Road set.

Modern Art and Modernism course

Francis Frascina on Courbet's *Painter's Studio.*
Anthea Callan on artists' techniques.
Tim Clark on Manet's *Olympia* and *Bar at the Folies-Bèrgere.*
Anthea Callan on Monet.
Tim Clark on Pissarro.
Fred Orton and Griselda Pollock on Van Gogh's *Potato Eaters.*
Tom Crow on Seurat's *Bathers* and *Grande Jatte.*
Belinda Thomson on impressionism and post-impressionism.
Charles Harrison on Cézanne.
Jill Lloyd on Kirchner's *Five Women on the Street.*
Francis Frascina on Picasso's *Demoiselles d'Avignon.*
David Cottingham on cubism.
Francis Frascina on cubism as a modern style.
Briony Fer on futurism.
Tim Clark on Matisse's *La Luxe.*
Jan de Bouts on Mondrian.
Peter Wollen on monuments and modernism.
Briony Fer on the 1922 futurist exhibition in Berlin.
Karl Werkmeister on Klee and the Munich revolution.
Benjamin Buchloh on authority and regression.
Gill Perry on Beckmann's *Departure* and *Temptation of St Anthony.*
Briony Fer on Léger.
David Bachelor on surrealist paintings.
Francis Frascina on *Guernica.*
Charles Harrison on Ben Nicholson and Alfred Wallis at St Ives.
Fred Orton and Griselda Pollock on the Museum of Modern Art, New York.
Clement Greenberg on Pollock.
Serge Guilbaut on abstract expressionism.
Clement Greenberg on criticism.
Donald Judd on abstract expressionism.
Terry Atkinson on Marcel Duchamp.
Michael Baldwin on Beaubourg.

The Enlightenment

Bath: a theatre for pleasure or intrigue.
Innocents: images in Hogarth's paintings.
Strawberry Hill: 'a little Gothick castle'.
The English landscape garden.
Joseph Wright of Derby.
Chardin and the female image.
Montgeoffroy: life in a Chateau.

Culture and belief in Europe 1450-1600

Pilgrimage: the Shrine at Loreto.
Maarten van Heemskerck, Humanism and painting in Northern Europe.
Christopher Plantin, polyglot printer of Antwerp.
Venice and Antwerp 1: the cities compared.
Venice and Antwerp 2: forms of religion.
Discovering 16th century Strasbourg.
Rome under the Popes: Church and Empire.
The University of Salamanca.
Seville: the edge of Empire.
Ottoman supremacy: The Sulemaniye, Istanbul.
Seville: gateway to the Indies.
Pieter Bruegel and popular culture.
El Escorial: Palace, Monastery and Mausoleum.
Fontainbleau: the changing image of kingship.
Toulouse: money and power in provincial France.
Hardwick Hall: power and architecture.
Shropshire in the 16th century.

5th century Athens

Seize the fire: a version of Aeschylus' *Promethus bound.*
The present in the past: authenticity in Greek drama.
The theatre and the state: archaeological reconstruction.
Silver: a source of power for the state.
Acropolis now: the public face of the state?
The weight of the evidence: the trial of Socrates.
The art of commerce: between Gods and men.
Interrogating the past: challenging the present.

Issues in women's studies

Feminist strategies.
Body art.
Counting the threads.
Public space, public works.
Alternative architecture.
Ndebele women painters.
Outside in.
Taking the credit.

Modern art: practices and debates

Manet.
Paris: spectacle of modernity.
Musée d'Orsay.
The Impressionist surface
Morisot and the city: an interview with
 Kathleen Adler.
Rodin.
Bathers by Cézanne and Renoir: modernism
 and the nude.
Colonial encounter.
Picasso's collages 1912-13 the problem of
 interpretation.
On pictures and paintings.
Mondrian.
Matisse and the problem of expression.
Le Corbusier: Villa la Roche
Film montage: the projection of modernity.
Max Ernst and the surrealist tradition.
Picasso's *Guernica*.
Museum of Modern Art, New York.
Public murals in New York.
Greenberg on art criticism.
Pollock.
Greenberg on Pollock.
Flag.
Art and the left: the critique of power.
Smithson and Serra: beyond modernism?

NB. Readers should check that the courses
 listed above are still running. British
 educational establishments can obtain off-
 air recording licences from the Open
 University and videotapes of some of the
 programmes listed above can be purchased
 from Open University Educational
 Enterprises Ltd., 12 Cofferidge Close, Stony
 Stratford, Milton Keynes, MK11 1BY.

Bibliography

Annan, Lord (Chairman). 'The arts in broadcasting', *Report of the Committee on the Future of Broadcasting,* London, Home Office/HMSO, 1977, pp. 325-35.

Appleyard, B. *The Culture Club: Crisis in the Arts,* London, Faber, 1984.

Armes, R. *On Video,* London, Routledge, 1988.

Art and Television: Transcript of a one-day Conference held at the Victoria & Albert Museum May 19 1990, London, National Art Library, Victoria & Albert Museum/Wimbledon School of Art, 1991, 48 pp.

Arts Council of Great Britain. *Arts Council Film & Video Library: Documentaries on the Arts,* London, Arts Council, 1988.

...*Films on Art from the Collection of the Arts Council of Great Britain,* London, Arts Council, 1991.

Ascott, R. 'Arte, tecnologia e computer', *Arte e Scienza, Biologia, Tecnologia e Informatica,* Venice, Edizioni La Biennale, 1986.

...'On networking', *Leonardo,* 21 (3), 1988, pp. 231-2.

...'Art education in the telematic culture', *Synthesis: Visual Arts in the Electronic Culture,* eds, M. Eisenbeis & H. Hagebolling, Offenbach am Main, Hochschule für Gestaltung, 1989, pp. 184-203.

...& Loeffler, C. eds. 'Connectivity: art and interactive communications', *Leonardo,* 24 (2), 1991. (Thematic issue.)

Bailey, D. *Andy Warhol: Transcript of David Bailey's ATV documentary,* London, a bailey litchfield/mathews miller dunbar co-production, 1972.

Bakewell, J. & Garnham, N. *The New Priesthood: British TV Today,* London, Allen Lane, Penguin Press, 1970.

Bakewell, J. 'The secret of success', (Broadcasting and the arts: television), *The Listener,* 94 (2436), December 11, 1975, pp. 797-8.

...'Art on television', *Art Monthly,* (110), October, 1987, p. 2.

Barber, L. 'Passions of a made-for-TV-man', (Melvyn Bragg), *The Independent on Sunday,* June 17, 1990, pp. 8-10.

Barker, J. & Tucker, R. *The Interactive Learning Revolution: Multimedia in Education and Training,* New York, Nicols Publishing/London, Kogan Page, 1990.

Bati, A. 'Arts flagships up periscope', *The Guardian,* July 27, 1990, p. 26.

Baxter, J. *An Appalling Talent: Ken Russell,* London, Michael Joseph, 1973.

Benthall, J. *Science and Technology in Art Today,* London, Thames & Hudson, 1972.

Beuys, Warhol, Higashiyama: Global-Art-Fusion, Bern, Art-Fusion-Edition, 1986.

Bishton, D. & others, eds., 'Digital dialogues: photography in the age of cyberspace', *Ten 8,* 2 (2), Autumn, 1991.

Billen, A. 'Gallery's rogue', (Maggi Hambling), *Observer Magazine,* October 7, 1990, pp. 28-9.

Billington, M. 'Art on television', *Burlington Magazine,* 108 (762), September, 1966, pp. 488-90.

Black, P. *The Biggest Aspidistra in the World: a Personal Celebration of Fifty Years,* London, BBC, 1972.

Bode, S. 'All that is solid melts on the air: art, video, representation and post-modernity', *Picture This,* ed. P. Hayward, London & Paris, John Libbey, 1988, pp. 63-73.

Booker, C. *The Neophiliacs: a Study in the Revolution in English Life in the Fifties and Sixties,* London, Collins, 1969.

Bragg, M. 'Television and the arts', *The Observer Magazine,* October 14, 1973, pp. 25-8.

...'Open space for the arts', *The Third Age of Broadcasting*, ed. B. Wenham, London, Faber & Faber, 1982, pp. 28-47.

...'Twilit intensity', *Art Monthly,* (74), March, 1984, pp. 3-6.

... 'How broadcasters serve the arts', (Third IBA Lecture, 1984), *Independent Broadcaster,* June, 1984, pp. xv-xx.

...'Russellmania', *Pick of Punch,* ed. A. Coren, London, *Punch*/Grafton Books, 1987, pp. 117-18.

...'Something to brag about', *Sunday Times Magazine,* January 10, 1988, pp. 41-5.

...'Don't take the Michael, John', (*The South Bank Show*), *The Observer,* September 23, 1990, p. 71.

...'Chorus of booze for the BBC's bar', *The Guardian,* November 10, 1992, supplement p. 7.

Brighton, A. 'Through a veil of clichés', *Art Monthly,* (121), November, 1988, p. 39.

Brooks, R. 'Is it really art or just an Armadillo?', *The Observer,* September 30, 1990, p. 73.

Buck, L. & Dodd, P. *Relative Values or What's Art Worth?,* London, BBC Books, 1991.

Bugler, J. 'Art and good form', *The Listener,* 124 (3186), October 11, 1990, pp. 14-5.

'Can TV be used to promote the visual arts?', *Arts Review,* 29 (1), January 7, 1977, pp. 11-13.

Canemaker, J. 'Over the edge with MTV', *Print,* 46 (5), September-October, 1992, pp. 21-31.

Carver, R. ed. *Ariel at Bay: Reflections on Broadcasting and the Arts, a Festschrift for Philip French,* Manchester, Carcanet, 1990.

Cave, J. 'Art for money's sake', *The Listener,* December 15, 1977, pp. 780-1.

Chatterjee, P. 'Beating that spawned a winner', *The Guardian,* January 1993, supplement, p. 19.

Chester, L. *Tooth & Claw: the Inside Story of Spitting Image,* London, Faber & Faber, 1986.

Coleman, J. 'Omnibus - the new art', *Studio International,* 198 (1008), 1985, pp. 34-5.

Coles, J. 'Heading off an arts attack', (*The Late Show*), *The Guardian,* March 2, 1992, p. 27.

The Conquest of Form: Computer Art by William Latham, Bristol, Arnolfini Gallery, 1988.

Cubitt, S. *Timeshift: on Video Culture,* London, Comedia/Routledge, 1991.

Devine, M. 'Turn on, tune in and fall out', *The Sunday Times,* December 13, 1992, p. 5.

Docherty, D. & others, *Keeping Faith? Channel 4 and its Audience,* London, John Libbey, 1988.

Docherty, D. *Running the Show: Twenty-one Years of London Weekend Television,* London, Boxtree, 1990.

Donoghue, D. *The Arts without Mystery,* London, BBC, 1983. (1982 Reith Lectures.)

Dugdale, J. 'A case of art failure?' *The Listener,* May 16, 1985, pp. 31-2.

Durgnat, R. 'TV: *The Late Show, Art Monthly,* (148), July-August, 1991, pp. 26-7.

Eddy, P. & Allan, E. 'How Andy Warhol's Trash was turned into gold', *The Sunday Times,* January 21, 1973, p. 4.

Ellis, J. 'Television and the arts: another fine mess', *Modern Painters,* 4 (1), Spring, 1991, pp. 60-1.

Englander, A. & Petzold, P. *Filming for Television,* London & New York, Focal Press, 1976.

Farson, D. *Gallery: a Personal Guide to British Galleries and their Unexpected Treasures,* London, Bloomsbury, 1990.

Fenwick, H. & Hockney, D. 'Paint box of tricks', *Radio Times,* May 2-8, 1987, pp. 82-4.

Ferris, P. *Sir Huge: the Life of Huw Wheldon,* London, Michael Joseph, 1990.

...'Wheldon: the pride of Auntie', *The Observer,* (review section), July 1, 1990, pp. 45-6.

Finch, N. 'Margins of error', *Art Monthly,* (76), May, 1984, pp. 6-8.

Foster, R. & Tudor-Craig, P. *The Secret Life of Paintings,* London, The Boydell Press, 1986.

Franke, H. *Computer Graphics - Computer Art,* Berlin, Springer, 2nd ed 1985.

Fraser, N. 'TV Nibelungs proffer ring of confidence', (about Martin Lambie-Nairn and TV logos), *The Observer,* May 13, 1990, p. 71.

Fuller, P. 'Editorial: Henry Moore on television, an open letter to Anthony Barnett', *Modern Painters,* 1 (3), Autumn, 1988, pp. 4-5.

Games, S. 'Hard Arte of the possible', *The Guardian,* January 21, 1993, supplement, pp. 8-9.

Geddes, K. *The Setmakers: a History of the Radio and Television Industry,* London, British Radio & Electronics Equipment Manufacturers, 1991.

Geller, M. & Olander, W. & others, *From Receiver to Remote Control: the TV Set,* New York, New Museum of Contemporary Art, 1990.

Gibson, F. 'Television: *Art of the Western World* on PBS', *New Criterion,* 8, December, 1989, pp. 61-5.

Gillespie, M. & Hines, S. 'Critical contradictions: media representations of *The Dinner Party* as "Feminist Art"', *Picture This,* ed. P. Hayward, London & Paris, John Libbey, 1988, pp. 151-9.

Gomez, J. *Ken Russell: the Adaptor as Creator,* London, Frederick Muller, 1976.

Goodman, C. *Digital Visions: Computers and Art,* New York, Abrams, 1987.

Gough, P. 'Art on the box', *Artists Newsletter,* March, 1991, p. 31.

Gough-Yates, K. 'Bragg-Art', *Art Monthly,* (48), July-August, 1981, pp. 35-8.

...'Gowing, Gowing, gone', *Art Monthly,* (77), June, 1984, pp. 30-2.

...'The ICA and two Moore films', *Art Monthly,* (121), November, 1988, pp. 33-4.

...*'Five Women Artists...',* *Art Monthly,* (130), October, 1989, pp. 33-5.

...'"Civilisation" and its discontents', *Art Monthly,* (124), March, 1989, pp. 30-1.

Grant, L. 'Regrets, they've had a few', (*Arena*), *The Guardian,* November 24, 1988, p. 25.

Greenaway, P. *Prospero's Books: a Film of Shakespeare's 'The Tempest',* London, Chatto & Windus, 1991.

Grundmann, H. ed. *Art Telecommunication,* Vancouver, Western Front/Vienna, Blix, 1984.

Hagen, C. 'The fabulous chameleon: video art', *Art News,* 88 (6), Summer, 1989, pp. 118-23.

Hall, P. *Peter Hall's Diaries: the Story of a Dramatic Battle,* ed. J. Goodwin, London, Hamish
 Hamilton, 1983.

Hamlyn, N. 'Film: one minute read', *Art Monthly,* (148), July-August, 1991, p. 25.

Hayman, P. 'Art films by John Read', *Sight & Sound,* 26 (4), Spring, 1957, pp. 217-18.

Hayward, P. 'Beyond reproduction', *Block,* (14), 1988, pp. 55-9.

...ed. *Picture This: Media Representations of Visual Art and Artists,* London & Paris, John Libbey, 1988.

...'Aberdeen Access television: the exceptional case', *Independent Media,* (95), January, 1990, pp. 16-8.

...ed. *Culture, Technology & Creativity in the Late Twentieth Century,* London, Paris & Rome, John
 Libbey, 1990.

Hearst, S. *Artistic Heritage and Its Treatment by Television,* London, BBC, 1981, 22 pp.

Hewison, R., Fisher, M. & Forgan, L. 'Pulling at the arts strings', *The Guardian,* January 27, 1992, p. 25.

Higgins, G. ed. *British Broadcasting 1922-82: a Selected and Annotated Bibliography,* London, BBC
 Data Publications, 1983.

Hill, A. 'BBC *Sketch Club*', *The Studio,* 161 (814), February, 1961, pp. 43-7.

Hockney, D. 'David Hockney's paintbox pictures' *Art & Design,* 3 (7/8), 1987, pp. 37-44.

Holroyd, M. 'Seeing in the dark', *The Observer,* (Review section), January 10, 1982, p. 25.

'Home is where the art is', (A week of British art), *Radio Times,* May 21-27, 1988.

Hooker, D. *Art of the Western World,* London, Channel 4/Boxtree, 1989.

Howkins, J. 'One cheer for Ross McWhirter', *Time Out,* (156), February 16-22, 1973, pp. 15-8.

Huffman, K. & Mignot, D. eds. *The Arts for Television,* Los Angeles, Museum of Contemporary Art, 1987.

Hughes, R. (Art on TV), *Art News,* 81 (9), November, 1982, pp. 115-17.

Ignatieff, M. 'Let élitists stand up and be counted', *The Observer,* December 1, 1991, p. 25.

Jankel, A. & Morton, R. *Creative Computer Graphics,* Cambridge University Press, 1984.

John Piper, London, Tate Gallery, 1983.

Jordan, S. & Allen, D. eds. *Parallel Lines: Media Representations of Dance,* London, Paris & Rome,
 John Libbey/Arts Council, 1993.

Khan, N. *'Signals* of change', *The Guardian,* September 29, 1988, p. 25.

Kiang, T. 'A week of British art', *Circa,* (41), August-September, 1988, pp. 14-5.

Kidal, M. 'Video art and British TV', *Studio International,* 191 (981), May-June, 1976, pp. 240-1.

Krikorian, T. 'Broadcast television and the visual arts', *Art Monthly,* (73), February, 1984, pp. 9-13.

...*'Dadarama* (Channel 4)', *Art Monthly,* (84), March, 1985, pp. 35-6.

Kustow, M. *One in Four,* London, Chatto & Windus, 1987.

...'High art dressed as haute couture', *The Guardian,* December 5, 1991, p. 26.

...'Arte of the possible', *The Guardian,* June 5, 1992, p. 28.

Lambert, S. *Channel 4: Television with a Difference?,* London, BFI, 1982.

Lassell, M. *Wellington Road,* London, Routledge & Kegan Paul, 1962.

Law, R. *A Nasty Piece of Work: the Art and Graft of Spitting Image,* London, Booth Clibborn, 1992.

Lee, D. 'BBC billboard project', *Arts Review,* 44, June, 1992, pp. 234-5.

Levinson, N. 'Art on television: history or mystery', *Art Monthly,* (77), June, 1984, pp. 10-4.

Levy, M. *Painter's Progress,* London, Phoenix House, 1954.

Lewis, C. ed. *Antiques Roadshow: Experts on Objects,* London, BBC Books, 1987.

Lewis, P. *Community Television and Cable in Britain,* London, BFI, 1978.

Lloyd, J. & others, *The Spitting Image Book (The Appallingly Disrespectful Spitting Image Book),*
 London, Faber & Faber, 1985.

McArthur, C. *Television and History,* London, BFI, 1978.

McLoone, M. 'Presenters, artists and heroes: television and the visual arts', *Circa,* (31), November-
 December, 1986, pp. 10-4.

…'Reviews: TV special', *Circa,* (45), May-June, 1989, pp. 35-7.

Marks, L. 'The men on the BBC *Omnibus*', *The Observer,* August 23, 1992, p. 63.

Mathews, O. 'Television producer John Read', *Antique Collector,* 53, November, 1982, pp. 80-1.

Merritt, D. *Television Graphics: from Pencil to Pixel,* London, Trefoil Publications, 1987.

Mignot, D. ed. *Revision: Art Programmes of European Television Stations,* Amsterdam, Stedelijk Museum, 1987.

Mullins, E. *A Love Affair with Nature,* Oxford, Phaidon, 1985.

Nam June Paik: Video Works 1963-88, London, Hayward Gallery, 1988.

Nigg, H. & Wade, G. *Community Media,* Zürich, Regenbogen, 1980.

O'Doherty, B. 'Art on television', *The Eighth Art: Twenty-three views of TV Today,* by E. Burdick & others, New York, Holt, Rinehart & Winston, 1962, pp. 109-15.

O'Pray, M. 'Video on Four', *Art Monthly,* (90), October, 1985, pp. 28-9.

…'Video: declarations of independence: shows, schisms and modernisms', *Monthly Film Bulletin,* 55 (649), February, 1988, pp. 57-63.

…'England's Henry Moore', *Art Monthly,* (119), September, 1988, p. 28.

Partridge, S. & others, *19:4:90: Television Interventions,* Dunning, Fields & Frames Productions/Glasgow, Third Eye Centre, 1990.

Passingham, K. *The Guinness Book of TV Facts and Feats,* Enfield, Middlesex, Guiness Superlatives Ltd, 1984.

Paulu, B. *Television and Radio in the United Kingdom,* London, Macmillan, 1981.

'PBS tackles Western art…', *Museum News,* 68, September-October, 1989, pp. 9-10.

Pearson, P. *Satellite Television: a Layman's Guide,* London, Argus Books, 1987.

Perree, R. *Into Video Art: Characteristics of a Medium,* Rotterdam/Amsterdam, CON Rumore, 1988.

Petley, J. 'Gurus: the cult of the TV personality', *Prime Time,* (5), Spring, 1983, pp. 14-7.

Phillips, T. (translator & illustrator), *Dante's 'Inferno',* London, Thames & Hudson, 1985.

…*A TV Dante directed by Tom Phillips and Peter Greenaway,* London, Channel 4, 1990.

Philpott, R. 'Crying "shame!": will innovation make the grade?' *Independent Media,* (82), October, 1988, pp. 16-7.

Pile, S. 'Putting us in the picture', (Pamela Tudor-Craig), *Sunday Times Magazine,* September 28, 1986, pp. 77-9.

Ponti, L. 'Matt Mullican: an installation of computer-generated art', *Domus,* (714), March, 1990, pp. 8-9.

Potter, J. 'Warhol & Poulson', *Independent Television in Britain Vol III: Politics & Control 1968-80,* London, Macmillan, 1989, pp. 124-36.

…*Independent Television in Britain Vol IV: Companies, Programmes 1968-80,* London, Macmillan, 1990.

Pring, I. ed. *Image '89: the International Meeting on Museums and Art Galleries Image Databases,* London, IMAGE, 1990.

Pye, M. 'Polygons and pixels: the city as techno-art', (Matt Mullican), *The Independent on Sunday,* February 11, 1990, p. 31.

Read, J. 'Artist into film', *The Studio,* 155 (780), March, 1958, pp. 65-9, 91.

Reichardt, J. ed. *Cybernetic Serendipity: the Computer and the Arts,* London, Studio International, 1968.

…*The Computer in Art,* London, Studio Vista, 1971.

Reisman, D. 'Telescreen as text: interactive videodisc now', *Artscribe International,* (69), May, 1988, pp. 66-70.

Ridgman, J. 'Inside the liberal heartland: television and the popular imagination in the 1960s', *Cultural Revolution? the Challenge of the Arts in the 1960s,* ed. B. Moore-Gilbert & J. Seed, London, Routledge, 1992, pp. 139-59.

Roberts, J. 'Art and the mass media', *Studio International,* 198 (1008), 1985, pp. 36-8.

Robertson, F. 'Robbie programme', *Art Monthly,* (11), October 1977, pp. 4-9. (Transcript of Fyfe Robertson programme, BBC 1, 15 August 1977, attacking avant garde art.)

Robinson, D. '*Monitor* in profile', *Sight & Sound,* 30 (1), Winter, 1960-1, pp. 41-3.

Romain, M. *A profile of Jonathan Miller,* Cambridge University Press, 1991.

Ross, D. & Em, D. *The art of David Em: 100 Computer Paintings,* New York, Abrams, 1988.

Russell, K. *A British Picture: an Autobiography,* London, Heinemann, 1989.

Sabbagh, K. 'Tall storeys', *The Listener,* 122 (3141), November 23, 1989, pp. 14-5.

…*Skyscraper: the Making of a Building,* London, MacMillan/Channel 4, 1989.

Singerman, H. 'Tainted image: Rothko on TV', *Art in America,* 71 (10), November, 1983, pp. 11-5.

Sudjic, D. 'In praise of stony silence', *(Building Sights* series), *The Guardian,* September 24, 1992, p. 28.

Sutcliffe, T. 'Some fell on stony ground', *(Arena), The Independent,* January 18, 1992, p. 30.

Swallow, N. 'Problems of the arts', *Factual Television,* London, Focal Press, 1966, pp. 155-63.

Tait, S. 'Auntie leaves artists cold', (Brighton conference report), *The Observer,* November 1, 1992, p. 58.

Taylor, B. 'TV: *Relative Values',* *Art Monthly,* (150), October, 1991, pp. 26-7.

Thomson, B. 'Television and the teaching of art history', *Oxford Art Journal,* (3), October, 1979, pp. 46-9.

Todd, S. & Latham, W. *Evolutionary Art and Computers,* London, Academic Press, 1992.

Tonkin, B. 'Jewel in the crown or toad in the hole?' *The Guardian,* October 26, 1992, p. 17.

Tretchikoff, V. & Hocking A. *Pigeon's Luck,* London, Collins, 1973.

Tynan, Kenneth. 'Television: *Tempo* fugit', *Encounter,* 18 (6), June, 1962, pp. 44-7.

Tynan, Kathleen, *The Life of Kenneth Tynan,* London, Weidenfeld, 1987.

Vaughan, D. *Television Documentary Usage,* London, BFI, 1976.

'Vincent the Dutchman', *Radio Times,* October 12, 1972, pp. 8-9.

Vine, R. 'Pandora's set', *Art in America,* 79 (2), February, 1991, pp. 51-5.

Von Bonin, W. 'The electronic museum: art mediation on television', *Synthesis: Visual Arts in the Electronic Culture,* eds M. Eisenbis & H. Hagebolling, Offenbach am Main, Hochschule für Gestaltung, 1989, pp. 296-303.

Wade, G. *'TV World* profile: Reiner Moritz', *TV World,* April, 1985, pp. 54-6.

Walker, J. A. *Art in the Age of Mass Media,* London, Pluto Press, 1983.

...*Art and Artists on Screen,* Manchester University Press, 1993.

Watts, J. 'Planning the battlefield', (Alan Yentob), *Sight & Sound,* 54 (3), Summer, 1985, pp. 187 90.

Wenham, B. ed. *The Third Age of Broadcasting,* London, Faber & Faber, 1982.

Wesker, A. & Januszczak, W. 'The odd couple: broadcasting and the arts, a debate', *The Guardian,* October 27, 1992, supplement, pp. 1-4.

Wheldon, H. ed. *Monitor: an Anthology,* London, MacDonald, 1962.

Williams, R. *Raymond Williams on Television: Selected Writings,* ed. A. O'Connor, London, Routledge, 1989.

Wilson, A. *Tempo: the Impact of Television on the Arts,* London, Studio Vista, 1964.

Winter, S. *'Voices* Channel 4', *Artscribe,* (39), February, 1983, pp. 66-7.

Wombell, P. ed. *Photovideo: Photography in the Age of the Computer,* London, Rivers Oram Press, 1991.

Worsley, T. 'Art', *Television: the Ephemeral Art,* London, Alan Ross, 1970, pp. 147-50.

Wright, P. 'Putting culture in the picture', *The Guardian,* November 28, 1991, p. 25.

Wyver, J. 'The arts on 2', *Prime Time,* (5), Spring, 1983, pp. 12-3.

...'From the Parthenon', *Art Monthly,* (75), April, 1984, pp. 22-5.

...'Television and postmodernism', *ICA Documents 5: Postmodernism,* London, ICA, 1986, pp. 52-8.

...'Post Monitorism...', *Revision,* ed. D. Mignot, Amsterdam, Stedelijk Museum, 1987, pp. 84-95.

...'I believe in Ghosts', *Invision,* (19), February, 1988, pp. 20-1.

...'Video art and television', *Sight & Sound,* 57 (2), Spring, 1988, pp. 116-21.

...'Representing art or representing culture? Tradition and innovation in British television's coverage of the arts 1950-87', *Picture This,* ed. P. Hayward, London & Paris, John Libbey, 1988), pp. 27-45.

...'Altered sight', *Marxism Today,* April, 1991, pp. 42-3.

Young Unknowns Gallery, 'Art on Trial: the Crown versus Sylveire & Gibson', *AND: Journal of Art and Education,* (20), 1989, pp. 3-9.

Youngblood, G. *Expanded Cinema,* New York, Dutton, 1970.

Zetterling, M. *All those Tomorrows,* London, J. Cape, 1985.

Civilisation

Clark, K. *Civilisation: a Personal View,* London, BBC/J. Murray, 1969.

'... talks to Joan Bakewell about *Civilisation* series', *The Listener,* 81 (2090), April 17, 1969, pp. 532-3.

...*The Other Half: a Self-Portrait,* London, J. Murray, 1977.

Freud, S. *Civilisation and its Discontents,* London, Hogarth Press, 1949.

Hilton, T. *'Civilisation',* (Book review), *Studio International,* 179 (920), March, 1970, pp. 125-6.

Marcuse, H. *Eros and Civilisation,* Boston, Mass, Beacon Press, 1955.

...*One Dimensional Man,* London, Routledge & Kegan Paul, 1964.

Sparrow, J. 'Civilisation', *The Listener,* 81 (2093), May 8, 1969, pp. 629-31.

Secrest, M. *Kenneth Clark: a Biography,* London, Weidenfeld & Nicolson, 1984.

Twist, R. 'Considering all the risks', *The Observer,* April 16, 1989, p. 41.

Walker, J. A. 'Clark's *Civilisation* in retrospect', *Art Monthly,* (122), December-January, 1988-89 pp. 16-9.

Williams, R. 'Television: personal relief time', *The Listener,* 81 (2086), March 20, 1969, p. 399.

...'Television: a noble past' *The Listener,* 81 (2090), April 17, 1969, p. 543.

Ways of Seeing

Art & Language, *'Ways of Seeing', Art-Language,* IV (3), October, 1978.

J Berger, *'Ways of Seeing'*(Part 1), *The Listener,* 87 (2233) January 13, 1972, pp. 33-6; (Part 2)
 January 20, 1972, pp. 75-76; (Part 3) January 27, 1972, pp. 107-10; (Part 4) February 3,
 1972, pp. 145-6; plus letters in February issues.

...*Ways of Seeing,* London, BBC/Penguin Books, 1972.

...'In defence of art', *New Society,* September 28, 1978, p. 702.

...'The confession', *New Society,* February 12, 1988, pp. 18-9.

Bruck, J. & Docker, J. 'Puritanic rationalism: John Berger's *Ways of Seeing* and media and culture
 studies', *Theory Culture & Society,* 8 (4), November, 1991, pp. 79-96.

Dibb, M. 'Letter to Fuller', *New Society,* April 22, 1988, pp. 13-4.

Dyer, G. *Ways of Telling: the Works of John Berger,* London, Pluto, 1986.

Fuller, P. 'Berger's anti-Clark lecture', *7 Days* January 12, 1972, p. 23.

...*Seeing Berger: a Revaluation of Ways of Seeing,* London, Writers & Readers, 1980.

...'The value of art', *New Society,* January 29, 1988, pp. 14-6.

...*Seeing Through Berger,* London, Claridge Press, 1989.

Walker, J. A. *'Ways of Seeing:* twenty years on', *Art Monthly,* (154), March 1992, pp. 3-6.

Shock of the New

Hughes, R. 'I wanted to see the twentieth century through the lens of its art', *The Listener,* 104,
 September 18, 1980, p. 364.

...*Shock of the New: Art and the Century of Change,* London, BBC Publications, 1980/Thames &
 Hudson, rev ed 1991.

Wyver, J. 'Is there life after *Civilisation?',* *Time Out,* (544), September 19-25, 1980, pp. 18-9.

Beyond the pundit series: *State of the Art*

Bird, J. 'Notes: *State of the Art', Artscribe International,* (63), March-April, 1987, pp. 11-2.

Currah, M. 'Images for the eighties?', *City Limits,* January 15-22, 1987, pp. 16-8.

Cooke, L. 'The *State of the Art', Flash Art,* (133), April 1987, pp. 94-5.

Fuller, P. 'The great British art disaster', *New Society,* January 23, 1987, pp. 14-7.

Dunlop, G. 'Comment! Ideas, images and television', *Crafts,* (87), July-August, 1987, p. 12.

Overy, P, Fuller, P, & Brett, G. *'State of the Art:* three views', *Studio International,* 200 (1016), May
 1987, pp. 58-60.

Roberts, J. 'Postmodernism, television and the visual arts: a critical consideration of *State of the
 Art', Picture This,* ed. P. Hayward, London & Paris, John Libbey, 1988, pp. 47-62. (Previously
 published in *Screen,* 28 (2), 1987.)

Sebestyen, A. 'The mannerist marketplace', *New Socialist,* March, 1987.

Index